DIGITAL OUTDOOR PHOTOGRAPHY

Editor: Frank Gallaugher
Book Design: Tom Metcalf
Cover Design: Thom Gaines

Library of Congress Cataloging-in-Publication Data
Angel, Heather.
Digital outdoor photography : 101 top tips / Heather Angel. -- 1st ed.
p. cm.
Includes index.
ISBN 978-1-4547-0117-0
1. Outdoor photography. 2. Nature photography. 3. Photography--Digital techniques. I. Title.
TR659.5.A526 2011
778.7'1--dc23
2011029591

10 9 8 7 6 5 4 3 2 1

First Edition

Published by Lark Photography Books, A Division of
Sterling Publishing Co., Inc.
387 Park Avenue South, New York, N.Y. 10016

Distributed in Canada by Sterling Publishing,
c/o Canadian Manda Group, 165 Dufferin Street
Toronto, Ontario, Canada M6K 3H6

Distributed in the United Kingdom by GMC Distribution Services,
Castle Place, 166 High Street, Lewes, East Sussex, England BN7 1XU

Distributed in Australia by Capricorn Link (Australia) Pty Ltd.,
P.O. Box 704, Windsor, NSW 2756 Australia

If you have questions or comments about this book, please contact:
Lark Books
67 Broadway
Asheville, NC 28801
(828) 253-0467
www.pixiq.com

Manufactured in China

ISBN 13: 978-1-4547-0117-0

For information about custom editions, special sales, premium and corporate purchases, please contact Sterling Special Sales Department at 800-805-5489 or specialsales@sterlingpublishing.com.

For information about desk and examination copies available to college and university professors, requests must be submitted to academic@larkbooks.com. Our complete policy can be found at www.larkbooks.com.

For more information about digital photography, visit www.pixiq.com.

DIGITAL OUTDOOR PHOTOGRAPHY : 101 TOP TIPS

by

HEATHER ANGEL

LARK
PHOTOGRAPHY
BOOKS
A Division of Sterling Publishing Co., Inc.
New York

contents

INTRODUCTION.................................6

Planning and Preparation ———●

1 Compile an Event Diary....................8

2 Best Place, Best Time...................10

3 RAW vs JPEG................................12

4 Accessories Checklist13

5 Check Temperature Extremes ..14

Gear to Go ———●

6 Go Green.....................................16

7 Practical Camera Backpacks..........18

8 Other Ways to Carry Gear.............19

9 Invest in a Photo Vest..................20

10 A Field Fix-It Kit..........................22

11 Brighten up Essential Items..........23

Camera Supports ———●

12 A Bird's Eye View..........................24

13 A Worm's Eye View26

14 Brace the Body28

15 Tripods vs Monopods....................30

16 Bag a Bean Bag............................32

17 Work a Window Mount...................33

Metering ———●

18 How to Meter................................34

19 Auto vs Manual Exposure..............36

20 Which White Balance?...................37

21 Read Histograms...........................38

22 High Key and Low Key Images....................40

23 Backlighting Basics.......................42

24 Simple Silhouettes........................44

Composition ———●

25 Vary the Format46

26 Keep it Level48

27 Prime vs Zoom Lenses...................49

28 Wide Angles for Impact.................50

29 A Picture Within a Picture.............52

30 Dynamic Diagonals54

31 Sensuous Curves...........................56

32 Framing the View..........................58

33 Color Contrast..............................60

34 Color Harmony..............................62

Shooting ———●

35 First and Last Light.......................64

36 Check the Perspective...................66

37 Visualize the Image.......................67

38 Creative Depth of Field68

39 Seek Reflections...........................70

40 Time Lapse72

41 Moody Mist73

42 Seductive Shadows........................74

43 Light and Shadow..........................76

44 Inside-Out Light............................78

Enhance the Light ———●

45 Reflector Fill.................................80

46 Carry a Mini Cloud........................82

47 Use a Polarizing Filter...................84

48 Neutral Density Filters...................85

49 Paint with Light.............................86

50 Tele-Flash.....................................87

51 Creative Flash...............................88

52 Working in the Dark.......................90

Work the Weather

53 Shooting in the Rain92

54 Weatherproof the Camera94

55 Capture Sunbeams...............................96

56 Hot and Humid.......................................98

57 Snow and Ice100

58 Polar Regions102

Wildlife Wonders

59 Animals on Location.....................................104

60 Blend In.....................................106

61 Learn Fieldcraft 107

62 Using Blinds ...108

63 Working on Water 110

64 On Safari...112

65 Animal Transport................................ 114

66 Facial Expressions 116

67 The Need to Feed 118

68 Animal Camouflage120

69 Baby Animals..122

70 Courtship.. 124

71 Wildlife and Flowers 126

Action Shots

72 Capturing Action................................ 128

73 Up the ISO ...130

74 Creative Blur ..131

75 Shoot on the Hoof.............................132

76 Shoot Sequences 134

Focus on Plants

77 Wild Places... 136

78 Garden Glories 138

79 Avoid Typecasting Lenses...........................140

80 'Garden' with Care............................. 142

81 Make Flowers 'Pop' 144

82 Steady Wobbly Stems 145

83 Use a Windshield ... 146

84 Impressionist Images.......................... 147

Magic of Macro

85 Lighting for Macro.................................. 148

86 Depth of Field 150

87 Isolate Shots ...152

88 Light Tents.. 153

89 Macro Flash...154

90 Enhance Textures.............................. 156

91 Shoot Through Water.............................157

92 Natural Designs 158

After a Shoot

93 Post Shooting Tasks.......................................160

94 Back Up Files.. 162

95 Keep Sensor Clean 163

96 Digital Workflow ...164

97 Post Production....................................... 166

98 Recover Highlights 167

99 HDR Blending.. 168

100 Stitched Panoramas............................ 170

101 Focus Stacking172

Resources ..174

Acknowledgements...175

Index ..176

Introduction

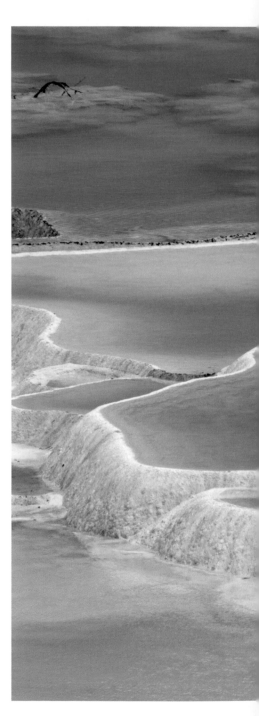

Whether taking wildlife, nature, or landscape pictures as a hobby or as a profession, it is invariably a rewarding experience. In many ways, digital capture has made photography less mystical and more accessible to everyone—although scrolling through the galaxy of menus in the camera can be quite daunting, even to a pro.

Digital Outdoor Photography: 101 Top Tips embraces macro subjects, nature, wildlife, and landscapes. The aim of this book is to encourage and inspire readers to get outside and enjoy finding and taking better images. Everyone approaches their photography in a different way; some may opt to concentrate on one particular aspect, while others prefer to illustrate a location by embracing the landscape as well as a selection of plants and animals that inhabit it. Only a few become so dedicated that they spend years of their life photographing a single species—as the Japanese professional photographer Teiji Saga did with the elegant whooper swan, photographing the birds in all kinds of weather on the Japanese island of Hokkaido.

If you asked half a dozen outdoor pro photographers what motivates them, you might get six different answers. However, I suspect they would all admit it was being able to work away from an office, to travel the world, and to experience the thrill of seeing a spectacular landscape or an endangered species in the wild.

Nothing beats getting outside with a camera and the joy of discovering stunning light on a landscape or seeing a new species for the first time. These aspects continue to drive me to both explore new areas and return to favorite haunts.

Whatever the motivation for taking photographs outdoors and regardless of traveling near or far, just being there can bring some rich rewards and magical moments that will live with you forever.

Finally, the best tip of all: Be ready to shoot whatever turns up— around a bend in the road, walking into a forest clearing, or having climbed to the top of a hill.

Introduction

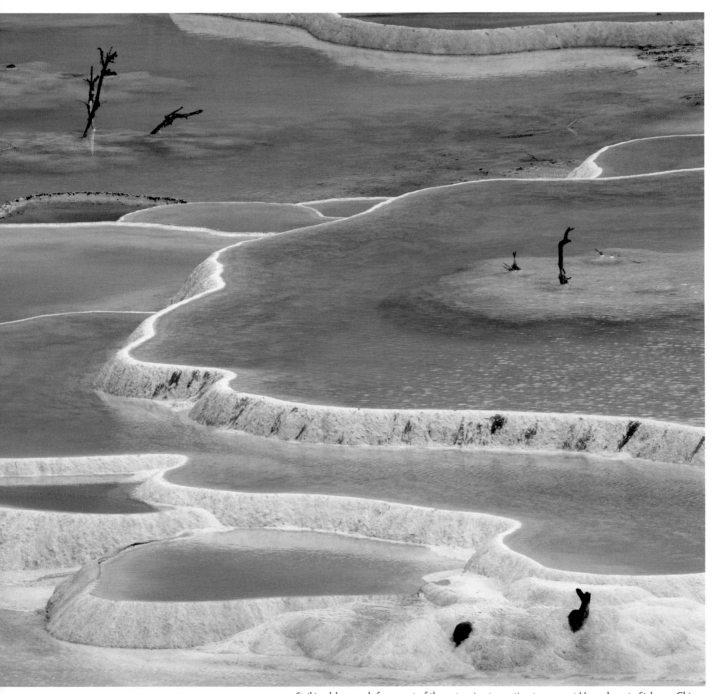

Striking blue pools form part of the extensive travertine terraces at Huanglong in Sichuan, China.

Compile an Event Diary

In British Columbia, a dominant run of sockeye salmon return to spawn in the Adams River once every four years in October. The last dominant run was in 2010.

Every outdoor photographer knows that being in the right place at the right time increases their chances of getting the image they want. Temperature influences events within the natural world, as does the length of the day. Since every type of plant has a limited span of time during which it appears in flower, it pays to do some research before venturing forth. Likewise, animals tend to migrate or breed at a specific time of the year.

A multi-year diary lists the dates of an event, but not the days of the week. Here, what is needed is the time when a particular wildflower comes into bloom, a tree turns color, or an insect species appears. After traveling farther afield and talking with photographers on location, the diary expands to cover places all over the world (see Tip 2) and is constantly updated.

For most of the time this works well, but sometimes a bit of fine-tuning is needed. For example: After an exceptionally severe winter, the appearance of early spring flowers is delayed until the soil begins to warm up. On the other hand, climate change and global warming have brought forward the time when some flowers appear. Nowadays, however, blogs and other Internet resources can be a great help in sensing trends, cutting corners, and gleaning information speedily.

If you miss certain flowers, it is worth noting that Spring comes later as you travel farther north in the northern hemisphere (or farther south in the southern hemisphere).

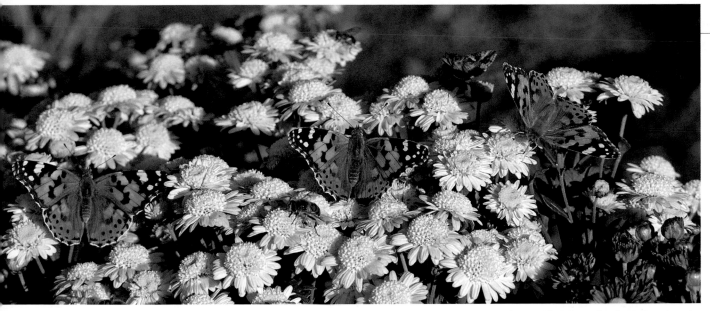

The timing of waves of butterflies is unpredictable, depending on temperature and prevailing winds. These clouds of painted lady butterflies landed on potted chrysanthemums in a Chinese Botanical Garden on September 28th, 2007.

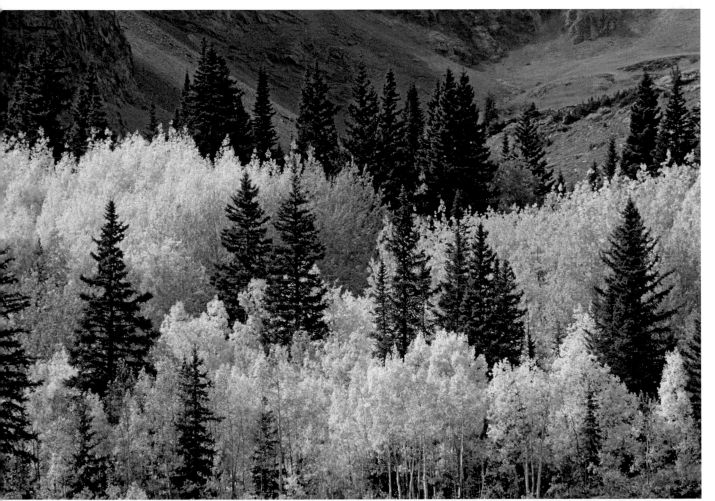

In any one location, the prime time for the fall color of Colorado aspens lasts only one week in September; but phone hotlines are regularly updated on fall foliage, and help highlight the best spots.

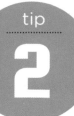
Best Place, Best Time

As television programs and articles feature exciting far-flung locations, so do adventure travel companies extend their range of destinations. Nonetheless, if you are traveling halfway around the world, you still need to research the best places and the best times to visit them. Here are twelve locations, one for each month, and each offering a special wilderness experience. Search the web for specialist tours.

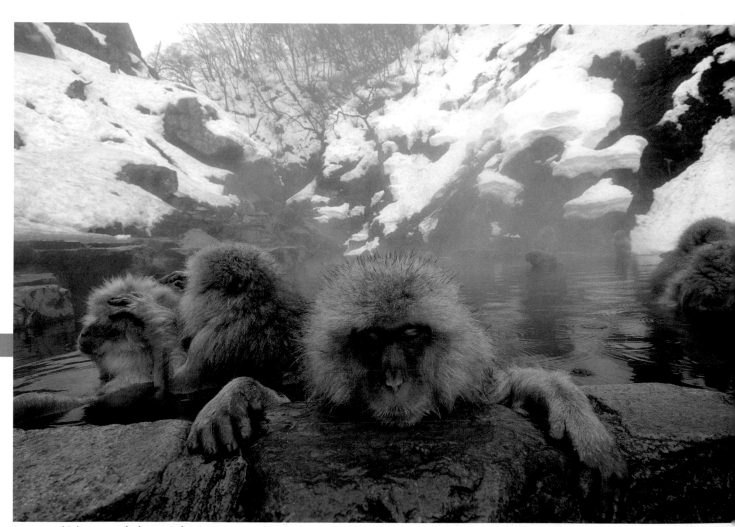

January and February are the best months to see snow monkeys bathing in their thermal pool, when there is snow on the ground at Jigokudani Monkey Park in Japan.

A mother brown bear with one of her new cubs taken at Hallo Bay in Alaska in July.

Planning and Preparation

January: **Jigokudani Monkey Park, Nagano, Honshu, Japan**...Snow monkeys living in a thermal valley and bathing in a hot pool

February: **Baja California and The Sea of Cortez**...Whale watching for gray and blue whales

March: **The Magdalen Islands, Canada**...Harp seal mothers and pups on ice floes in the Gulf of St. Lawrence

April: **India**...Tigers can be seen in the first and last few months of the year

May: **Galápagos Archipelago, Ecuador**...Giant tortoises, marine and land iguanas, seabirds, and lava

June: **Iceland, Land of Ice and Fire** ...Atlantic puffin capital of the world plus a host of waterfalls

July: **Etosha National Park and Sossusvlei Sand Dunes, Namibia** ...Game congregates at waterholes; shadows sculpt the dunes

August: **Rwanda**...Gorilla trekking is optimal from June to September

September: **Katmai National Park, Alaska**...Brown bears feast on salmon running up Brooks River, surrounded by fall colors

October: **Polar bears at Churchill, Canada** ...Polar bears can be photographed from elevated tundra buggies

November: **Kaziranga National Park in Assam**...Indian rhino-viewing from atop an elephant

December: **Icebergs in Antarctica** ...Penguins appear cleaner if snow still present

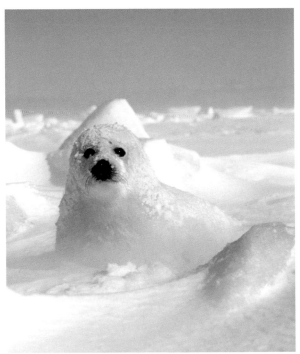

In early March, harp seal pups are born on the pack ice off Canada's Magdalen Islands. This whitecoat is waking up after an overnight blizzard.

RAW vs JPEG

Determining whether to shoot JPEG or RAW means considering how the digital images are intended to be used. JPEGs are processed by the camera itself, and their quality is compromised each time any edits are made and the file is resaved. In exchange, JPEGs do not require post processing, and are perfect for speedily uploading images to a website or for making quick prints for friends and family—especially if the White Balance (WB) and exposure were correctly captured in the first place. JPEGs also have smaller file sizes and take up less digital storage space. Megapixels (MP) relate to the resolution of the camera's image sensor, whereas megabytes (MB) relate to the size of and storage space occupied by a file. JPEGs have fewer megabytes than RAW files, but both formats have the same number of megapixels. As the cost of high-capacity memory cards continues to drop, another option is to record in both RAW and JPEG format at the same time.

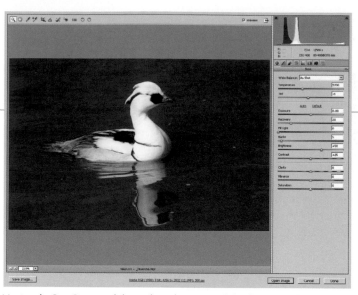

Moving the Raw Recover slider to the right corrected the clipping and moved the extreme right peak in the histogram toward the left. After opening the RAW file, very slight adjustments were made to the mid tones, and floating bits were removed from the water before the file was saved as a TIFF.

RAW files, on the other hand, are like digital negatives, in that edits can be made, saved, and resaved without loss of image quality. Also, changes are reversible in a RAW format, and there is much more latitude for post processing (especially when working on 16-bit files). A RAW file is usually uncompressed and retains all the data recorded from the camera sensor. This lossless file has a higher dynamic range than a JPEG. However, RAW files require post processing on a computer using software to create JPEG or TIFF files. I use Adobe Camera RAW with Adobe Photoshop; other processing software options include Aperture, BreezeBrowser Pro, and Adobe Lightroom. If high-quality images are required for exhibition prints or for supplying stock images, RAW files usually generate the best possible image quality.

Most image files—including RAW files, plus JPEG or TIFF files made from them—retain all of the image's EXIF metadata (date of capture, camera, lens, ISO, exposure settings, etc.). This information is invaluable when writing copy for photo magazines or websites. It should also be taken into consideration that some photographic competitions require entries to have minimal post-processing adjustments, and insist on seeing the original RAW files.

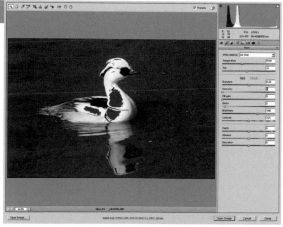

This screengrab of Adobe Camera Raw has the highlight clipping warning switched on (red) showing how the neck of the smew has been clipped.

tip 4 — Accessories Checklist

Having driven some distance or flown halfway round the world to a wilderness destination, it can be a great blow to discover a crucial item is missing. In addition to my fix-it kit (see Tip 10), which remains in my photo pack, additional photo accessories are selected depending on the terrain and means of transport used to get there.

The choice of cameras and lenses will vary depending on the location, the prime targets, and the length of a trip. Make a list of your equipment including serial numbers (take several copies) just in case overseas customs needs it. It can also be useful if you need report a stolen item to the police.

Warning: Do not present your gear list to customs unless they press for it. Doing so often necessitates much form filling and can delay your arrival and departure.

- >•> **plastic sheet or trash bag (to protect gear on wet or snow-covered ground)**
- >•> **knee pads or kneeling mat**
- >•> **full-length ground mat**
- >•> **field notebook**
- >•> **reflector**
- >•> **diffuser**
- >•> **camera bivvy or small tent for changing lenses in dusty locations**
- >•> **waterproof cover for camera pack**
- >•> **LED head flashlight**
- >•> **tape or string to tie back branches**
- >•> **swiss Army knife**
- >•> **filter wrench**
- >•> **water bottle**
- >•> **collapsible seat when waiting for birds—in or out of blinds**
- >•> **waders and a fly-fisher's vest for wading**

A full-length padded mat is useful for lying on damp ground, and has peg loops on the corners to anchor it on slopes. The mat can also be folded up to sit on hard rock.

Gardeners' knee pads with Velcro straps stay put, to cushion knees for low-level work on hard ground.

Check Temperature Extremes

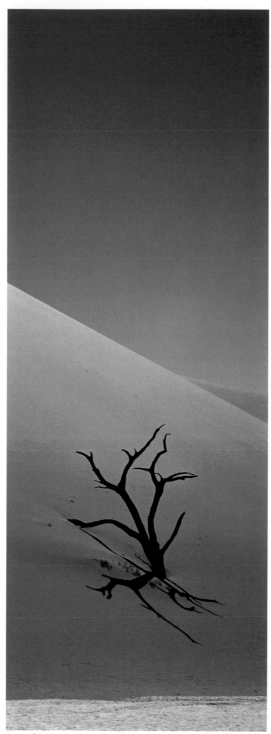

Once the sun rises on Dead Vlei at Sossusvlei in Namibia, there is no cover from the searing heat rising from the sand.

It is essential to be suitably dressed for the relevant climate—for comfort as well as basic survival. Being too hot or too cold is a distraction to your photography. If traveling as part of a group, the tour operator should provide helpful information on the expected weather; but if traveling alone, you will need to research the weather extremes. Websites provide this information: www.wunderground.com gives a 5-day forecast that includes maximum and minimum temperatures, wind speed, humidity, pressure, chance of precipitation, UV index, sunrise and sunset times, and visibility; www.worldweather.com gives a similar 3-day forecast, plus a bonus of climatological data for each month of the year, including total rainfall amounts and the average number of rainy days per month.

Because I often travel at short notice, I have designated separate storage areas for specific clothing—safari (see Tip 64), tropical rainforest (see Tip 56) and polar regions (see Tip 58). No doubt, you will want to compile your own, but it is always easier to amend a list than to start from scratch. Whatever the climate, the secret is to dress in layers, which can be removed or added as the temperature fluctuates.

Knowing what climate to expect can also be a great help in making sure you have adequate protection for your photo gear, although a waterproof cover for your photo pack should be carried at all times.

In extremely cold conditions, changing a camera battery while wearing several pairs of gloves is not easy. Now I carry two extra battery chamber covers, each with a fully charged battery attached, enabling the dead battery and its cover to be replaced without having to disconnect and reconnect batteries. It makes sense in any weather.

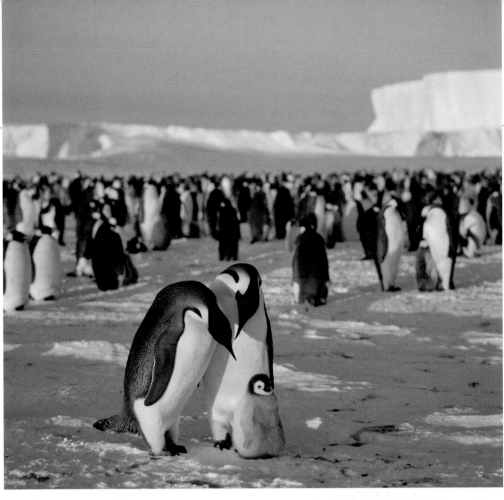

As the austral mid-summer light approaches midnight, Emperor penguin parents watch over their fluffy chick in sub-zero temperatures.

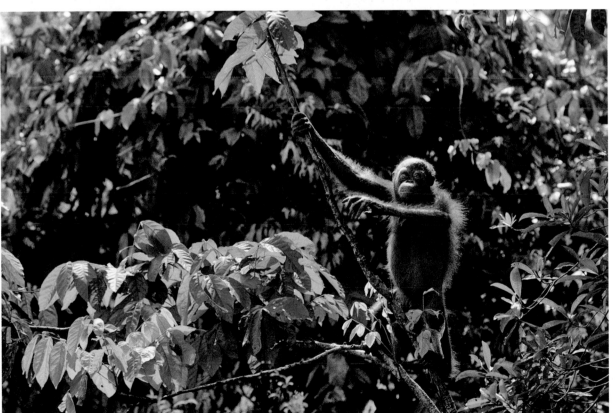

An orphaned young orangutan enjoys its freedom after it was reintroduced to the hot and steamy forest in Tanjung Puting National Park in Kalimantan, Indonesia.

Gear To Go

Anyone who cares for the future of our environment—and that surely includes most wildlife photographers—will avoid using disposable batteries. By using rechargeable batteries for both cameras and flash units, the battery weight taken on location is reduced and in the end saves money.

However, chargers that depend on AC power are not as eco-friendly as solar-powered units, which should now be a serious consideration—especially when working out in the open in locations with copious hours of sunlight each day. More models are gradually becoming available. The portable Solargorilla by Powertraveller™ can be used in remote locations—in a desert, in Antarctica, up a mountain, or on safari—as a solar charger for the Powergorilla, which itself can then be used as a portable charger for a laptop.

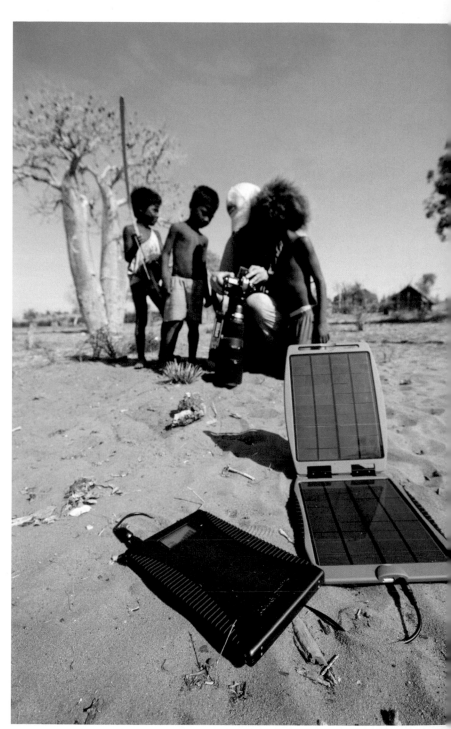

Powered by solar energy, the Solargorilla from Powertraveller™, used to charge their Powergorilla in Madagascar, provides energy on the go during sunny days in any location. © Nick Garbutt / Indri Images www.nickgarbutt.com

As the ultraviolet intensity of the sun increases, the center of the UVmonkey made by Powertraveller™ changes color from white to purple.

The Solargorilla can also be used to power up a laptop, hard drive, or cell phone directly when there is plenty of sun. It works on two photovoltaic (PV) solar panels, which generate an electric current when exposed to sunlight, and weighs 30 oz (820 g). The red LED on the Solargorilla indicates the strength of charge—the greater the ultraviolet (UV) intensity, the better it will work! For charging in the field, attach the Solargorilla to the outside of a photo pack or hang it on a vehicle or tent.

Other ways to go green include using a wind-up flashlight and sending e-cards instead of paper ones. Some solid pith helmets are now even available with their own built-in solar-powered fan.

The Eco Pro Torch is a wind-up flashlight that ensures a mobile bright LED light source anywhere anytime. One minute of winding gives 90 minutes of light.

Practical Camera Backpacks

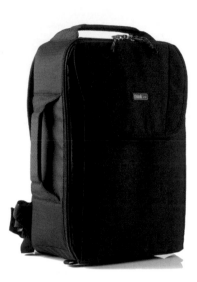

Exterior view of the compact Think Tank® Airport™ Ultralight backpack has a removable front laptop case; altogether it weighs a little over 2.5 lbs (1 kg).

Essential Camera Backpack Features:

>•> Comfortable to wear over rough ground

>•> Regulation size for flight carry-on

>•> Flexible inner compartments for different lens combinations

>•> Speedy access to gear

>•> Separate laptop pocket

>•> All-weather cover to protect from rain, snow, or dus

>•> Security cable and lock

>•> Clear, inner zipped pockets

>•> Lockable zipper sliders

For Serious Trekking:

>•> A thick waist strap with a quick-release buckle

>•> Thick padded adjustable shoulder straps

>•> A sternum strap to prevent shoulder straps from slipping

>•> A separate outer pocket for stowing wet clothing

>•> Optional side pockets for extra lenses and water bottle

>•> Lash tabs for tripod and umbrella

As the design of camera backpacks has evolved, they have become lighter, with many optional extras—such as a waterproof cover and a security cable—now standard. A shockproof and waterproof camera bag is essential for protection off the beaten track. My assorted collection of camera bags is necessary for working in different situations, and some others are included in Tip 8.

With such a vast range of camera packs on the market, it can be daunting to decide which one is best for your equipment and type of photography. Ask anyone you meet about the pros and cons of their pack.

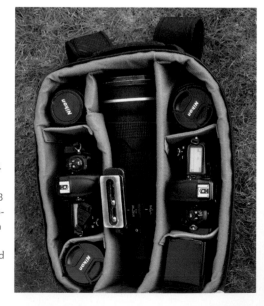

A Think Tank® Airport Ultralight backpack with my gear ready to go: a Nikkor 500mm f/4 lens (the lens hood is checked), two Nikon D3 bodies, a 105mm micro-Nikkor lens, a 12-24mm wide-angle lens, a 28-300mm superzoom, and an SB-900 speedlight.

tip 8

Other Ways to Carry Gear

There are times when it pays to switch to some other method of carrying gear besides a typical backpack. For instance, when wading in a river or the edge of the sea, it saves a lot of time trekking back and forth to dry land if you can carry and gain access to what you need on the spot. My preference is for a padded waist pack, which carries a spare lens (a wide-angle if I have a macro on the camera, or vice versa), plus a flash and filters. One that opens outward from the body allows a clear view of the contents, without any risk of items falling out, and leaves both hands free to carry a camera on a tripod.

When driving to a location with paved paths, such as a botanical garden or a zoo, a sturdy shopping cart is invaluable for stashing a long fast lens, reflectors and diffusers, an umbrella, a thermos flask, and food (which keeps me going all day); in fact, it holds everything that will not fit into my camera backpack. When visiting gardens or zoos abroad, it is worth hiring a stroller to transport gear, especially if the paths are undulating as at San Diego Zoo.

When shooting on the hoof in fine weather, a convenient way to carry a camera and lens is by using a camera body harness. This ensures the camera is at the ready and avoids wasting time removing and replacing a camera pack. It also avoids neck ache from carrying too heavy a camera on a neck strap alone. Several types of body harnesses are available. The Trekking Safari Camera Harness enables binoculars to be carried above a camera at the same time. With the Cotton Carrier® System, it is possible to carry one or two cameras, including one with a large heavy lens.

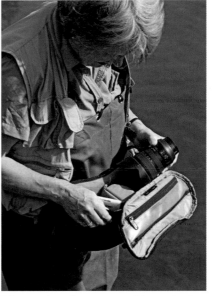

A fanny pack used to carry essential gear when wading mid-river.

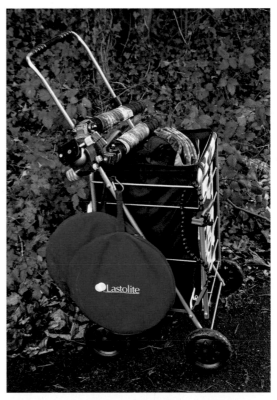

This shopping cart holds a 500mm f/4 lens, a full-length padded mat, umbrella, backgrounds, a Gitzo tripod with ball head, a Plamp, a large Tri-grip diffuser, and a reflector—plus drink and lunch.

Invest in a Photo Vest

Like camera packs, photo vests used to be bulky and far from flattering. A few years ago, I found one that is both practical—with variable sized pockets in the best places—as well as a stylish fit. The Scottevest® Travel Vest has no less than 22 pockets, but as with any photo vest, you need to be organized and decide what is stored where, to avoid time spent searching through every pocket.

When working abroad on location, the Travel Vest carries my passport, money, cell phone, all my flashcards, an external drive used to back up my images, and a field notebook and pen so that, if faced with an emergency evacuation from a boat or plane, all the images plus the notes I made at the time are retained.

The plus points are: no Velcro fastenings (which spook wildlife when you suddenly rip open a pocket) and a lightweight material that dries rapidly. Plus, the side pockets are large enough to carry a couple of small lenses onto a plane when your photo pack is over the specified weight limit.

When wading, I use a fly-fishing vest, which is a chopped off version of a photo vest, so there can be no risk of vital gear getting flooded in a lower pocket. Even so, I adopt a belt-and-braces approach, with all my flash cards stored in dust- and waterproof digital media storage cases (made by Hakuba and Gepe), which float if accidentally dropped in water.

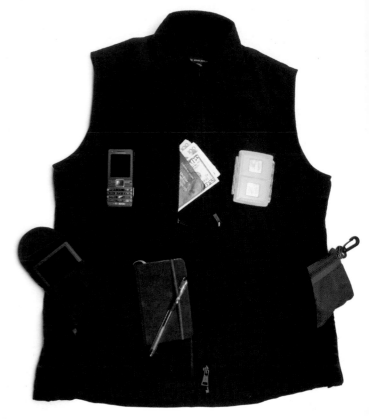

The Scottevest® Travel Vest has 22 pockets—plenty of room for all my key items when traveling abroad.

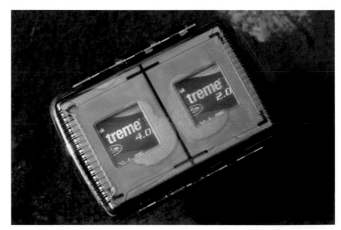

Memory cards are safe in the waterproof and dustproof Gepe Card Safe holder, which also floats on water.

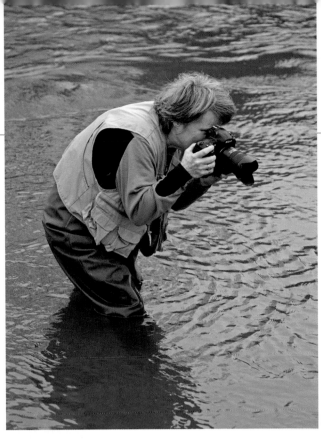

A cropped fly-fishing vest is perfect for carrying memory cards and other essential items when wading in water.

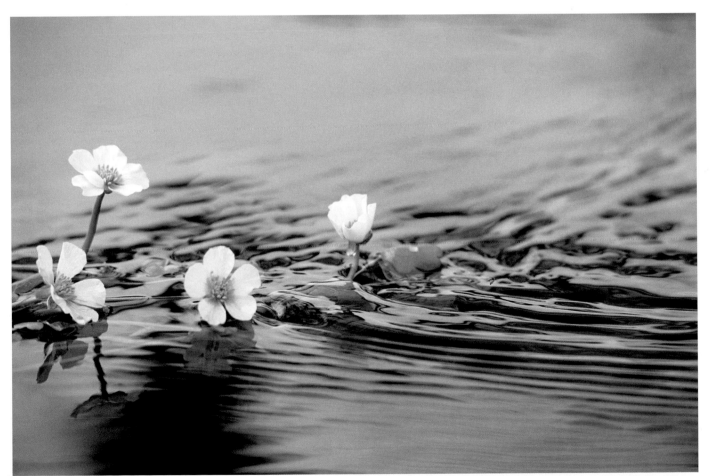

Water crowfoot with the wake created from the current streaming past emergent stems. Taken by wading out into the edge of a river.

A Field Fix-It Kit

Even with a back-up camera body, disasters can still arise on a long-haul trip—like the time the metering on a Nikon F4 body broke down on day one of a trip to Botswana. Early the very next morning, a 500mm lens that I was cradling in my arms after a dawn shoot suddenly separated from the back-up body together with the lens mounting. Once I realized that both camera bodies were out of action, all thoughts of amazing photo opportunities began to evaporate. Fortunately, I had a resourceful guide who got on the radio to other camps in the Delta and located a spare Nikon body. A fairly basic SLR came in on the next plane, and the first thing I did was buy a color print film to test the exposure with different lenses. The body lasted the trip, enabling me to fill essential gaps for a book.

Accidents inevitably occur when shooting on location; unstable tripods fall over or a footing is lost on slick rock when carrying a camera. My emergency camera repair kit has enabled me to keep shooting more than once (although it did not bail me out on that particular Botswana trip).

Fix-It Kit Checklist

>•> Allen wrenches for tightening quick-release plates
>•> Jeweller's screwdrivers
>•> Lens tissues
>•> Adapter busking to convert a 3/8-inch to a 1/4-inch hole
>•> Battery tester
>•> Roll of black vinyl insulating tape for mending a cracked lens shade, taping over a hole or crack in a camera or flash, or for securing a damaged electronic cable release
>•> Plastic bags
>•> Rubber bands to secure plastic bags around camera and lens in wet weather
>•> Contact cement or superglue
>•> Swiss army knife or Leatherman tool
>•> Spare flash sync cord

As soon as snow is forecast on Huangshan or Yellow Mountain in Anhui Province, China, hordes of tourists converge. The myriad steps become treacherous as the snow turns to ice and accidents frequently happen to both people and their photo gear.

tip 11

Brighten Up Essential Items

When traveling abroad, it is sensible to keep photo packs as inconspicuous as possible, so that they don't shout "expensive gear!" Back when we had more generous baggage allowances, I used to check my 500mm f/4 lens in its metal case inside an old kit bag I had literally dragged through the mud. Now that everything is X-rayed, there is little point in going to such extremes—although it does help to ensure checked gear does not have "Nikon" or "Canon" plastered all over the pack.

But it is often the little things that prove essential on a shoot. I make my Allen wrenches and watchmaker's screwdrivers as conspicuous as possible by adding yellow self-adhesive labels, so they cannot disappear in long grass or leaf litter. Bright red or blue mechanical cable releases once existed, but I have yet to find a gaudy electronic one; instead, I wrap red or yellow electrical tape in bands around the black release so that it resembles the red, yellow, and black warning colors of some caterpillars or poisonous snakes. Electrical tape is preferable to using paint, which eventually chips off and can easily find its way inside lenses or cameras.

Carabiners and S-biners, which come in assorted sizes and colors, are useful for hanging items such as a thermometer, a compass, and a small reflector or diffuser from a belt or a camera pack so they are readily at hand when out on a shoot. However, avoid using them on public transport or when walking through cities. At first light, I stepped outside my hotel in Antananarivo—the capital of Madagascar—to shoot some flowering street trees. My husband came with me to wear my camera pack. He felt a tug on the pack and by the time he had turned around, a young lad was racing off with my reflector in its case, which he had cut free from a carabiner.

Add color stripes (using self-adhesive labels or electrical tape) to make small items like Allen wrenches and jeweller's screwdrivers clearly visible if dropped in leaf litter. The red and yellow bands on the black electronic release mimic the coloration of a poisonous coral snake.

Carabiners and S-biners are useful for hanging items on a photo pack, and colored ones are more visible when dropped.

A Bird's Eye View

Camera Supports

Whether taking pictures from a plane, a hot air balloon, a pylon hide, a high building, or a cable car, you should always plan carefully because there will be no chance to dash back to a vehicle if you forget something. Check that the camera battery is fully charged and there is an empty memory card in the camera, with spares on hand. A camera strap is also good insurance.

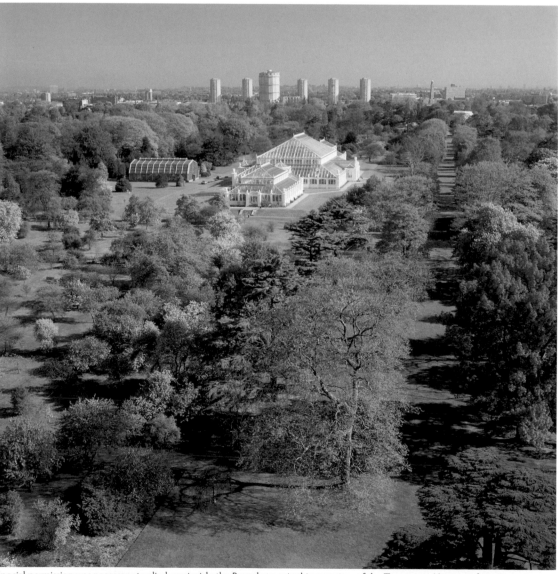

Special permission was necessary to climb up inside the Pagoda to gain this overview of the Temperate House and specimen trees in Kew Gardens (UK). Designed by Decimus Burton, the building is the world's largest surviving Victorian glass structure.

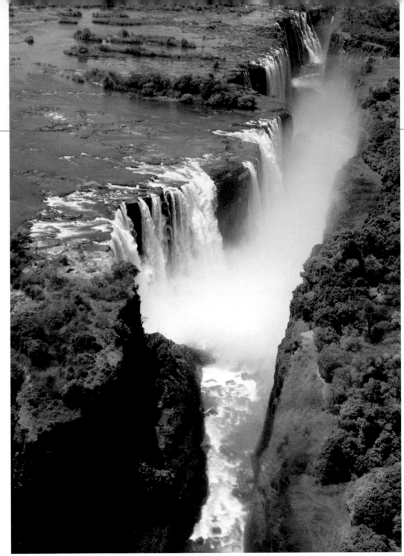

Only when flying above the mighty Victoria Falls on the Zimbabwe/Zambia border is the full extent and drop of the current cataract visible.

speed 8x the focal length of the lens—so with a 50mm lens use 1/400 second. Before taking off, make sure the pilot knows your objectives. Once you get airborne, take a few shots to check the exposure and zoom in on the LCD to check the sharpness.

Lenses with Vibration Reduction (VR) or Image Stabilization (IS) are designed to correct for handshake, not vibration of a plane; so they may not counteract this. Try some shots with VR or IS switched on and some with it off. The most productive aerial shoot I ever did was over the River Severn sitting next to the pilot, from where I directed the angle of the plane simply by tilting my hand to the left or right.

For anyone who dislikes flying, shooting from a high-rise building is a good compromise for taking cityscapes, and aerials of mountain scenery are possible from cable cars. Beware of distracting reflections in windows and shoot as close to the window as possible.

Before booking a small plane, check that your window will open—a better bet than shooting through scratched Plexiglas®. Serious aerial photographers prefer to shoot without a door in place. Before opening the window, wrap the camera strap around your wrist and stow all lightweight, loose items. Vibration of the engines and turbulence will mean a fast shutter speed is obligatory. As a rule of thumb, select a

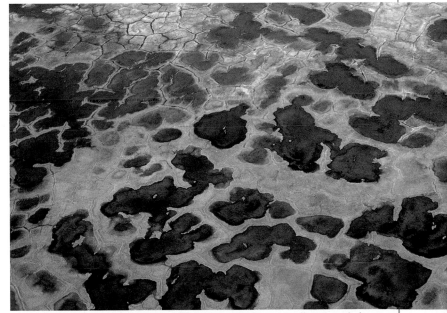

Alternating freeze and thaw conditions above the permafrost at Prudhoe Bay, Alaska create an intriguing aerial mosaic.

A Worm's Eye View

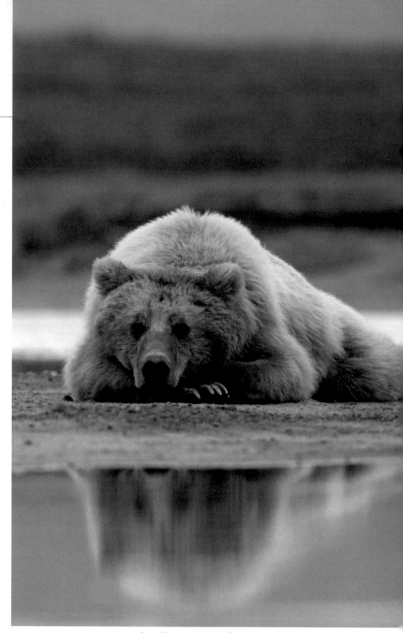

The perspective we gain from our normal eye level—around six feet (two meters) off the ground—is very different from a minibeast's view. A low-level shot, especially with a wide-angle close-focus lens, gives an arresting viewpoint and shows a flower, fungus, or insect in its habitat. The only snag is that you will have to lie prone to get your eye close to the viewfinder, unless either a right-angle viewfinder or a swivel live view screen is used.

A large trash bag waterproofs wet or damp ground, and Tip 4 explains a few ways to make kneeling or sitting on hard substrates more comfortable. Tripods useful as low-level supports include the Benbo and Baby Benbo (with the unique bent-bolt design that allows the center column and each leg to be moved through 360° before locking), and several

A relaxed brown bear reflected in a pool at Hallo Bay, Alaska was a speedy, low-angle shot taken with a 500mm lens.

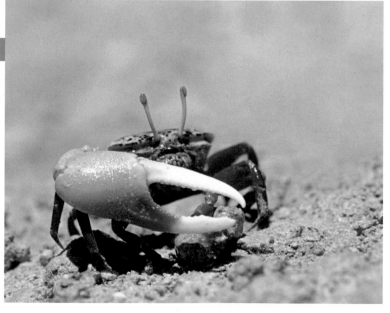

Fiddler crabs, with their periscopic eyes, have 360° vision and scuttle back into their burrows at the slightest movement. On the Red Sea coast, I laid down on wet sand with my finger on the shutter release, waiting for these wary crabs to re-emerge.

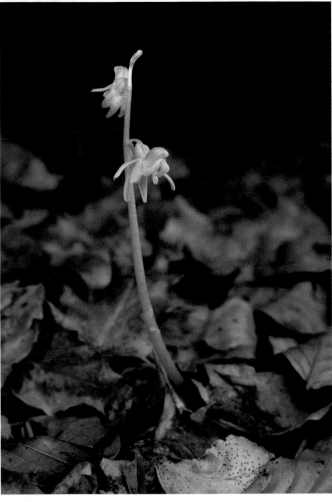

The best way to locate the rare and tiny ghost orchid is by lying on the ground and panning across the leaf litter with a flashlight.

Gitzo models without a center column. All of these can have their legs adjusted so that they lie on the ground. Both the Kirk Low Pod Mount or the Skimmer Pod II, topped with a ball-and-socket head, are ideal for ground-level work. Any low-level support is invaluable for aiding composition and accurate focusing.

Alternatively, gain a graphic perspective by shooting skyward with a wide angle for a striking shot of trees, grasses, or tall flowers against a blue sky. If the sun is shining and it is on the left or right of the shot, a polarizing filter will increase the saturation of the blue sky, making a dramatic backdrop for white lilies.

The BBC uses naturalistic objects—such as a boulder (the boulder cam) to hide a video camera to film lions, or a block of fake ice to film polar bears at ground level. Bored bears ended up leaping on the ice cams and trashing them—filming themselves in the process!

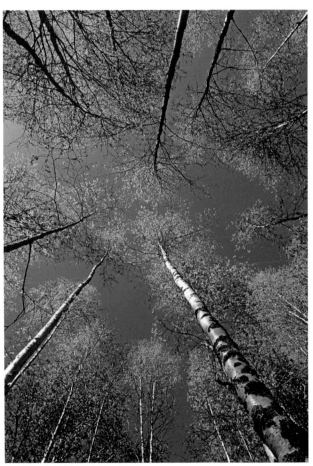

Birch trunks radiate in towards the center of the frame when taken from a low viewpoint with a wide-angle lens looking up at the canopy in Finland.

Brace the Body

For fast action, a tripod is going to be more of a hindrance than a help; so pushing up the ISO may be the answer. Indeed, with wildlife photography there are times (see Tip 75) when setting up a tripod can mean losing an action shot. Nevertheless, there are occasions, when on location without a tripod, in which an alternative support is going to be better than nothing at all.

We are not as lucky as kangaroos, which have their own built-in tripod so that when they stop bounding along, they are able to rest on their two rear legs with their tail functioning as the third point of contact. However, there are several ways to improvise using your body as a speedy and effective camera support in poor light without a tripod. Not only will this help to steady a long lens (although with built-in VR or IS, this problem is now much reduced), it will also aid careful composition.

Lean against a tree trunk or a wall with an arm and lower part of the body to support a longer lens.

Without kneepads, both knees can be used as camera supports by sitting on hard ground.

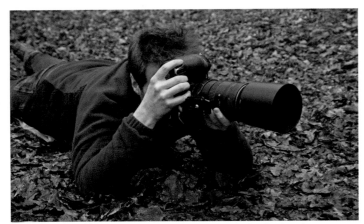
Lie prone on the ground, using the elbows as supports for low-level work.

Essentially, any way you can brace your body against a solid support will make for a steadier camera than one held out at arm's length. Most simply, when standing, prop the side of your body against a tree trunk or the wall of a building and lean into it before shooting.

For a low-angled viewpoint, sit on the ground with your knees raised so each one can support an elbow. Lower still, lie prone on the ground like a marksman and rest your elbows on the ground to support the camera. Tops of walls or railings can also be useful as temporary camera supports, although the height may not always be ideal for the best composition.

To show the thorny devil's body raised off the ground, it required lying prone for a very low angle.

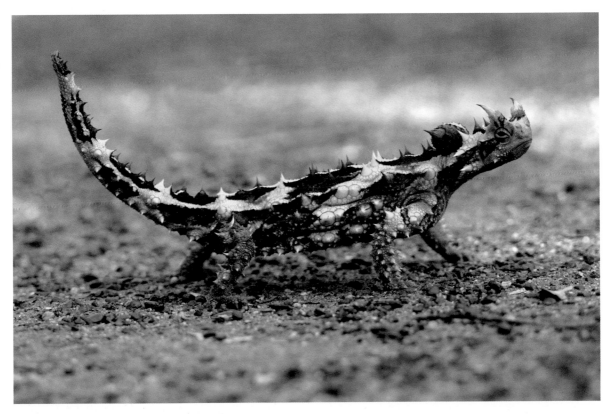

Camera Supports

Tripods vs. Monopods

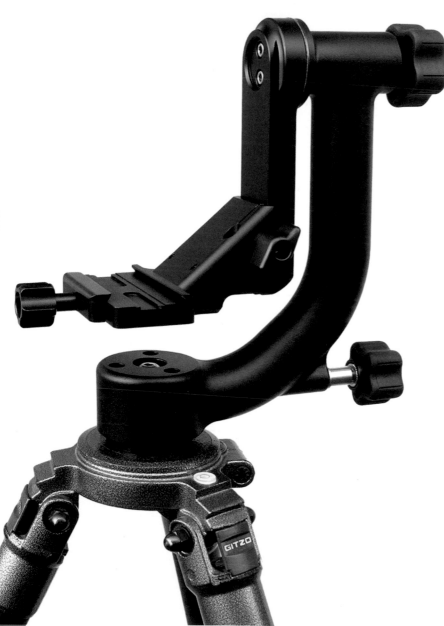

The gimbal-type design of the Wimberley Head Version II™ is a must for any serious wildlife photographer wanting easy and careful adjustment of large heavy lenses. © Wimberley Inc.

Whether to use a tripod or a monopod relates to the size of the subject, how active it is, and the safe working distance. When taking a small, wary bird from a hide with a long, fast 500mm or 600mm f/4 lens, then a tripod is the obvious choice and it needs to be sturdy yet with a minimum leg length that supports the camera at eye level when sitting down. When tracking a moving bird, speedy, fluid movement with such a lens is essential, and the Wimberley Head™ with a built-in Arca-Swiss style quick-release clamp is ideal because it allows rotation of the lens around its center of gravity. The Dietmar Nill gimbal head, designed by the German photographer, allows two cameras to be mounted on the head simultaneously.

For careful composition of any landscape shot, a tripod is a great boon, because it slows down the process of picture taking long enough to check that the horizon is level and the whole frame is inspected for any distracting elements. Often a slight adjustment is all that is necessary to fix the problem.

A tripod is essential for critical focusing of static macro shots and for using the depth-of-field preview to decide the best aperture. The best tripod for macro work is one without a center column, or one designed so the center column can be folded flat with one of the legs for low-level work (see Tip 13).

A Gitzo tripod, with the legs (plus camouflage leg warmers) collapsed for low-level work.

Encrusting lichens on a wall, taken with the camera sensor plane parallel with the wall, to ensure it was sharp across the frame.

A monopod is a useful and adaptable support in more dynamic situations when both the photographer and the subject are on the move—either when stalking an animal, requiring the camera to be constantly repositioned and refocused, or when working on a boat deck. In the latter case, a useful accessory is a monopod suction cup with a retractable spiked foot secured to the base of the pod.

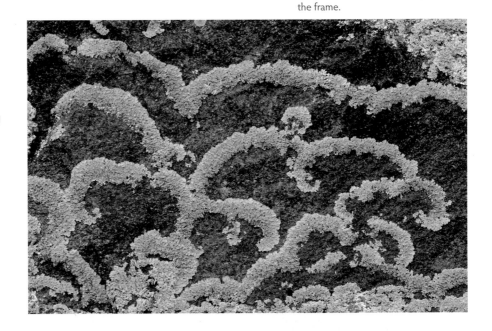

Working on the deck of a ship, a monopod supported a camera with a long lens to take Cape (or Pintado) petrels skimming the sea in Antarctica.

Bag a Bean Bag

A double bean bag, filled with rice, straddles a fallen trunk to support a camera with an 80-400mm lens.

Working in a jeep or a safari van with a group, a tripod is not practical because the legs clutter up the floor space. Many telephoto zoom lenses—up to 400mm with built-in VR or IS—can be hand-held for speedy shots, except at dawn and dusk. Even so, keeping arms braced against the body can be tiring and shots get missed having to reposition the lens each time the camera is picked up.

For taking shots of animals while remaining within a confined area, a bean bag is a useful camera support. They come in a variety of shapes and sizes, the best design being the double-pocket type, which forms a "V" that straddles each side of a narrow window frame or the window itself, projecting up a couple of inches. To prevent a carnivore making mincemeat of a bean bag, either buy one with a retractable cord or sew on some tapes so it can be secured inside the vehicle and retrieved if it falls overboard.

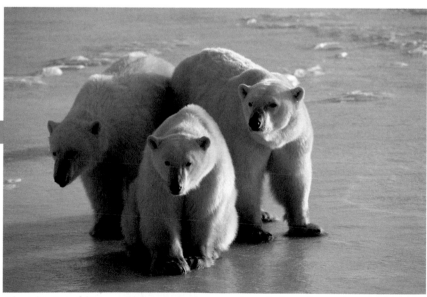

A bean bag is useful to support the camera when capturing polar bears from within one of the tundra buggies that operate out of Churchill in Canada.

When flying, take an empty bean bag and fill with dry beans or rice once you arrive at your destination. Do not overfill the bag, but rather leave a depression to cradle the lens. A bean bag can also be used atop a vehicle, a rock, or a tree stump. A lightweight buckwheat pillow used on long-haul flights can double up stuffed inside a pillowcase with tapes as a secure camera support on safari.

Before setting off on a game drive in a safari van, check that the windows will open. Ones that slide sideways work well and give some flexibility as to which side of a window you can use. Windows that open vertically need to open nearly all the way down; childproof ones will not work—so see if the childproof restriction can be deactivated first.

tip 17 — Work A Window Mount

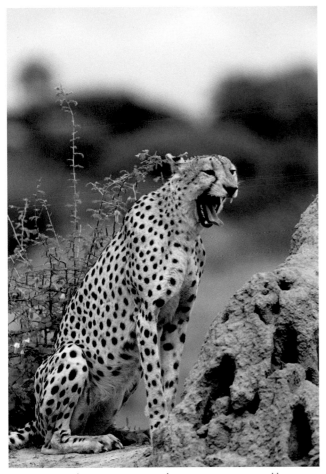

By supporting the camera on a window mount, it was speedily rotated to a vertical format within the lens collar, to capture a yawning cheetah in Botswana.

A Kirk Window Mount used to support a 500mm f/4 lens.

For supporting a longer and heavier lens, such as a 200-400mm f/4, a 500mm f/4, or a 600mm f/4, a bean bag will not be adequate. Neither is it practical when wanting to track a moving animal by panning the camera. A much better option is to use a Kirk Window Mount. When a solid ball-and-socket head is attached to this heavy-duty mount, it can handle lenses up to 800mm, whether clamped inside a car window or resting

on a jeep bonnet. This camera mount also doubles up as a sturdy "lowpod" for resting on the ground for more dramatic ground level shots (see Tip 13)—but it should be used only in situations where it is safe to alight from a vehicle.

Another option, which is not so weighty to transport on the plane, is a Manfrotto 035 Super Clamp, which weighs 14.5 oz (0.41 kg), has a load capacity of 33 lb (15 kg), and a unique secondary safety lock. We use these clamps a lot in the studio for securing boards and diffusers in position. By fitting a good ball-and-socket head to it and then clamping it to part of the metal framework of a jeep, this makes for a convenient mount with a head that can be panned through 360º of motion, ideal for working in an open-topped jeep.

How to Meter

Metering

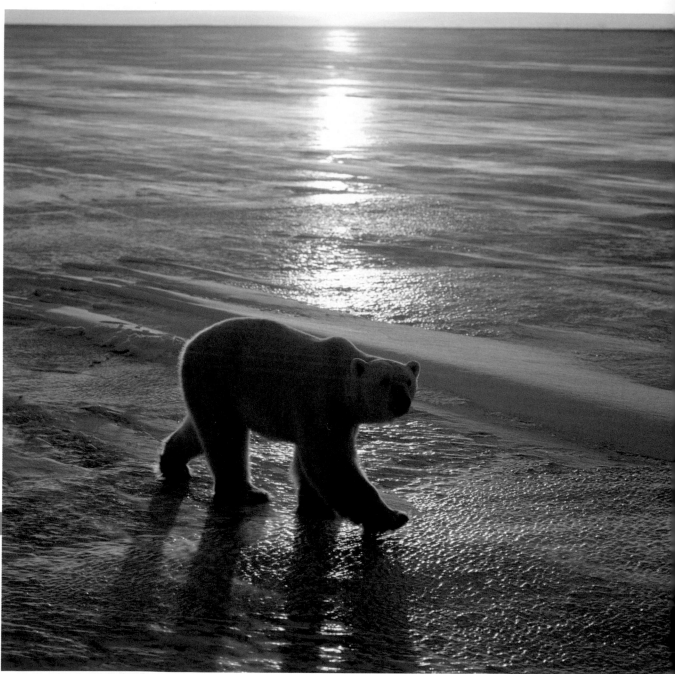

For this backlit shot of a polar bear walking over the ice as the sun was setting, the flank of the bear in shadow was manually spot-metered.

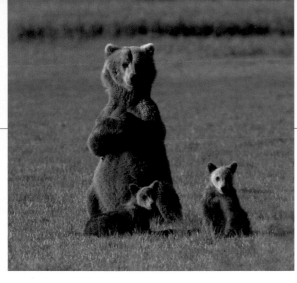

Using a multi-segment reading will work fine when average-toned green grass and well lit brown bears fill the frame.

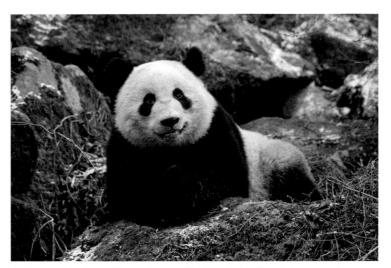

A giant panda with roughly equal areas of black and white fur relaxes on average-toned rocks and can be metered with an overall multi-segment reading.

To grasp the essentials that relate to your camera, read the user manual and talk to others who use the same model. Four factors affect the exposure: ISO, aperture (f/stop), shutter speed, and last but not least, the quality of the lighting. A low ISO (i.e. 100) is used when there is plenty of light or when shooting a static subject at a slow shutter speed on a tripod; and a higher ISO is used in low light or for fast action. However, a higher ISO increases the risk of noise and can lower image quality.

All D-SLR cameras provide choices as to which parts of the frame are used to meter reflected light from the subject through the lens (TTL). Multi-segment metering ("Matrix" on Nikon or "Evaluative" on Canon) takes a number of readings from across the frame and calculates the best exposure for the whole scene; but with tricky backlit or lowlight shots, it will not be so accurate as center-weighted or spot metering. Center-weighted metering takes an average reading from across the whole frame, but with a bias toward the center; while spot metering takes a reading from a very small area—usually the centermost 2.5% of the frame, but also sometimes the tiny area around whichever focus point is selected. This method works well providing a mid-toned area is used;

otherwise it will give an incorrect reading. See Tip 22 for metering subjects that are lighter or darker than mid tone.

With the instant feedback gained from LCD screens, the choice of metering mode is not so crucial as it was with film cameras. With brightly lit scenes, be sure to switch on the highlight clipping display—it takes no time at all to check if highlights are flashing due to overexposure. However, when inside a forest shooting up at the canopy, with tiny gaps of bright sky between the trees, it may be preferable to have these gaps slightly overexposed rather underexposing the forest floor, so it is worth checking the histogram as well (see Tip 21).

Auto vs Manual Exposure

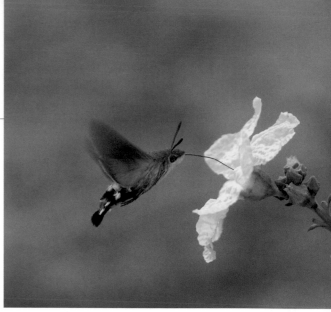

Having worked out the best way to meter (see Tip 18), the next decision is deciding which exposure mode to use. With Program (P) autoexposure mode, the camera selects both the aperture and shutter speed. However, this will not help you better understand how to be creative about selecting these two exposure parameters independently.

Shutter Priority (S) autoexposure mode allows you to select the shutter speed (e.g., fast to freeze action) and the camera then takes care of the aperture. If the light level should drop off, an increase in the ISO may be necessary to maintain the same combination of shutter speed and aperture. Aperture Priority (A) mode allows you to select the aperture (for controlling the depth of field) with the camera selecting the appropriate shutter speed. Manual exposure (M) allows selection of both the shutter speed and aperture, and is what I use most of the time.

Is it better to shoot first, and then peek at the histogram to adjust the exposure? Or should the scene be properly metered from the start? The ideal way is to get it right—or nearly right—the first time, because you cannot afford to spend too much time chimping (repeatedly checking the image preview on the camera LCD immediately after capture) when taking action shots of wildlife.

As long as you use the same lens and ensure the light remains constant, you can first manually metering off an average-toned subject such as green grass, and then recompose your final shot. If an autoexposure method is preferred and the average tone is off-center, meter it using either center-weighted or spot metering, then lock the exposure (see AEL or Autoexposure Lock in your camera user manual) before recomposing.

With no flash on hand, I manually selected 1/600 second to capture a hummingbird hawk moth hovering to feed. This was fast enough to freeze movement of the body and the long proboscis, but not the wings.

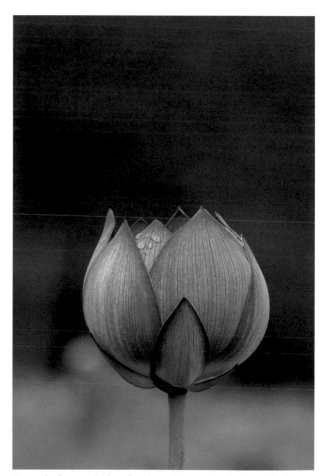

To get the front and sides of a spherical lotus lily bud in focus, the lens is partially stopped down. Use either Aperture Priority or Manual exposure to select the best aperture (check the depth-of-field preview and open up the aperture if the background appears too much in focus).

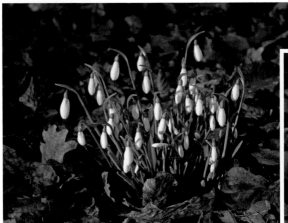

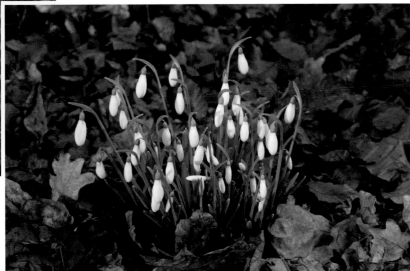

With the white balance (WB) set to tungsten, the whole frame has a distinct blue cast; but when set to cloudy, the white snowdrop flowers appeared a true white. When shooting in RAW, an incorrect WB can easily be changed.

tip 20
Which White Balance

Natural light has a distinct color cast at different times of the day and in different locations. For example, early and late in the day, light has a warm cast; whereas shadow areas tend to have a cooler blue cast—which becomes apparent in shadows on snow.

Our eyes readily adapt to changing light conditions; but with digital cameras, if the incorrect white balance (WB) has been selected for the relevant light source, an unnatural color cast will appear rather than an accurate representation of the scene's colors. WB temperatures ranges from 5200K in direct sunlight to 8000K in the shade. However, when shooting RAW files, it is not such a disaster if images are shot with the incorrect WB, because this can easily be changed in the RAW converter without any loss of image quality.

If the WB is set to tungsten light for an outdoor shot, the color cast is blue. When the correct WB is set, the colors are rendered neutrally and accurately. So why is it that many people opt to stick with auto white balance (AWB)? Probably because they regard it as a safe option, even if it doesn't always produce the most accurate colors. When shooting naturalistic scenes outdoors, the incandescent and fluorescent settings can safely be ignored, which then leaves a choice of Direct Sunlight, Cloudy, Shade, or Flash.

For the most accurate WB setting, photograph a color grid such as the GretagMacbeth ColorChecker Chart® in the same light as the subject. With 24 distinct color squares, the chart enables accurate calibration of the camera, monitor, and printer.

Read Histograms

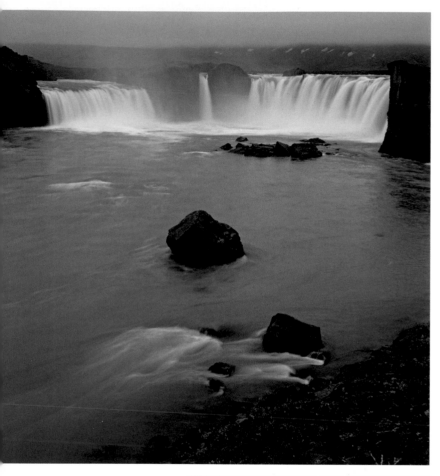

You cannot shoot digital without understanding histograms—whether in the camera or in the Levels and Curves dialog boxes in post-production. Nonetheless, too much time spent looking at in-camera histograms means less time taking memorable shots. My philosophy is to always check out shots that are clearly tricky to meter—especially high- and low-key images (see Tip 22). Otherwise, when shooting an average-toned subject, metering should not be a problem. That said, it is always preferable to get the exposure correct in the camera rather than correcting afterward in post-processing—that should be for only small tweaks, ideally. If you make a habit of using Exposure Compensation, it is probably just as well to check the first shot on a shoot that it has been reset to 0, so it will not adversely affect your subsequent exposures.

The histogram is a graphic representation of the tonal values of the pixels in an image, and is meant for speedy evaluation of exposure. (Your camera may also be able to display separate histograms for each red, green, and blue [RGB] channel). The extreme left side of the histogram is pure black (0 value), and the extreme right is pure white (255 value). Regardless of what the curve looks like between these two limits, the bottom line of the graph should extend all the way to both edges—indeed, the stock agency Alamy will accept images only if the black/white points are within 5% of these edge values.

A good way to understand the RGB histogram is to look at the separate RGB channels after a shoot, when the peaks and troughs of each color become apparent. It then becomes clearer how the RGB histogram is built up from the three channels.

Godafoss waterfall, shot at midnight in Iceland, shows how the bulk of the average tonal values are grouped in the center of the frame with a separate peak for the dark rocks to the left and one for the white water to the right.

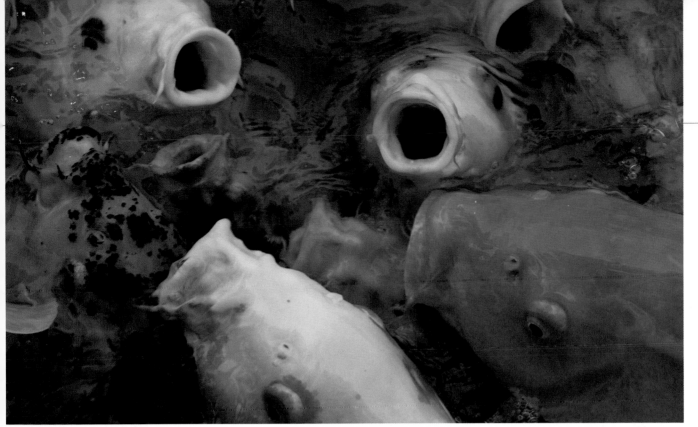

This shot of hungry koi carp surfacing shows that neither the shadows nor the highlights are clipped. The multiple peaks correspond to the different tonal values of the fish.

The pink magnolia flowers against the blue sky show three distinct peaks grouped around the mid-tone area, illustrating how the sky has distinct tonal values from the different parts of the flowers.

High Key and Low Key Images

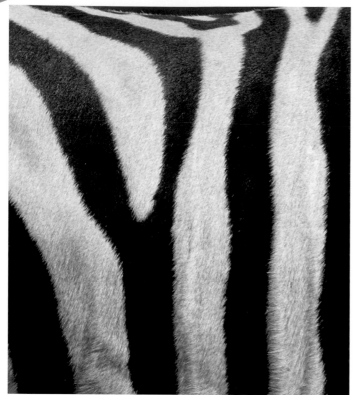

A frame-filling zebra flank illustrates that when the area of white stripes equals the area of black ones, they cancel each other out and render a neutral scene. Thus, multi-segment metering will work fine.

A dandelion leaf growing in the shade was laid on top of a high-key bull thistle flower for manual spot metering in the same light.

For much of the time, the camera's autoexposure mode—Program, Shutter Priority, or Aperture Priority (see Tip 19)—works fine in conjunction with the multi-segment metering mode (see Tip 18). However, because the camera meters light reflected from a subject and attempts to make everything a neutral gray tone, it gets it wrong with bright- or dark-toned subjects.

Readjusting the exposure after chimping (repeatedly checking the LCD) wastes time. Autobracketing (shooting a rapid sequence of images, each with a slightly different exposure) does not cost anything, but it increases the odds of the best action shot being incorrectly exposed. A better way is to predict an average tone when you see one—such as green grass, leaves, or gray rocks.

White swans on snow or a white flower that fills the frame are both high-key subjects. Their correctly exposed histograms will still have a full set of tones, with some mid-tones and some black present, but with a high peak over to the far right. Being much brighter than green grass, any shot taken with an unadjusted in-camera reading will appear underexposed, so that white flowers and snow will appear gray.

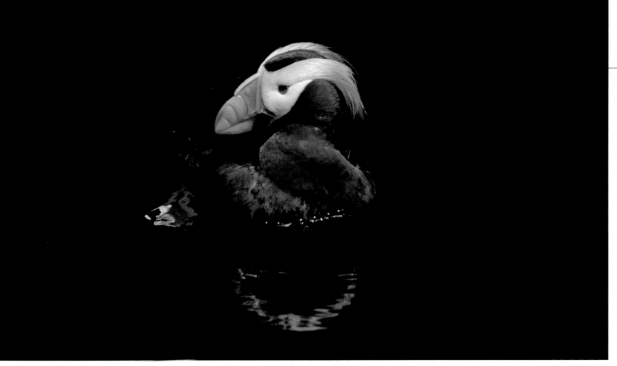

Spotlit by the sun late in the day, a tufted puffin produced a low-key image. Sunlit green leaves that were just out-of-frame were first manually spot-metered, and the frame was then recomposed on the puffin.

Low-key subjects are largely dark images, often black, but also dark red or deep purple. Their correctly exposed histograms will show a high peak over to the far left, with some mid-tones and some white. Without any adjustments made to an in-camera exposure, images will appear overexposed.

To get the correct exposure, I manually meter off an average tone and use this exposure to shoot the high-key (or low-key) subject. If an autoexposure mode is preferred, meter as above and retain this reading by holding down the shutter release halfway (autoexposure lock or AEL). Without an average tone nearby, use a separate light meter to measure light falling on the subject and set the exposure manually—or add exposure compensation for making high-key subjects brighter, or some negative exposure compensation for making low-key ones darker.

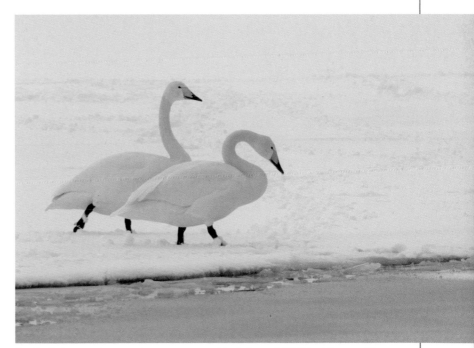

A pair of whooper swans court on snow-covered ice in Japan. With this white-on-white scene and without any average tone in sight, I used the in-camera reading and added 1.5 stops exposure compensation, then checked the histogram.

Backlighting Basics

Backlighting adds drama to many a photograph and is most effective when the sun is low in the sky. Shadows of branching trees stretch forward to cast shapely patterns on a pale-toned foreground; solid objects isolated against the sky or water appear as silhouettes (see Tip 24), while translucent flowers, leaves, hairs, and spines all glow.

Greater care needs to be taken when shooting *contre jour* or against the light. Use a lens hood (or failing that, your hand) to shade the lens from direct sunlight, which can cause flare. Check that the lens hood is not so long that the corners of the image appear vignetted. A wide-angle lens is more likely to present flare problems than a narrow-angled telephoto lens, and zoom lenses are more problematic than prime lenses; but multi-coated lenses of any sort do help to reduce flare.

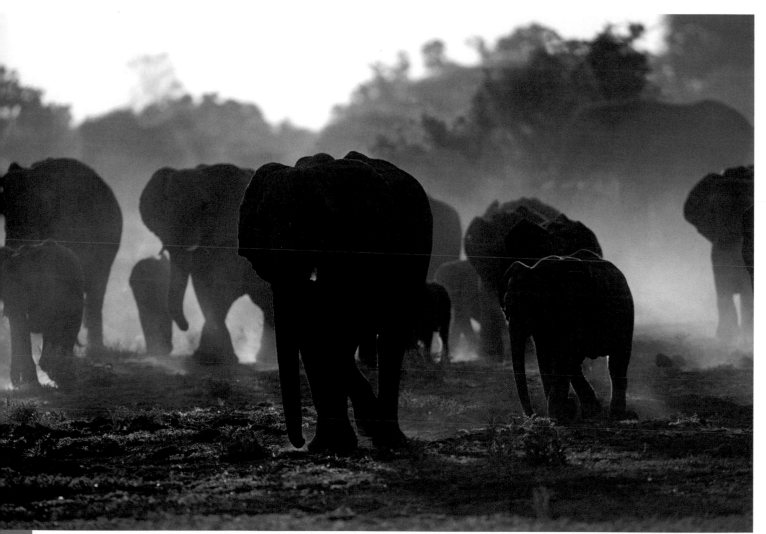

As a large herd of elephant passes on either side of our jeep in Botswana, they kick up copious dust clouds, which add impact to this dusk shot. A shadow on the ground was manually spot-metered.

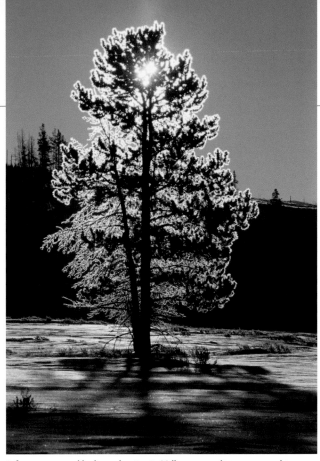

A frost-encrusted lodgepole pine in Yellowstone glistens as sun shines through it in mid-winter.

If the sky is very bright, there are three options: Frame the scene in such a way to exclude the sky entirely, use a graduated neutral density filter over the sky area to bring it nearer to the tonal range of the rest of the scene, or shoot a series of exposures for High Dynamic Range (HDR) blending (see Tip 99).

Remember that in-camera metering measures light reflected back from a scene, not light falling on it. A large expanse of sky or water will be brighter than average and tend to result in underexposure. I either manually spot meter several average-toned areas in the scene, or turn around 180° to matrix meter the light falling on the landscape behind me.

If you prefer to use an autoexposure mode, turn around and meter the light falling on the scene, then use Autoexposure Lock (AEL) to hold that exposure and turn back to recompose. If after looking at the result it still needs tweaking, apply exposure compensation accordingly.

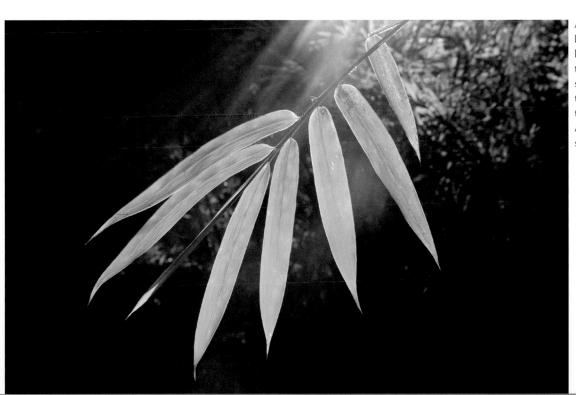

A low-angled sun beams onto the back of bamboo leaves, bringing them to life and separating them from the shadows falling on the green forest behind. A leaf was manually spot-metered.

Simple Silhouettes

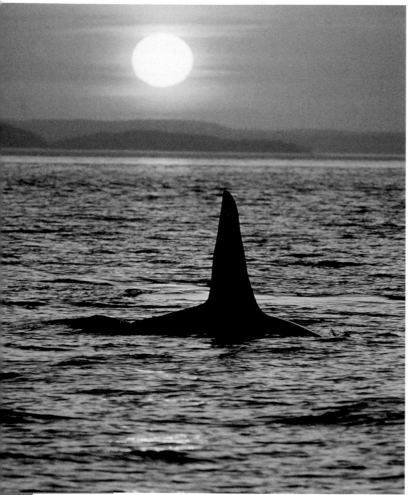

Simple uncluttered silhouettes are most effective, such as this dagger-like fin of an orca or killer whale breaking the sea surface off Canada.

A silhouette defines the outline of an object at the expense of losing that object's color and texture. The hardest part in taking a successful silhouette is finding an uncluttered subject with a clean backdrop—be it a colorful sky or bright water.

For colorful backdrops at dawn or dusk, look for open standing trees growing on raised ground, mammals standing on a hill, or dolphins leaping out of the sea. Side views of animals are preferable to head-on ones, so that characteristic shapes are instantly recognizable—such as the long neck of a giraffe, the outsized hind legs of kangaroos, or bison horns.

Keep it simple. Avoid overlapping trees or animals because it then becomes difficult to see where one ends and the other begins. Longer lenses are useful for isolating leaf mosaic patterns or hanging fruits, as well as complete trees or animals. Metering is easy: Simply spot meter off the bright sky or water to ensure the subject is underexposed by several stops. Be sure to use a lens hood when shooting into the light.

The first silhouettes pre-date photography. Étienne de Silhouette (1709 - 1767), a French politician, is credited with producing the first examples by cutting head profiles of people from black paper. However, paper was invented in China around the end of the first century, so it is not surprising that paper-cutting as a craft originated in that country five centuries later, where it is still practiced today.

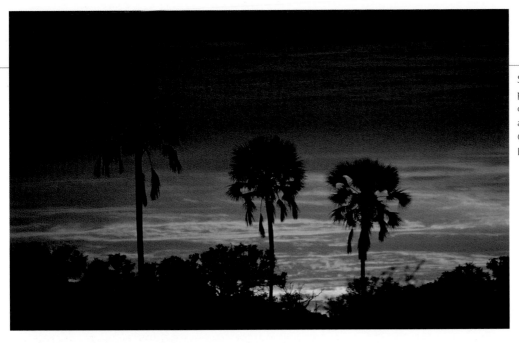

Silhouetted fan palms stand proud of other plants at dusk in the Okavango Delta, Botswana.

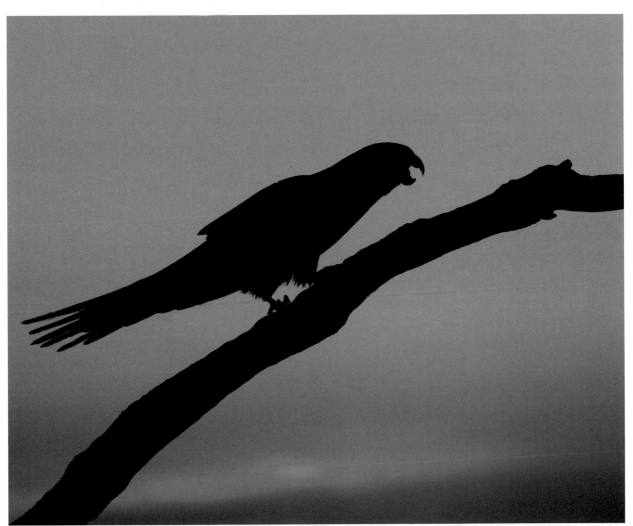

Even without its striking colors, a king parrot walking up a tree at dusk produces quite a distinctive silhouette.

Vary the Format

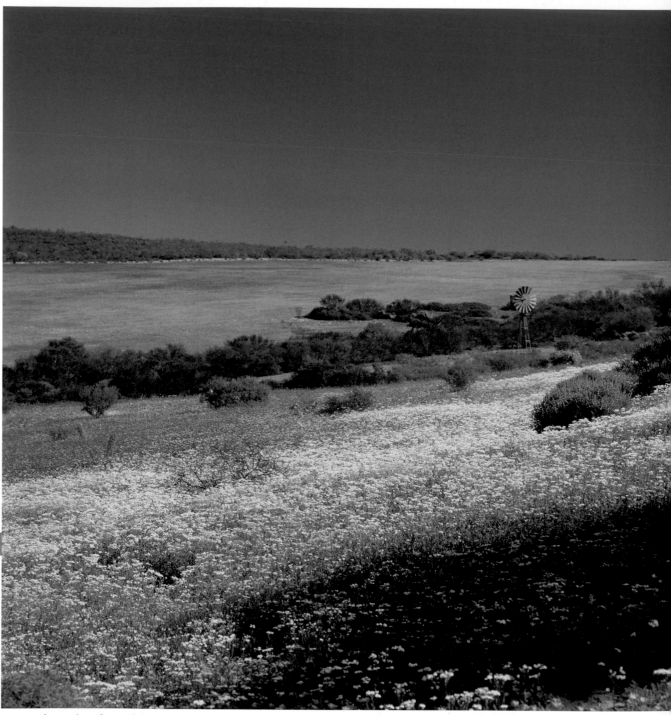

A square-format shot of massed daisies flowering in Namaqualand gives more flexibility to a designer. It can be used full frame, cropped as a vertical or as a horizontal.

Whatever the subject, a change of pace will help to arouse greater interest, whether you're illustrating an article or making a PowerPoint presentation. There are two simple ways of doing this: Use different focal lengths or change the format.

If you look at any well-illustrated article or the opening spreads of some books, the initial image often sets the scene as a full page on one side of the gutter, with text and maybe a smaller image on the opposite page. Alternatively, a single image can fill an entire spread by running across the gutter. Ideally, there should be some negative space at the top for the title and on one side for overprinting an introductory paragraph. A seasoned photographer will shoot iconic subjects in a variety of aspect ratios to give a designer more flexibility with the layout.

With rectangular formats (e.g., 3:2), there is the option of taking horizontal (landscape) or vertical (portrait) images. However, it seems to take much more effort to turn a camera through 90º to shoot a vertical! Yet, most magazine and many book covers are vertical shots.

A vertical rectangular format was needed to include the emergent lotus lily bud with its reflection at dawn in Malaysia.

The ratio of the width to the height of any format is the aspect ratio. The Nikon DX format has a crop factor of 1:5, but it shares the same 3:2 aspect ratio as the full-frame FX format. Some D-SLR cameras have the option of switching to a 5:4 aspect ratio crop if so desired. A square format is anathema to some people, yet square images can and do work, whether taken as shot or cropped from an original rectangle. However, it will mean more enlargement for the preferred file size of the final image. Stitched panoramas (see Tip 100) open up the scope for a completely different—and highly variable—format option.

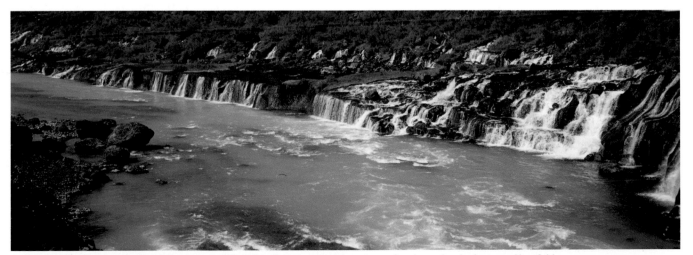

A panoramic format frames the broad-fronted waterfall of Hraunfossar in Iceland that emerges from beneath a shrub-covered lava field before entering the blue glacier-fed waters.

Keep it Level

When photographing buildings or bridges with distinct horizontal and vertical lines, it is easy to check whether the camera is level. However, when working at night or in the wilderness on uneven ground and without a level horizon, it becomes more difficult to spot leaning trees or rivers running uphill. A hastily composed picture may look acceptable in the viewfinder, but when enlarged on a computer screen, its dodgy composition will be all too obvious.

A crooked image can be straightened by cropping, but this will reduce the resolution. It is better to get it right when composing in the first place. There are many devices incorporating bubble levels for photographers, including digital levels built into some newer camera models. Pro tripods often come with a built-in spirit level, and some tripod heads come with a level—such as the Really Right Stuff BH-55 Ballhead. Otherwise, the cheapest option is to buy a small bubble level that simply slides into a camera's hot shoe.

The dual bubble spirit levels are more accurate than those with a single bubble, because they allow the camera to be leveled in both horizontal and vertical axes. The Seculine Action Level is a more sophisticated modern spirit level that costs up to four times as much, and fits onto the hot shoe of a D-SLR. The Action Level uses a traffic light system to confirm when the camera is perfectly level. Five LED lights (which can be adjusted for brightness) show green for level, amber for just off, and red for way off level. The tiny unit is fitted just above eye level, so it can be viewed while looking through the viewfinder, whether using a tripod or hand-holding the camera. It is ideal for use in dim light or in positions where a conventional bubble level would not work (such as holding the camera above your head).

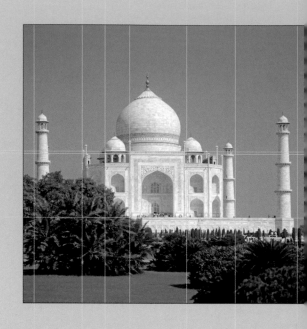

If there is no way to avoid leaning verticals, they can be corrected in Photoshop by using the Filter>Lens Correction function, and checked by using guidelines (View>New Guide...) afterward. Here, the horizontals are level on the Taj Mahal with the verticals slightly off, but still acceptable.

A hot shoe spirit level with three levels and three bubbles, bought in a Shanghai photographic shop.

A Really Right Stuff ballhead has its own built-in spirit level.

Prime vs Zoom Lenses

Prime lenses have a fixed focal length and range from ultra wide angles to long telephotos. Prime lenses tend to be "faster" than zoom lenses, meaning they have a larger maximum aperture (e.g., f/1.8 or f/1.4, whereas some zoom lenses are as "slow" as f/5.6); this allows for a faster shutter speed to be gained when working in poor light. Secondly, when used wide open, these lenses offer an extremely shallow depth of field for creative effect.

Zoom lenses with a variable focal length have evolved both in quality and in price. The introduction of VR and IS technology has revolutionized hand-holding even the longer zoom lenses by reducing the risk of camera shake by up to four stops. Additionally, zoom lenses used with digital cameras cut down the risk of getting dust on the sensor from repeatedly changing lenses. Zooms are ideal when faced with rapidly changing scenes with fluid elements, such as markets or wildlife. With airline restrictions on hand baggage, a couple of zoom lenses, each spanning the range of three or four prime lenses, become a very attractive way to carry more for less weight.

A zoom lens is much speedier to use than a prime lens, because you just zoom in and out for the best crop. The downsides are that the cheaper zooms have a variable aperture, and all zoom lens hoods are something of a compromise. To avoid vignetting at the widest angle of a zoom range, the hood is not as deep as an equivalent prime lens hood at the longest focal length, which may cause flare when shooting against the light.

Using a fast 85mm f/1.4 lens and shooting with a wide open aperture gave minimal depth-of-field to this tropical orchid spray, with just the front flower in focus.

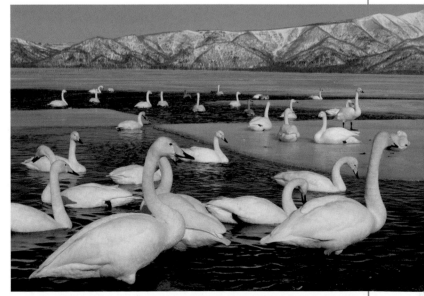

A wide-angle zoom lens (12-24mm) was perfect for framing the whooper swans in their winter landscape setting in Japan, and for getting a good depth of field.

Wide Angles for Impact

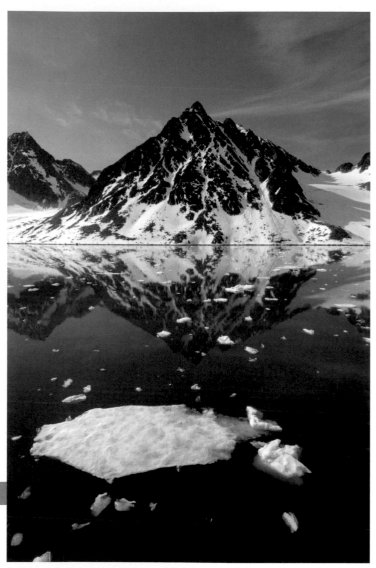

By leaning over the bows of a boat off Spitsbergen with a 12–24mm lens, a remnant of pack ice could be included as foreground interest with the peak and its reflection behind.

A wide-angle lens (24 – 35mm on a full-frame, 36x24mm sensor) has a shorter focal length than a standard lens, so that everything appears smaller than with a standard 50mm lens from the same viewpoint. Also, the perspective is quite different. Ultra wide-angle lenses have a focal length shorter than the short side of the sensor (so less than 24mm on full frame). Use these lenses as close to the subject as possible for the greatest impact. This is opposite of the way to work with a long telephoto lens.

Nikon DX cameras have a smaller digital sensor, with a crop factor of 1.5 compared to full frame. Therefore, when any FX lens is used with a DX camera, it effectively becomes a longer focal length lens. This can be an advantage when using longer lenses, but becomes a disadvantage with wide angles. Special wide-angle DX lenses are now available, with the shortest being 10mm. The Nikon DX 12 – 24mm ultra wide-angle zoom shows vignetting when used wider than 17mm on an FX format.

Wide-angle lenses are used either to add foreground emphasis, or include more information beyond the foreground (see Tip 77). They are also useful when working in a confined area, especially small, walled gardens.

Take care when using wide angles with a large front element. A lens hood is essential and it may be necessary to extend it with a hand, checking that it does not impinge into the field of view. To avoid unwanted converging or diverging verticals appearing from tilting a wide-angle lens (see Tip 36), use a Perspective Correcting (PC) wide-angle lens to fix them.

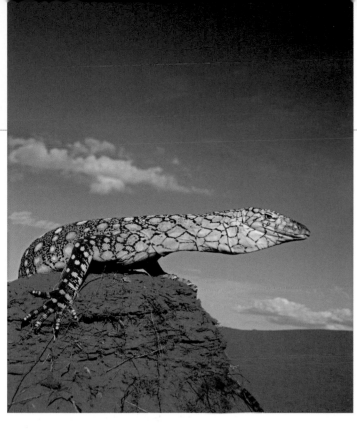

A low camera angle
and a wide-angle lens
gave added impact to
Australia's largest lizard—
the perentie goanna.

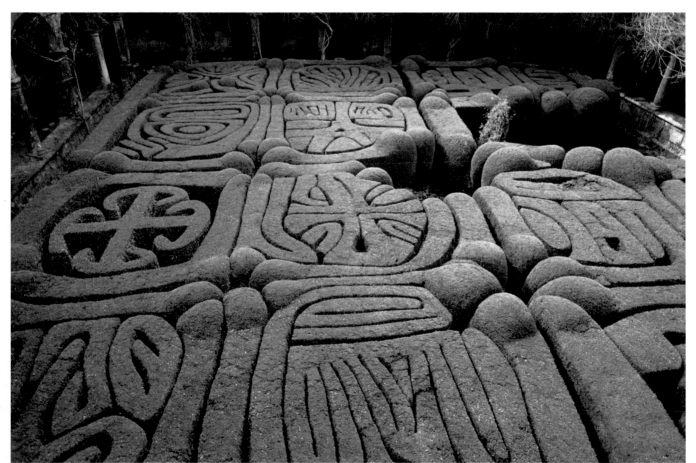

The pattern of the six-foot (two-meter) high ancient box topiary within a monastery in Santiago de Compostela in Spain could be seen
only from an overlooking gallery by using a 20mm lens. The sun cast a strong shadow on one side, so I waited for complete cloud cover to
provide even lighting.

A Picture Within a Picture

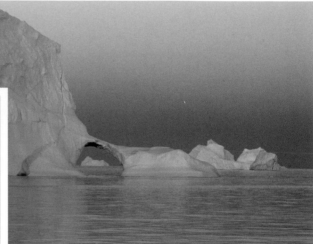

A 20-35mm wide-angle lens was used to take a large iceberg off Greenland as the sky behind became diffused with a pink afterglow. Changing to a 300mm lens, I took a vertical shot of the ice arch framing the berg beyond.

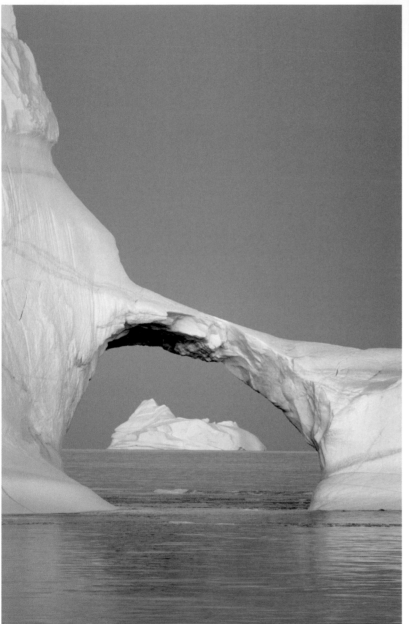

With time to spare, a fun task is to seek a more intimate image contained within the first image found—which may not always turn out to be the best. Any massed wildflowers—whether red poppies in Europe, orange Californian poppies, or the annual daisies in South Africa—present plenty of scope for varying the composition. Vibrant splashes of red poppies in a cornfield are a quintessential English summer scene that never fail to stop me in my tracks.

Everything was perfect for this wide shot of a lowland river scene: The trees had just leafed out, the water was calm, and the water weeds were beginning to flower. Taken from a bridge, a polarizing filter cleared the skylight reflected in the lower half of the frame and also removed the reflections on the leaves.

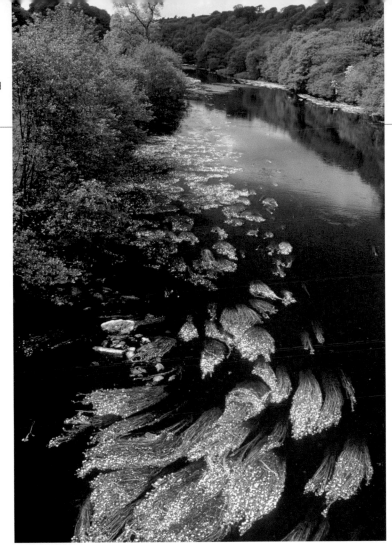

Icebergs are mobile features of a landscape that are also constantly shrinking. After enduring almost two days of ferocious seas traveling from Iceland, we encountered our first icebergs late in the day off Greenland. As the sun sank, a pale pink afterglow appeared in the sky behind a large berg, with a natural arch at one end. While taking the whole berg with a wide-angle lens, a smaller berg began to appear behind the arch. With the boat and both icebergs on the move, I knew the arch would perfectly frame the smaller berg for only a matter of moments, so I raced across the deck, changing over to a long telephoto lens on the way.

Other subjects worthy of this approach include a complete sand dune and its rippled surface, a lowland river scene in summer viewed from a bridge or a bank, and a shot of aquatic flowering plants taken either from the riverbank or by wading out into the river.

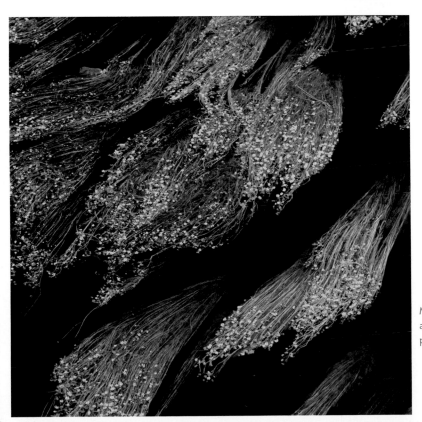

Moving down to the river bank and changing to a long lens, the diagonal lines of water crowfoot plants gave a strong design to the water weeds.

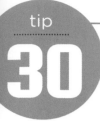
Dynamic Diagonals

Natural linear elements that cut through landscapes, such as a canal, a river or a canyon will appear more dynamic if they run across the frame in a diagonal line instead of a horizontal one. Paths with a contrasting color or texture that weave through woodlands or gardens can create these diagonal lines within a frame.

Try to avoid placing any diagonal so that it runs directly from one corner to the opposite one; this tends to split the image into two parts, as happens when a horizontal line runs through the center of an image. Wherever possible, try to compose so that the diagonal is slightly off-center. Where a diagonal line leads the eye across the frame to a key element of the composition, such as a rock, a plant, or an animal, it gives a picture more depth. Even partial diagonals can perform the same function.

The diagonal rainbow over Gullfoss in Iceland reinforces the line of the rock face behind.

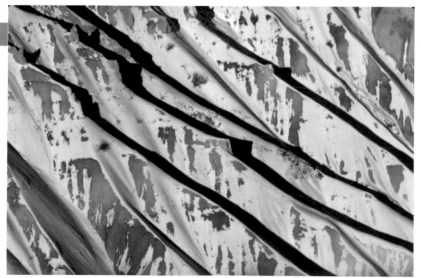

Direct sun casts shadows of snow-covered ridges in Bryce Canyon, clearly defining their profiles.

A view up toward a bamboo canopy in China portrays the stems as diagonals radiating from the edges of the frame in toward the center.

Diagonal lines do not have to be continuous; for example, a few trees growing vertically down a sloping rock face help to reinforce the downward diagonal slope. Lines of animals that come to mind are dolphins surfacing in the sea, game animals seen from the air, or processionary caterpillars crawling over the ground. All can make striking diagonals. By tilting a camera skywards at a group of trees or bamboos with tall straight trunks, they will appear as diagonal lines meeting towards the center of the frame.

Sensuous Curves

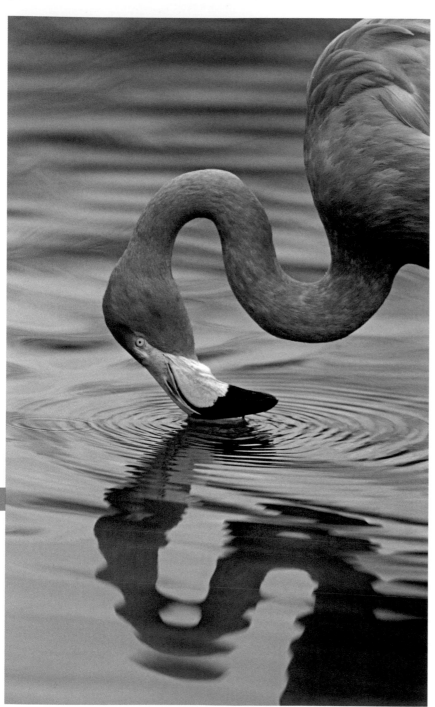

A flamingo filter-feeds in a curious way: by lowering its long neck and bending it over so the bill is turned upside down, creating the dramatic curve of the pink neck.

Nature abounds with patterns and designs on all scales. Curvaceous lines are commonplace in many habitats, where they introduce a more elegant and sensuous element to a picture than a hard diagonal. Large-scale curves visible from the air include ox bow lakes and streams snaking through gallery forests.

On the ground, curves appear in coves, in meandering streams and paths, in bowed rock arches and ephemeral rainbows, and along the knife-edge of mobile sand dunes. The gracious necks of flamingos, egrets and swans, writhing eels and snakes, as well as long sinuous seaweeds carried back and forth as the tide ebbs and flows are examples of smaller scale curves.

An S-curve is a bonus because it has the potential of forming part of the composition in many different ways. Most obviously, it is the key element in the composition, especially if it is an attractive stream or river, a backlit liana hanging from a branch, or a snake moving across sand or swimming in water. A small sunlit stream, viewed against the light, can appear as a leading line to a bird or two silhouetted on the water in the distance. Where the tonal values of water in a pond or a cove on the coastline and the land are quite distinct, the curve that separates the two can be used to frame the water.

A curving line generates a feeling of a more leisurely pace than the direct straight line of a diagonal. At close range there can be little to rival the gentle S-curves of the calla lily flower (surely one of the most sensuous of all flowers).

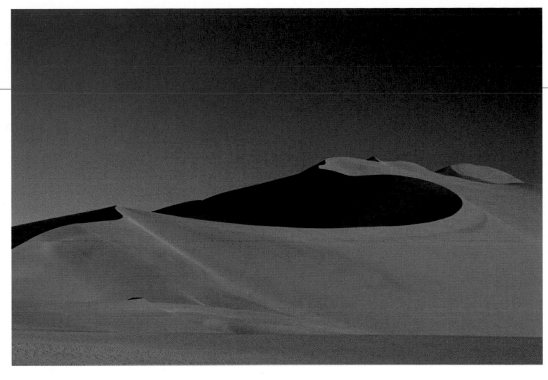

The knife-edge of a crescent sand dune at Sossusvlei in Namibia is constantly on the move as sand falls down the slip-face and builds up on the other dune. The best shots of dunes are lit at a low angle, so one side is bright while the other is in shadow.

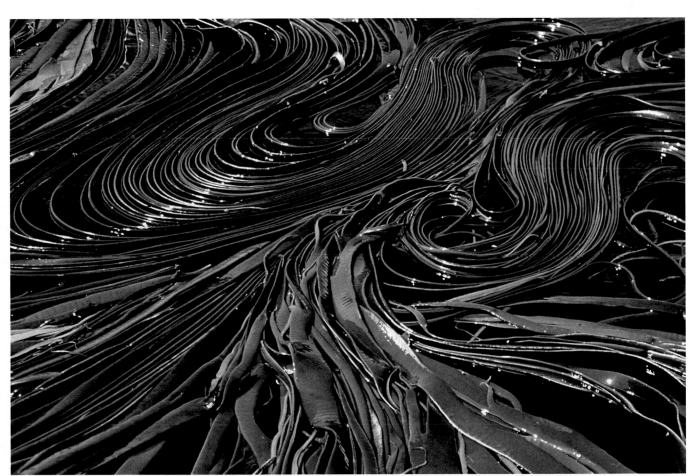

On a rocky shore in New Zealand, my eye turned to snaking bull kelp fronds swishing back and forth in the tide, giving a fluid composition.

Framing the View

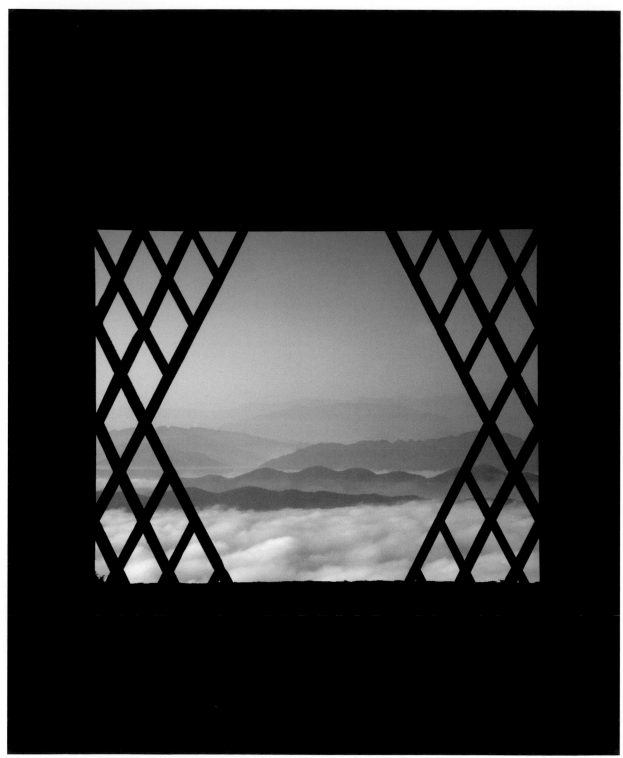

Chinese pavilions built in wilder areas often frame a view onto a sea of clouds—which are much revered after rain or snowfalls—as here in the Bamboo Sea, Sichuan.

Any frame—natural or manufactured—helps to lure and tempt the eye to focus beyond it. A window or a door can frame an outside view, while natural frames occur at cave entrances or in rocks and hollow trees. Even a horizontal branch curving from a tree trunk provides a three-sided frame with the ground. Rock arches form inland by erosion from frost and wind; whereas marine arches form as the sea pounds each side of a rocky headland, eating away at the rock until an opening appears. Rock bridges form by erosion from the freezing and thawing of water within cracks in the rock, and flowing water gradually enlarging those cracks.

Arches National Park in Utah has 2,000 natural sandstone arches, making it the largest concentration of arches in the world. Depending on the position and angle to the sun, some arches can be spotlit while the view inside is bathed in a softer light. Conversely, a silhouetted arch may frame a view bathed in full sunlight. In these two scenarios, decisions have to be made about which part of the image needs to be correctly metered. It is easy when the frame itself appears as a silhouette, because then it is the brighter view beyond which has to be correctly exposed; otherwise, it will appear overexposed if the frame is included in a matrix reading.

Topiary or floriferous archways are widespread in gardens. Other, less commonplace features are windows in hedges, garden walls, and grottoes. Windows are a familiar feature of Chinese classical gardens. Often they puncture bare walls that meander around the garden providing tantalizing glimpses of what lies beyond. Special viewing pavilions erected in both Chinese and Japanese gardens enable the best views to be enjoyed regardless of the weather.

The North Window rock arch in Arches National Park, Utah provides a natural frame to more rock formations and Turret Arch in the distance.

A series of archways frames a statue of Pomona at the Château de Canon in France in late summer.

Color Contrast

Objects (and images) that stand out from the crowd are those with colors that contrast with one another. In the color wheel used by artists, the three primary colors (red, yellow, and blue) appear with the corresponding secondary colors (orange, green, and purple) interspersed between them. White light comprises all the colors of the rainbow. A colored filter, placed in front of a lens, transmits its own color while blocking the light of its complementary; for example, a red filter stops green light—although with digital images, individual colors can be tweaked in post production.

A six-color wheel with the three primary colors (red, yellow, and blue) and the three secondary colors (green, orange, and purple).

The bright red and black bands of the arrow poison frog serve as warning colors to would-be predators.

Fresh green magnolia leaves contrast well against a red wall in a Chinese garden.

These complementary colors create visually pleasing contrasts. We see this when a large red flower is offset with green foliage, and it is no accident that red and green are the most important colors used in traffic lights. Animals that want to be noticed also show color contrast. Examples include toxic or poisonous animals, which advertise their presence by sporting red and black or yellow and black colors coupled with an unpleasant taste, or a toxin, that predators soon learn to leave well alone. Commercial websites that have a striking logo will often repeat that color throughout their branding so that it stands out clearly on the web page.

The blue-fringed edge of a hyacinth macaw's eye is surrounded by a yellow ring set in the surrounding deep blue feathers—a stunning and striking colorway.

Different shades of stately delphinium spikes are set off against a somber, stormy sky.

Harmonious colors blend in with each other, are gentle to the eye, and evoke a feeling of tranquility and peace. Most natural colors have a hint of pigment from neighboring colors in the spectrum. Lighter colors that are paler than pure hues are tints, whereas darker hues are known as shades. Monochromatic colors are different tints or shades of the same hue.

Harmonious colors lie side by side on the 12-color wheel. Garden designers may plant a border using plants with foliage and flowers of harmonious colors such as red, orange, and yellow for a so-called "hot-colored" border. Florists often select harmonious colors to create a bridal bouquet or a funeral spray.

Color should also be an important consideration when designing a website to showcase images. The best designs are simple ones that use a limited range of colors that do not shout or compete with the images themselves. Remember that different colors create different emotional reactions, so the color scheme of, say, your website could affect the way visitors react to it.

A harmoniously colored planting of lavender with old roses in a Welsh garden.

A twelve-color wheel with three primary colors, three secondary colors, and six tertiary colors (yellow-green, yellow-orange, red-orange, red-violet, blue-violet, blue-green) formed by combining equal parts of the primary and secondary colors that lie on either side of them.

A leaf study: Yellowish golden hop leaves entwine through green Oriental poppy leaves.

Shooting

For a brief time after sunset, the sky turned a deep blue providing a perfect foil for the huge ice sculptures lit by colored internal lights created in Harbin, China's ice city.

To be certain of getting this fleeting alpenglow on the Canadian Rockies meant driving to the location in the dark.

The prime shooting time for most landscape photographers is just before sunrise or after sunset, when the sun is below the horizon and a clear sky becomes transformed by a pink or orange glow that brings a sense of magic to many a scene. A very brief time before sunrise and after sunset, a clear sky may appear deep blue, providing a dramatic backdrop. Then when the sun is just above the horizon, mountaintops are bathed in a pink cast—known as alpenglow. This bewitching time is referred to as the magic hour.

"Wow" dusk and dawn shots are the result of meticulous planning, from researching viewpoints on the web, to buying local postcards and marking up maps. Make a recce (a visit in advance to scout out an ideal location) in poor light to check which viewpoints work best with which lens; this can mean the difference between capturing the ephemeral alpenglow shot and missing it. See www.sunrisesunsetmap.com for times of sunrise and sunset worldwide. Aim to arrive on site well beforehand, and take a flashlight.

In the tropics, the sun goes down very quickly, so there is virtually no twilight. As latitude increases, this period is extended, until north of 49°N latitude (and south of 49°S), midnight twilight is experienced in midsummer. The purest twilight colors occur when there are no clouds in the sky and no dust in the atmosphere.

To balance the exposure between a bright sky above and a darker scene below, use a graduated neutral density filter. For gaining detail in a scene with both highlight and shadow areas, bracket the exposures and blend them using the High Dynamic Range (HDR—see Tip 99). If there is not enough light on a foreground subject, painting it with a continuous LED light (see Tip 49) will give a more natural effect than using flash.

A whooper swan calls as it runs at dusk along the edge of a beach on the east coast of China.

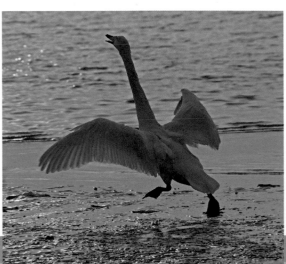

Check the Perspective

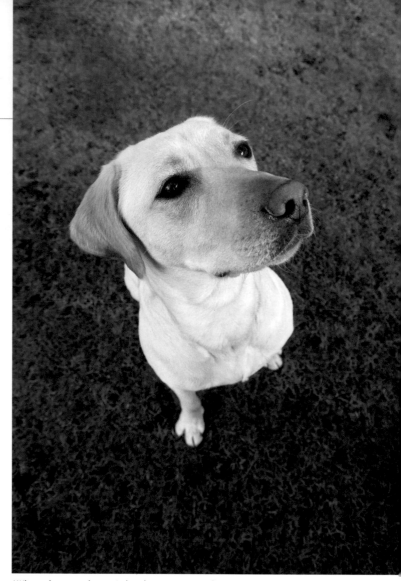

There are several ways to change the perspective of a photograph, perhaps most obviously by using a wide-angle lens and tilting the camera up toward the sky (verticals will converge) or down to the ground from an elevated position (verticals will diverge). Purposely using greatly exaggerated converging or diverging verticals for creative effect can produce some eye-catching shots. This is because the wide angle is getting a greater length of tall trees or buildings within the image.

Since the angle of view changes with the focal length of the lens, if different lenses are used from the same viewpoint, a wide angle will include much more of the background than a longer lens. Indeed, when faced with a sweeping landscape, the instinct is often to use a wide-angle lens, or to take a series of images to make a stitched panorama, but it is also possible to use a long lens to compress the perspective of distant portions of a landscape.

When photographing a Labrador retriever at close range with a wide-angle lens, the head dominates the picture and the visible leg appears minute, because of perspective distortio

A quirky angle of a giraffe head looking down both appeals to editors of kids books and works well for advertisements. Indeed, this photo has appeared on Redbush tea packaging.

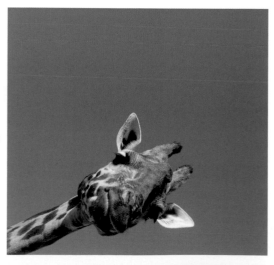

The original and traditional approach to animal photography is to depict either complete animals or head portraits. In recent years, a trend has developed for unconventional crops with ultra wide-angle lenses so that the heads of animals appear disproportionately large. It is also popular to hold the camera at an angle to the vertical or horizontal. This quirky style is not to everyone's taste, but it can appeal to some art directors, especially for eye-catching ads. Essentially, it is horses for courses and if you want to stand out from the crowd, you need to vary how you frame your pictures.

tip

37

Visualize the Image

There are two distinct approaches to taking photographs. This simplest approach is to take photos on the fly, as they appear, with some deliberation about the choice of lens and how best to frame the shot. In this case, there is a strong element of luck about being in the right place at the right time.

A completely different approach is to visualize what to take, as well as how to capture and light it, before making a single step outside. This is how art directors work—by sketching their ideas on paper first. One time when I was shooting a prestigious photographic calendar, the art director depicted flying birds reflected in a river; yet the odds of achieving this and getting a stunning composition were ridiculously long. Working with any wildlife is unpredictable, but if you do your research and are prepared to spend several days on location, the odds are reduced.

Perhaps one of the easiest approaches is to make a collection of images that explore different concepts—such as love, beauty, leadership, speed, or solitude. Love can be portrayed in many different ways, whether it is a mother interacting with her offspring, primates holding hands, birds billing each other, or a penguin touching another with its flipper. Speed can be illustrated by panning the camera in the same direction that the animal is moving so that the land becomes blurred; or by freezing the moment when an animal runs toward the camera with dust or water flying out all around it. Leadership is demonstrated when groups of animals are on the move, such as a herd of elephants or a flock of geese. Solitude is best portrayed by showing an animal or a group quite small within the context a wide-open desert or an expansive ice sheet.

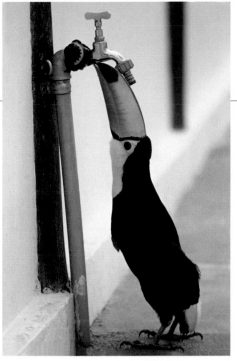

The toucan drinking from a leaking tap in the Pantanal sparked the concept of using it with the tagline "Tap into our website."

After photographing free-form ice sculptures by Lyle Braund in Colorado, I visualized a shot of fire and ice. A fire pit was dug beneath the sculpture and by the time twilight approached, leaping flames lit the interior of the sculpture, viewed against a deep blue sky.

38 Creative Depth of Field

An informal planting of primulas and buttercups in a woodland garden clearing seemed appropriate for a soft, dreamy, selective-focus shot. By focusing on the smaller flowers (the buttercups), the large pink primulas were still identifiable by their vibrant color.

Depth of field is the zone of apparent sharpness on each side of the plane of focus, and is a function of the focal length, camera-to-subject distance, and lens aperture. It is increased by using a wider focal length, putting more distance between the camera and the subject, and/or stopping down the aperture. Understanding and knowing how to use depth of field is an important aspect of every genre of photography. Yet, by using an autoexposure mode like Shutter Priority and allowing the camera to select the aperture, you have no control over the depth of field. To have complete control over the aperture, use either Aperture Priority or Manual exposure mode.

When a lens is wide open at a low f/stop, only a narrow plane will appear sharp. This shallow depth of field can be used creatively, to isolate the subject against a soft, out-of-focus background. With plenty of light, a wide aperture may require a high shutter speed—even with a low ISO—to prevent overexposure.

On the other hand, when shooting a landscape with considerable depth, the lens will need to be stopped down (to f/11 or f/16 on an SLR) if the foreground, middle ground, and the background are all to be brought into focus. And because two thirds of the total depth of field extends behind the plane of focus, with one third in front, maximum depth of field is gained by focusing beyond the nearest plane (for non-macro shots). With depth-of-field scales no longer engraved on modern lenses, depth-of-field calculators are handy tools, and available both online and on mobile devices such as smartphones (see www.dofmaster.com).

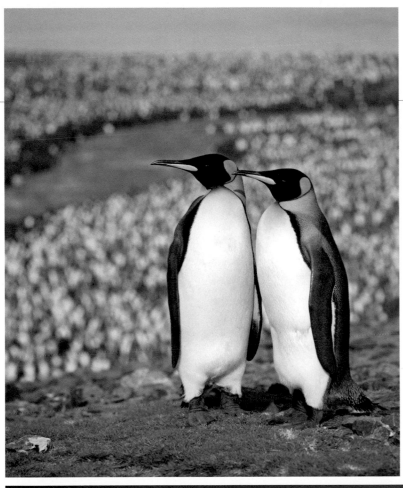

Two sharply focused king penguins stand on a hillock overlooking part of the vast rookery on South Georgia. The brown river margins are formed by fluffy chicks that congregate where the air is cooled by glacial meltwater.

Shooting

By using a wide-angle lens, focusing just behind the rock, and stopping down the lens, the whole scene on Steeple Jason Island, in the Falkland Islands, could be brought into focus.

Seek Reflections

Early morning is often a good time to take mirror-like reflections in water, before the wind begins to pick up. At this time of day, the best light—such as alpenglow on a mountain peak—may last for only a matter of seconds. For any landscape reflection, it is essential to research the best viewpoint beforehand. In popular tourist locations, it is worth checking out postcards for well-known landmarks and their prime viewpoints. Then mark up a map and determine how long it takes to drive there. Arriving even five minutes too late is a lost photo opportunity.

A flowering umbrella thorn reflected in a pan in Moremi Game Reserve, Botswana shortly after the start of the rainy season.

Rippled water made by swimming ducks creates an abstract impression of autumnal beech trees that resemble liquid gold.

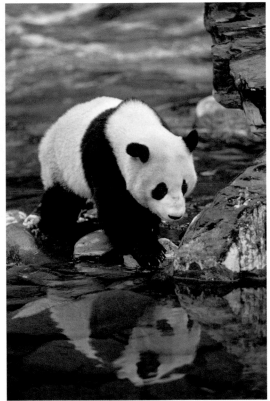

China's natural treasure, a giant panda, appears reflected in a pool as it walks beside the Pitiao River in Wolong.

The reflection of a colorful dawn or dusk sky can dramatically change a drab, flat expanse of water—be it a pond or lake, a wet road, or a wet sand beach— into a memorable shot, with or without the sky itself in frame. Reflections that are more intimate include a single tree, an emergent lotus lily, an animal bending down to drink, or the head of an animal rising above the water.

One of the easiest ways to take an abstract is by shooting distorted reflections created by wind, a swimming duck, or a rising fish creating ripples. Bold color blocks, such as autumn trees or colored boats, make for the most effective abstracts.

A small ice-free area of a large lake, kept open by waterfowl moving around, concentrated the birds in a defined area. A little grebe surfaced just as the inverted reflection of a swan appeared in the frame.

tip

40

Time Lapse

Taking a series of still images of the natural world to create a time-lapse sequence can be a fun project, spanning cloud cycles, sunrises and sunsets, or changing seasons. Long-term time lapses are more of a gamble because of unpredictable weather; plus, there is the difficulty of determining how long to wait between shots in the sequence. For example, the times of high and low tide levels in an estuary are predictable—even if the weather is not—and could be taken on a single day or over several days, whereas it may take many years to see the difference between photos of a shrinking glacier.

Taking the initial shot is easy; completing the grand plan may not always come to fruition. An open standing tree is a good way to depict the seasons, but branches may fall during a storm. Finding historical postcards or old prints in books of local scenes and seeking the same viewpoint to take a repeat image can be a rewarding project.

Tips for Single Time Lapse Sequence

> • > For short-term time lapses, sketch a storyboard of each distinct stage

> • > Use a solid tripod

> • > If possible, put markers in the ground for exact repositioning of the tripod legs

> • > Keep the background simple

> • > Line up notable objects to aid in reframing the same viewpoint

> • > Note the focal length of the lens, especially if it's a zoom (can be obtained from EXIF data)

> • > Carry a print of a previous shot when returning to the field

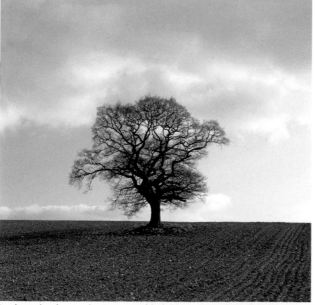 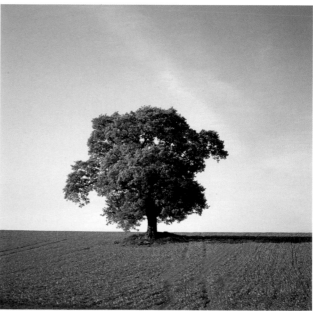

A solitary deciduous oak tree in an arable field is a good subject for taking a time-lapse series through the seasons—in winter (left) and leafing out in spring (right).

tip 41

Moody Mist

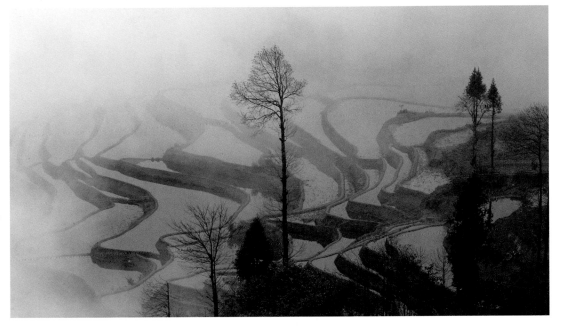

Sun breaks through mist wafting across 1,300-year-old flooded Yuanyang rice terraces at dawn in Yunnan, China.

Mist forms when a cool night follows a warm day, causing warm, moist air to cool down and condense into tiny water particles. Local pockets of mist can form above rivers and ponds and collect in dips and depressions. Expansive areas of mist form at sea or within forests, and when it swirls around mountain peaks and funnels up gullies it helps to separate mountain ridges and to isolate rock pinnacles. When it rains or snows over many mountainous areas in China in the winter, the highly humid air forms overnight, what the Chinese call the "Sea of Clouds," often depicted in Chinese ink brush paintings and now much sought after by photographers. As you climb up to the best viewing points, the higher peaks emerge from the white expanse of clouds below, like islands in an ocean.

When a light mist envelops a landscape, it acts like a huge diffuser softening harsh shadows and changing saturated colors into soft pastel tones to create an ethereal quality. Perfect conditions do not last long, when the sun begins to light up the subject and the mist still blots out the background. You then need to work fast because once the sun warms up the air, the mist soon clears as the water drops evaporate.

When photographing wildlife or flowers in mist, it is essential to move in as close as possible so that the foreground interest is clearly distinguished (a wide-angle lens is perfect for flowers), with the background objects appearing as ghostly shapes that gradually fade away into the mist. There are times when mist can be used to advantage to blot out unsightly backgrounds such as electricity pylons or telephone wires.

Seductive Shadows

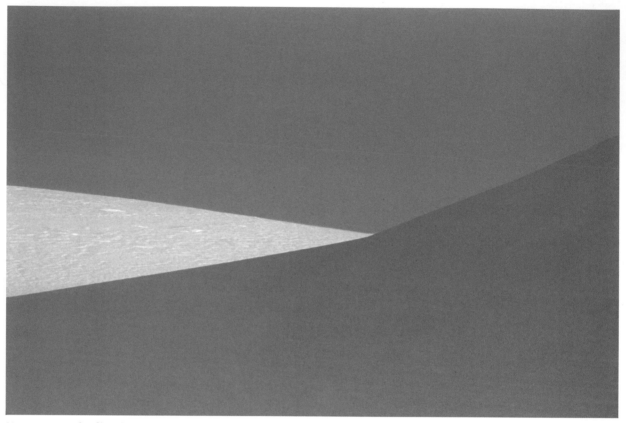

Here is an example of how less can be more with a simple sky, snow, and shadow abstract taken in Yellowstone.

Bright light casts shadows, which can become a strong element of the composition, particularly in monochrome photography. This can also apply with color shots, but the color palette should be limited; too many colors will detract from the impact of the shadows. Within the landscape, long shadows of trees or hills cast by low-angled sunlight early or late in the day help to fill large areas of negative space—such as ground blanketed with snow—with exaggerated shapes. Depending on the aspect, a road or track lined by trees may have shadows of the trunks cast across it both early and late in the day.

Shots of animals casting their shadows work best when shooting down from a high viewpoint, such as a single file of animals from a small plane or a microlight; but sometimes climbing a hill or even a small rock will work. In every case, the ground needs to be fairly uniform with little or no vegetation (sand works very well). For this reason, deserts and sandy beaches are excellent places to seek out animals with their shadows. These locations are also great for lovely abstracts of ripples in sand, whether on a beach or a dune.

An African penguin, walking up Boulders Beach in South Africa, made a natural vertical frame-filling shot, captured using an 80-200mm zoom lens. When it turned to cast a Concorde-like shadow, I speedily zoomed out and rotated the lens on a lens collar mount for a horizontal format.

After mandarin ducks swam past, shadowed reflections of a bamboo fence gave a wonderful, fluid abstract in a classical Chinese garden.

Taller plants, including trees, are most effective at casting striking shadows; reeds emerging from water, on the other hand, provide simple minimalist shapes that attract many a photographer.

Garden designers often position structures that will add interest by casting shadows on the ground or on bare walls. Look for shadows cast by balustrades, overhead struts of a pergola (before it becomes completely covered with creepers and climbers), or ornate lamps.

Light and Shadow

This tip is not about using shadows as shapes within the composition. Rather, it covers how to utilize a combination of light and shadow in situations where subjects are spotlit against a black backdrop, but not backlit or rimlit. This is nature's equivalent of spotlighting someone on a stage and is a dramatic way of isolating plants or animals. When these opportunities occur, they are often fleeting; for example, a shaft of sunlight beaming onto a flower or a fungus in a forest can be there one moment and gone the next. It is therefore essential to make quick decisions about the choice of lens and camera angle, otherwise the shot will be history.

Early or late in the day are the best times to encounter brightly lit subjects against a shadowy backdrop. Often these are low-key subjects (see Tip 22) that need special care with metering. Even pale-toned subjects lit on an overcast day can separate equally well from a dark, unlit backdrop, although not quite so dramatically as when they are spotlit by sun.

Likewise, the reverse scenario wherein a dark subject appears against brightly lit water can also help to separate one from the other. A place where birds or mammals come to water to drink, where waders work at the edge of the sea, or where birds swim out onto a pond or a lake will be productive— providing a shooting position can be found in the optimum place for the best light.

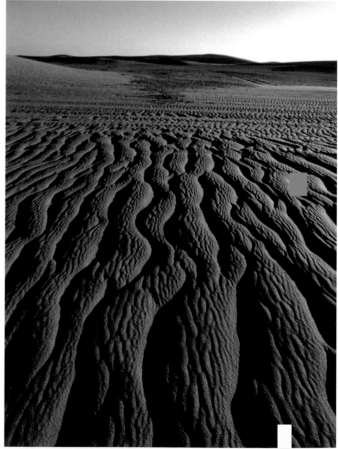

Pronghorn, spotlit by the first rays of sunlight, emerge to graze in Yellowstone.

The texture of smaller ripples on the surface of prominent sand waves on a dune on the Skeleton Coast in Namibia are revealed by grazed light, illuminating the raised parts while casting shadows in the dips.

An unlit forest behind these striking daisy flowers is an effectively simple, contrasting backdrop, achieved with a low camera angle.

Inside-Out Light

The silhouetted entrance to Jiuxiang Cave shows both the sunlit plants outside and a river flowing out into the open.

Using the entrance of a cave to provide a silhouetted frame of the outside is an easy option: Simply meter the light on rocks or plants outside and the rest takes care of itself. This is not the case when most of the frame depicts internal structures that need to be discernible without the outside view being grossly overexposed.

Digital capture now enables us to achieve shots that would have been quite impossible with film. Coping with the high dynamic range (HDR) between a bright sky above an unlit landscape can sometimes be cured with a graduated neutral density filter, but you cannot simply slap a grad filter over a shot with a cave opening in part of the upper frame. Take, for example, this scenario I found inside a Chinese cave. Using an ISO of 160, the outside view of the vegetation bathed in sunlight gave an exposure of 1/20 second at f/10, while the twin waterfall plunging down inside the cave had an exposure of 1.6 seconds at f/10—a full 5 stops difference on a Nikon D2X. What is more, the waterfall was lit with colored lights, so the color balance was quite different as well!

Because the trees outside and the waterfalls inside were both moving, it was not possible to take a series of bracketed exposures and blend them in HDR software (see Tip 99) in this case. The solution was to merge both exposures by hand using masks. After opening each exposure in Photoshop and holding down the shift key with the Move tool selected, one image was dragged into the other. The shift key snaps the second image into alignment with the first. Then, with the Pen tool, a selection was made around the opening of the cave, and a mask was added to reveal the correct exposure layer underneath. Further selective adjustments to color and contrast made the image a seamless, evenly exposed composition.

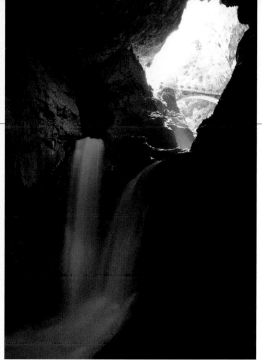

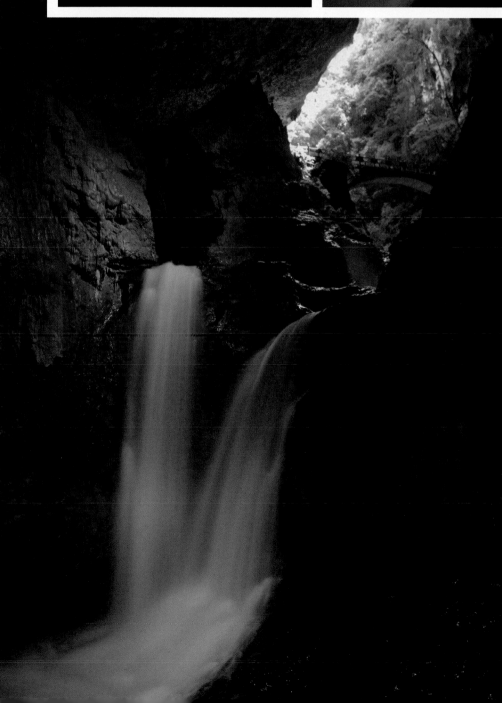

Two original images were exposed: one (left) for the vegetation outside the cave, and another (right) for the double waterfall inside. Because the water was moving and the plants were blowing in the wind, the final image was blended by hand. Some of the yellow light was removed from the waterfall and the rock on the right was lightened.

Reflector Fill

Enhance The Light

An orange imperial fritillary contrasts well against a blue sky, but because the flowers hang down, the sun cannot light inside the flowers. To gain uplighting, a skirt of aluminum foil was fixed around the stem, and a large reflector was held on the right side to fill in shadows cast by sunlight from the left.

One of the great advantages of using a reflector rather than a flash is that the effect is seen before the image is captured. Reflectors modify existing light in a variety of ways: They boost the level of natural light, fill in shadows, or throw light onto a subject completely in shadow. They are especially useful for filling in shadows on a branch with flowers that hang down, such as cherry blossom, or the underside of autumn leaves so they glow.

Reflectors come in several finishes—white, silver, gold, or a mix of the latter two. Lastolite, the original manufacturer of collapsible reflectors, have two silver/gold finishes: Sunlite (5000K) has wider alternate gold and silver bands, whereas the Sunfire (4750K) version has narrower alternating bands. The pure gold version is fine for red, orange, or yellow subjects; but otherwise it tends to give an unnaturally warm cast. Silver is safe for most things, but I tend to prefer a silver/gold version.

Circular reflectors open up into sizes ranging from 12 inches (30 cm) to 48 inches (120 cm). The large circular reflectors are virtually impossible to hold steady outside in wind with a single hand; so for non-macro work, I prefer to use the TriGrip reflectors, which have a moulded handle with securing strap. With each reflector being double-sided, if you choose carefully you need take only one out. My preferred option is the Sunfire/Silver version, with Sunlite/Softsilver a close second. To get the best results from a reflector, tilt it back and forth until the optimum angle is found.

Enkianthus flowers were found hanging down in shade, but a reflector bounced back some of the sun. To simplify the second image, one of the branches has been removed.

Carry a Mini Cloud

Great landscape shots are so dependent on the weather that options for changing the lighting are often limited to using a graduated or a polarizing filter. If the sun is shining, the only way to get soft, diffuse light falling on a landscape is to wait for a cloud. But with a subject at close range, if the shadows are too imposing, or the contrast between one part of the frame and another too great, the contrast can be reduced by carrying a diffuser—in effect, your own miniature cloud. This is particularly useful when photographing white or pastel-colored flowers that reflect more light than average-toned green leaves and grass.

For larger subjects or white magnolia flowers high above the ground, the Lastolite TriGrip diffuser, with its moulded handle, is easier to hold than a circular diffuser. Always be sure to meter with the diffuser in place. Without an assistant or a companion, mount the camera on a tripod to free up a hand.

Without a diffuser on hand, improvisation is possible by using your body to block the sun and thereby even out the light. The pair of images here of a crocus flower shows just how effective a diffuser can be to improve a shot where shadows impinge rather than enhance it. The great thing about working with macro subjects is that you have complete control over the lighting. The downside is that there can be no excuses about lackluster lighting!

Direct winter sunlight on a crocus flower casts shadows (left) that are eliminated when a diffuser is held between the sun and the flower (right). This also creates a darker, less distracting background.

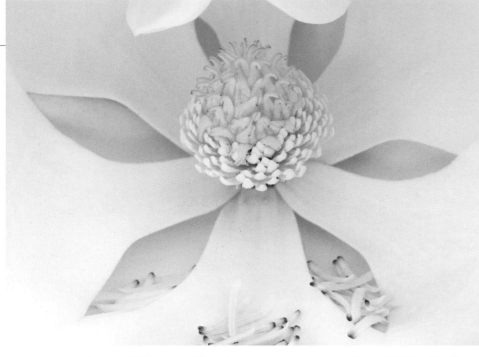

A large diffuser converted direct sunlight to a soft, even light for the cream-colored Magnolia grandiflora flower.

The heart of a tulip flower (left) was backlit by sun late in the day. A diffuser softened the light (right) and eliminated the two highlighted areas in the top corners.

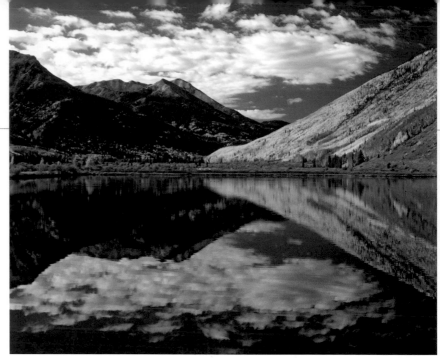

tip 47 — Use a Polarizer

With a plethora of filters available, how do you choose the best ones to buy? For naturalistic shots, the range is, in fact, quite limited. A haze/UV filter basically only protects the front lens element (unlike film cameras, most digital cameras block ultraviolet light via a filter permanently placed directly over the imaging sensor); neutral density (ND) filters reduce the amount of light (see Tip 48); and graduated filters help to reduce the contrast between a bright sky and a darker landscape.

A polarizing filter (or polarizer) has many different uses for outdoor photographers, and a circular polarizer enables TTL metering and autofocus to function.. Blue skies darkened with a polarizer increase the contrast between the sky and white clouds,

A colorful landscape—whether of rocks or vegetation—reflected in calm water rarely fails to make a striking reflection. Crystal Lake in Colorado is a popular haunt of photographers during the fall. A polarizing filter enhanced the contrast between the blue sky and clouds.

white rocks, or tall white flowers. For maximum effect, you need to shoot at a 90° angle to the sun, which should therefore lie to your right or left when looking at the subject. The speediest way to check whether the filter is worth using is to rotate it in your hand in front of your eyes; you should be able to observe the strengthening and weakening of the polarizing effect. This filter can also help increase color saturation by removing the myriad of skylight reflections from leaves and grass. However, beware of taking a shot whereby naturally shiny leaves (such as holly) fill the frame, because they look quite unnatural when devoid of all reflections.

A polarizer is also useful when shooting through water to clear unwanted skylight reflections off the surface, so that fish and aquatic plants can be seen more clearly (see Tip 91). When the filter is used at maximum polarization, there is a loss of 1.5 stops of light; but this is not much of a problem in digital photography because the ISO can be increased if necessary.

Water lily pads as found (above), and as taken with a polarizing filter (right). The filter removes the skylight reflection and enhances the colors.

tip 48 — Neutral Density Filters

A 4x neutral density filter reduced the overall brightness so that a one-second exposure could be used to create a soft, ethereal feel to the slender Svartifoss fall in Iceland.

Many landscapes, especially those shot early and late in the day, have such a wide dynamic range that it is impossible to expect any sensor to expose all parts of the scene correctly. One solution is to bracket the exposures and combine them in HDR (see Tip 99). Another is to use a graduated (grad) filter, which has a darker, shaded portion at the top of the frame that "gradually" fades into a transparent portion at the bottom. The shaded portion stops some of the light, and so when framed over an excessively bright sky, it will bring the sky closer to the brightness of the ground and allow the shot to be correctly exposed by the sensor. I prefer to use a neutral density (ND) gray grad filter, because this looks much more natural than the magenta ones used so often in advertisements for cars.

Screw-in grad filters are not as useful as drop-in ones, because the position and depth of the darker stripe is fixed and therefore determines the composition. The most versatile grads are the professional square or rectangular ones made by Lee Filters, which slide into a filter holder so they can be both used for lenses of various diameters, as well as moved up and down or angled from side to side, to suit each individual composition. Lee Filters also produces the Big Stopper, which reduces the exposure by a whopping 10 stops—for when a very slow shutter speed is required in bright light. Finally, Lee Filters also produce the RF75 Filter System for use when handholding a digital compact camera and using Live View. Grad filters come in different strengths and as soft-step or hard-step versions.

If the light is too bright for using a slow shutter speed to reproduce falling water as a soft blur, a complete ND filter will reduce the exposure over the entire frame. It is possible to use an ND (or any filter) combined with a polarizer, although the exposure will be reduced. Additionally, combining (or "stacking") filters tends to degrade image quality.

A graduated gray filter reduced the contrast between the white sky and the teddy bear cholla cacti.

Paint with Light

Rather than using flash in poor light or at night, try another way to light subjects in the dark: Treat your flashlight like a paintbrush. Anyone with an LED flashlight will know how effective the beam is, and shining it on your subject will paint light onto small areas. Litepanel's MicroPro (a scaled down version of larger Litepanels used for television and film production) is powered by 96 powerful LED lights and provides heat-free and flicker-free lighting. A dimming knob provides continuous output control from 0 – 100%, and a white diffusion filter allows further control. Rechargeable batteries, AC electricity, or car batteries power the slightly larger MiniPlus version.

In an unlit section of a Chinese cave, a small LED flashlight was used to paint the interior.

Two LED Litepanels were used to light this gravestone at dusk. One was placed behind the stone for rimlight, while the other was used to paint light on the front during the long exposure.

Each panel is fitted with a flash shoe connector for mounting on the camera or attaching to a lighting stand. Hold in the hand to move it back and forth throughout the exposure to paint light, preferably using a low ISO to give a long exposure of at least 20 seconds.

The daylight-balanced (5600K) LED lights in the LitePanels allow use outside as a fill with available light at dusk or dawn. Weighing less than a separate speedlight, a single panel is no effort to carry in the field to spotlight a small area of forest at the end of the day.

Alternately, a speedlight flash unit is also useful to paint light in a cave. Simply set the shooting mode to Bulb, and fire the flash manually on different areas of the frame (if the shutter speed is long enough, you can move throughout the scene without being recorded in the image). The main disadvantage with this is that you cannot see the effect until after the end of the exposure.

tip 50 — Tele-Flash

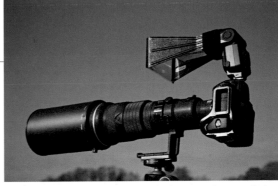

A Visual Echoes Better Beamer attached to an SB900 speedlight for use with a 500mm f/4 lens.

A male golden snub-nosed monkey was photographed with a long lens and flash extender, to gain a catch light in the dark eyes.

Both the Kirk Flash X-Tender and the Better Beamer aid the use of flash with lenses 300mm or longer—check for the correct model to fit your particular flash unit. Each extender weighs only a few ounces, folds flat for carrying out into the field in a pack, and consists of two flash arms, a Fresnel lens, and an attachment strap.

If the flash is being used as the main light source, it needs to be positioned off-camera on a flash bracket to avoid the problem of red-eye. I use an extender to fill in shadows and most often to add some sparkle to a dark eye. Getting even a tiny catch light in one or both black eyes, particularly if they are set within dark fur or black feathers, immediately brings an animal to life. This is especially true for giant pandas with black eye patches, and also applies to black birds with black eyes. Because the extender creates a narrow beam, it needs to be precisely aimed when used as the prime light source.

External flash units used with D-SLR cameras are superb for working with lenses ranging from wide-angle up to about 300mm; but with longer focal lengths, the light falls off quickly. In such cases, a tele-flash extender can be used to concentrate and narrow the flash beam with a Fresnel screen, allowing it to reach even farther. Even though these tele-flash extenders are inexpensive and lightweight, they can increase the flash power by two stops (or three, if the flash is manually set to 50mm).

WARNING: Do not point a long lens at the sun with a Fresnel screen in place, as it will melt the plastic in the flash window and even in the sensor window below.

Creative Flash

A Sto-Fen Omni-bounce diffuser fitted to an external flash unit.

The Honl Traveller 8 Softbox has an 8-inch (20-cm) diameter circular diffuser and weighs a mere 3.75 oz (105 g).

The key to using flash creatively outside is to make slight adjustments, such as reducing the flash output, diffusing the flash, moving it off the camera, or using more than one flash unit. To use flash to fill in shadows or get a catch light in a dark eye, meter the available light and then underexpose the flash output by –1.7 EV so that it simply functions as a fill.

An external flash unit can be diffused in several ways to give a wider angle with softer light, resulting in softer shadows. The SB900 Nikon Speedlight comes with its own slip-on diffuser. For other flash units, the compact Sto-Fen Omni-Bounce diffuser is available with specific fits for each model. These diffusers are less obtrusive for photographing wildlife than a larger softbox. For smaller subjects, the Honl Photo Traveller 8 Softbox is ideal for macro shots of flowers, fruits, and leaves as well as groups of flowers. It can also be folded flat when not in use.

The Lastolite Ezybox Speed-Lite Softbox has a square 8 x 8-inch (20 x 20-cm) outer diffuser, plus an optional diffuser inside. It weighs twice as much as the Honl, which is a consideration when climbing mountains. Velcro strips attach either softbox to an external flash unit.

The cheapest way to use one or more flash units off the camera in order to gain side- or backlighting is to connect them to a multi-flash adapter via extension cords. Alternatively, use a wireless trigger on the hot shoe to fire multiple flashes. On soft ground, a wooden dowel pole with a point at one end and a flash shoe at the other can be pushed into the ground. If the ground is hard, the speedlight can be placed on top of a rock or photo pack. Stand behind the flash to check that the line toward the subject is correct.

With massed spring bulbs naturally backlit, the Honl Softbox was used to fill-in the shadows to make a more usable shot.

A Honl Softbox was used on an external flash unit to photograph a rice paper butterfly feeding on milkweed.

Working in the Dark

To selectively light a small area, use a permanent light source. Here, on the Lijiang or River Li Guilin, a cormorant helped to shield the direct beam of the fisherman's light, which illuminated his face and body as he crouched on his bamboo raft just before dawn broke.

As we walk out at night with a camera, we soon realize that our senses of sight and sound are poorly developed compared to nocturnal animals. This ensures that night photography offers us a special magic of its own.

Use either a flash or LEDs (see Tip 49) to photograph at night—unless you are in the Land of The Midnight Sun (north of the Arctic circle) in midsummer or photographing structures illuminated by lights.

An LED headlamp is useful for walking around a garden at night to see what animals are active. For this shot, a single speedlight flash unit was used to freeze the silver Y moth feeding on a lily flower.

A stroll around a garden on a damp evening with a LED headlamp will reveal a myriad of creatures that shun daylight only to emerge when the sun goes down. Slugs and snails crawl up trunks and over lawns, moths feed on flowers, and nuts wedged in a log or in cracks of a path will tempt field mice. A tiny LED flashlight taped to the camera serves as a useful focusing light.

Nocturnal forays into Madagascar forests can turn up comet moths, mouse lemurs, sleeping chameleons, frogs, and spiders. The simplest way to work at night is to use a camera with attached external flash—preferably fitted with a diffuser. Even a small pop-up flash will give quite acceptable results, but—like any direct, front-facing light—it lacks modeling. A ring flash that encircles the lens provides shadow-free lighting, but a circular reflection will appear on shiny fruits and beetles, or indeed, any wet surfaces.

Better modeling is achieved by moving the flash off-camera, connected via a sync cord onto a flash bracket. Stroboframe brackets position the flash above the lens, eliminating side shadows and red-eye in animals. A twin-flash setup is useful for photographing small animals at night: A flashlight is mounted on each side of the lens either on a bracket or on a special ring around the lens, such as the Nikon SB-R1C1 Close-Up Commander Kit.

After spotting a slow loris at night in a tree, I walked around it until I found a clear view while my guide held my speedlight off-camera and a flashlight so I could see to focus.

Shooting in the Rain

Work The Weather

Backlighting
showcases falling rain
in South China, taken
from an open hotel
window in Jinghong.

When rain begins to fall, the natural instinct is to pack the camera away. Yet, providing your camera is adequately protected (see Tip 54), some stunning shots can be taken in the rain or immediately afterward. Falling rain is difficult to show in a photo unless it is lit from the side or behind and taken against a dark backdrop. Switch to manual focus and preferably use a slow shutter speed of around 1/8 second. To do this you need to set the ISO to the lowest value possible and support the camera on a tripod.

Rain streaks can be digitally added in post production, but this approach often looks unnatural because raindrops are not all equal in size, and so the streaks should be randomly positioned and not uniform in length.

A wide-brimmed hat umbrella—bought in China for a few dollars—protects both the camera and me. It is a perfect way to shoot "on the hoof" in the rain for brief periods.

Water falling on rocks or dusty vegetation enriches their color. Raindrops add interest to flowers and also dark bird feathers or mammal fur, appearing as ephemeral pearls. Hairy caterpillars and leaves trap raindrops, which add an extra dimension to otherwise drab or uniform colors. Ultra-macro shots of life size (1:1) raindrops on spiders' webs or on petal and leaf edges function like fish-eye lenses, capturing miniature replicas of flowers, trees, and even distant landscapes beyond them.

Macro shots of raindrops function as miniature fish-eye lenses. Here, inverted images of Kew Palace appear in each one.

Weatherproof the Camera

In light rain, a camera with a short lens can be protected by encasing it in a thick plastic bag (check that there are no holes in it) secured around the lens with a rubber band. When using a long lens in more persistent rain, a waterproof camera cover that protects both camera and lens is well worth the investment. When made of silver or black material, this is not as ideal for shooting wildlife as camouflaged covers. Covers with a clear window positioned over the viewfinder are also useful.

An all-in-one cover protects the camera and lens in all weathers, shown with the back closed for working in rain or snow. © Wildlife Watching Supplies.

In persistent rain, mammals will stand or sit, often waiting until it stops before they shake their head several times to remove surplus water. A more creative shot can be gained here by using a slow shutter speed to portray the water as swirling lines rather than as frozen droplets. Long-haired mammals, such as monkeys and bears, will do the same thing as they emerge from water.

If rain does fall on a camera, use a towel to soak up surplus water before leaving it out in the open to dry out completely. A hair drier or a car heater will speed up the process, and also help to remove any fogging on internal lens elements.

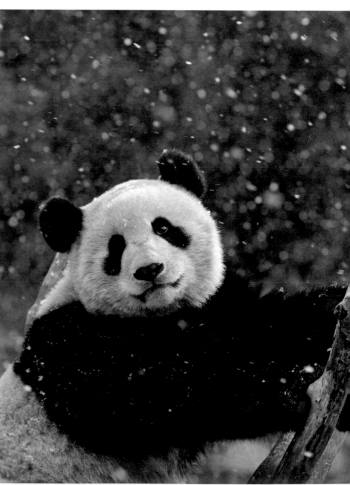

A camera also needs protection when snow falls, as here on a giant panda in China.

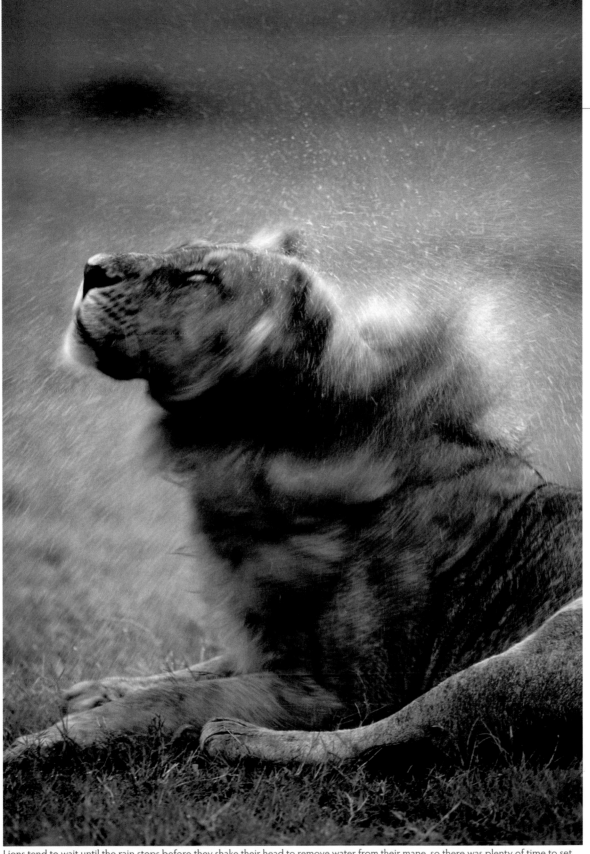

Lions tend to wait until the rain stops before they shake their head to remove water from their mane, so there was plenty of time to set up a camera with a 500mm lens and frame the shot.

tip

55 Capture Sunbeams

More often than not, photographers strive to avoid direct sunlight landing on their lens, as it causes unwanted flare. Yet, capturing the moment when sunbeams radiate out from clouds or through a forest canopy can produce a spellbinding image.

The reason we do not see sunbeams more often is because they are most obvious only when sunlight is viewed against a dark backdrop and scattered by particles in the atmosphere such as mist, dust, or pollen clouds. On the ground, light beams are most likely to appear early in the morning or late in the day, and for that reason, they are also known as crepuscular rays. Getting the correct exposure can be tricky, so this could be an instance when it is prudent to bracket exposures. Also, make sure the sun itself is hidden behind clouds or a tree trunk.

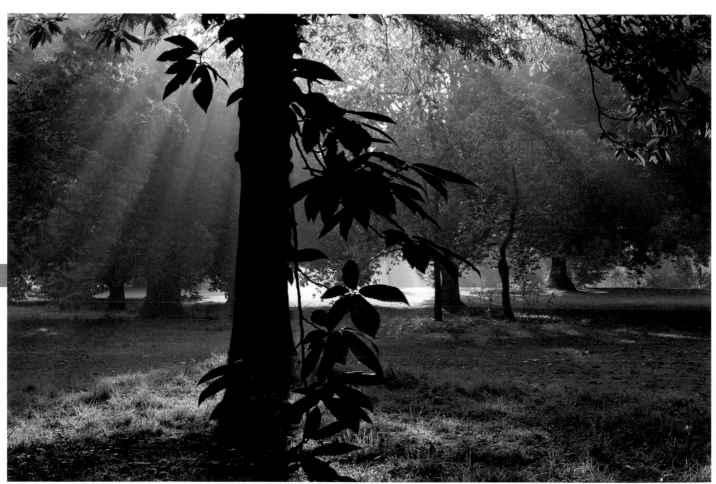

Sunbeams break through mist on an autumnal morning at Kew Gardens in Surrey, England.

Late in the day sunbeams radiate upward from clouds in Botswana.

When optimum daytime conditions exist and sunlight squeezes through gaps in the clouds, the rays beam down toward the earth. Whereas when then sun is low in the sky and there is a complete bank of clouds below, the rays are seen radiating out and upward

Within a forest, shafts of sunbeams spotlight leaves and the ground as they filter through the canopy above. Look for a tree trunk blocking out the direct sunlight to create a dramatic starburst effect. Smaller starbursts also appear when sun squeezes through a narrow opening. Sunbeams can add a magical and ethereal feeling to what is otherwise a dull forest scene or a drab solitary tree.

Light beams can also transform the interior of caves or slot canyons with an opening in the roof above; but in this case, the sun needs to be overhead. Indeed, midday is the best time to capture the light beams in Antelope Canyon, one of the most photographed of all the desert canyons in the American southwest.

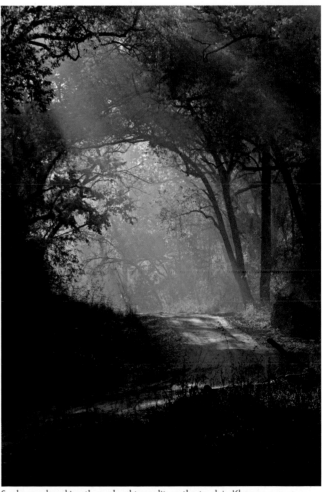

Sunbeams breaking through sal trees lit up the track in Khana National Park, India.

Hot and Humid

A mother white-cheeked gibbon with her newborn baby pauses on a liana before swinging through the canopy, shot handheld with an 80-400mm lens using flash as a fill.

Tropical rainforest is one of the most difficult habitats in which to take photographs of wild animals. Thus, when you are successful, it is immensely satisfying. From the ground, there are tantalizing glimpses of birds, monkeys, and squirrels moving through the canopy. Dappled sunlight beams down through gaps above, so that when framing animals looking skyward, they appear partly silhouetted—unless fill-flash is used. When rain falls, paths become slippery and everything gets soaked (unless enclosed in waterproof bags).

Once a tree comes into flower or starts bearing fruit, birds and arboreal mammals converge to gorge themselves. At this time, or when monkeys pause to groom each other, working with a tripod is practical. Otherwise, working "on the hoof" and grabbing shots with a handheld camera and a long lens with IS or VR is the best option. You can also try pushing up the ISO.

Elevated walkways and towers in South American and Asian rainforests provide a rewarding rainforest experience. High towers present a novel insight for experiencing high-rise life in a wilderness area. The Canopy Tower Ecolodge, converted from an abandoned military installation in the Panamanian jungle, provides a magnificent, panoramic bird's-eye view of the rainforest canopy.

A tropical clipper butterfly rests on a water lily pad to drink.

Essential Rainforest Gear:

>•>Waterproof insect repellent

>•>Compass

>•>Whistle

>•>Plastic shower cap

>•>Waterproof cover for SLR cameras

>•>Head and wrist sweat bands

>•>Waterproof notebook and pencil

>•>Waist pouch for spare gear

>•>Ziplock plastic bags

>•>Waterproof tape to protect
flash connections

>•>Hat umbrella (see Tip 53)

>•>Whitewater stuff sack with straps for
protecting backpack in torrential rain

>•>Ultralight microfiber absorbent
towel such as a Packtowl®

>•>Jungle boots or leech socks
(to protect legs from leech bites)

The waxy torch ginger flower grows in Asian rainforests.

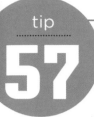

Snow and Ice

**Essential
Cold-Weather Gear:**

>•>Sled to transport equipment over snow and ice

>•>Self-adhesive rubberized strips to insulate focusing rings on long lenses

>•>High-energy lithium batteries guaranteed down to –4˚F (–20˚C)

>•>Tripod leg warmers

>•>Fisher Space Pen with sealed pressurized ink cartridge (for use on Apollo shuttle flights) works from –50˚F to +400˚F (–46˚C to +204˚C)!

>•>Thermometer key ring attached to camera pack

Photographers who live in places where heavy snow is guaranteed each winter are much better equipped for the elements than visitors who jet in for a week or two, both in terms of clothing and the way they work. While photographing the balletic cranes on Hokkaido, I spotted serious Japanese photographers pulling their gear over the snow on a sled. This inspired me to take a sled, with everything secured in place with elasticized bungee cords, on a trip to Antarctica to photograph emperor penguins.

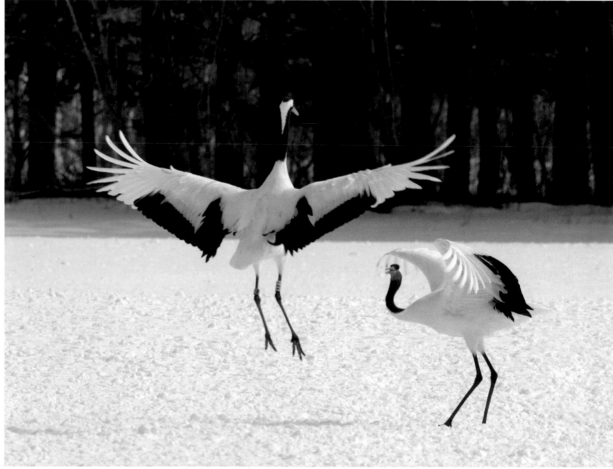

Japanese cranes dancing in the snow on Hokkaido in sub-zero temperatures, shot with a 500mm lens.

Plastic squares distribute the weight of a tripod over the surface of deep snow, functioning just like snowshoes for your feet.

The only way to walk efficiently over deep snow is to use either skis or snowshoes. To prevent tripod legs from sinking into deep snow, colored 6 x 6-inch (15 x 15-cm) squares cut from the corrugated plastic sheeting used in mailing shipments help spread the weight. Cut a hole in the center of each square for the tripod tip to prevent the legs from slipping.

Spiky pavement crampons, designed to slip over boots as ice grips, are essential for walking on ice, whether it be a sheet at the base of a waterfall or the myriad of ice-covered steps on some Chinese mountains.

Snow camouflage covering cloth is used to disguise a camera and tripod. © Wildlife Watching Supplies.

CAUTION: Beware of towing a heavily laden sled downhill over snow or ice. Take a zig-zag course to prevent it from crashing into you.

Work The Weather

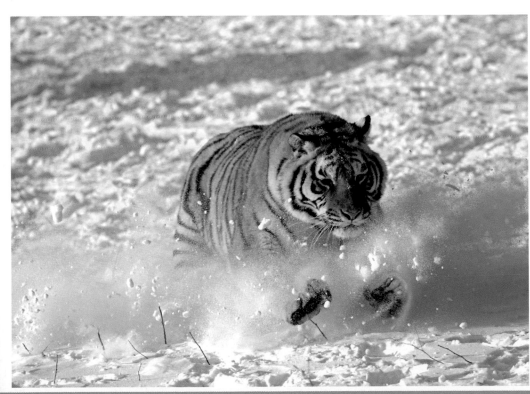

Snow flies in every direction as a Siberian (or Amur) tiger races across the ground in northeast China.

Polar Regions

The weather can change dramatically in the Arctic or Antarctic spring and summer from one day to the next. There is nothing more frustrating than experiencing a stunning polar landscape only to find the wind chill factor turns your fingers to useless appendages, incapable of releasing the shutter. So layered gloves are just as important as the main clothing. I wear a pair of aluminum thermal gloves inside a polypropylene pair, covered by a layer of thicker gloves with an optional over-mitten.

Avoid making direct skin contact with a cold metallic object, since in very cold conditions the two will stick together. Extreme cold can prevent some camera batteries from functioning, so carry at least one spare battery kept warm in an inner pocket, preferably attached to a battery holder if necessary.

For polar bear tours out of Churchill in Canada, specially designed vehicles known as tundra buggies trundle over the frozen fields. A beanbag is a convenient way to steady a long lens, but be sure to secure it (see Tip 16).

With any large expanses of snow and ice, the in-camera exposure readings need to be adjusted; otherwise images will appear underexposed (see Tip 22).

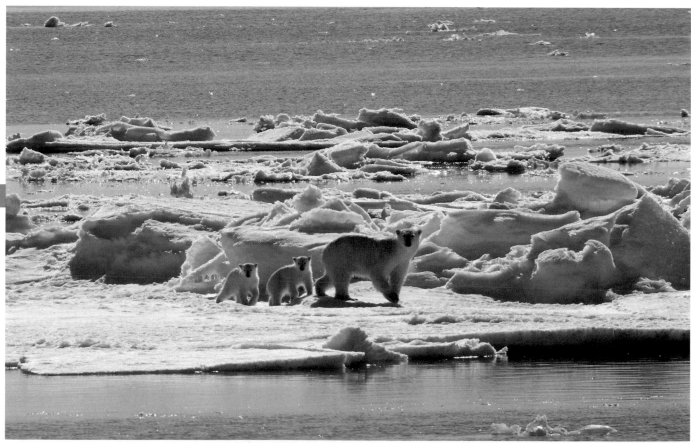

Polar bear mother and cubs walk on an ice floe surrounded by sea off Svalbard in the Arctic. If they get cut off from the main pack ice, the mother is unable to hunt for seals.

When a harp seal pup sleeps on pack ice in the Gulf of St. Lawrence, the warmth from its body forms an ice cradle.

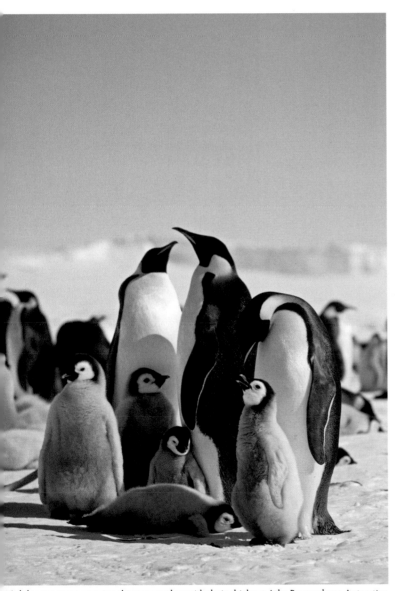

Adult emperor penguins cluster together with their chicks at Atka Bay rookery, Antarctica.

Essential Polar Gear:

>•> **Thick tights**

>•> **Long-sleeved and long-legged thermal underwear that "wicks" up sweat**

>•> **Double-layer pants**

>•> **Windproof pants**

>•> **Long-sleeved light sweater or shirt**

>•> **Long-sleeved fleece**

>•> **Padded vest**

>•> **Winter parka**

>•> **Neck and chest warmer**

>•> **Warm hat with ear flaps/balaclava or fleece snood hat**

>•> **Mountain sunglasses with leather side shields or ski goggles for wind/ glare protection**

>•> **Silk glove liners**

>•> **Waterproof gloves/mitts with separate thumb and index finger**

>•> **Arctic boots that cover ankles guaranteed to –40˚F (–40˚C)**

>•> **Chemical hand and foot warmers**

>•> **Sunscreen**

>•> **Lipsalve**

>•> **Foot crampons**

>•> **Walking pole**

Wildlife Wonders

Climbing a hillock was the only way to show a section of wall-to-wall king penguins with their brown chicks in South Georgia.

As a pair of bison walk into the vast, snow-clad landscape at Yellowstone in winter, they appear dwarfed by the trees and shadows behind them.

There is a temptation, once you have invested in a long, fast telephoto lens, to keep it as a permanent feature on the camera for frame-filling animal portraits. There are times, however, when it is preferable to select a shorter lens to show more of the animal's natural habitat. This is not an easy option, and careful consideration of both composition and lighting are crucial.

Lines of animals—penguins walking or tobogganing over snow, or zebra migrating across the African savannah—add a dynamic dimension to a picture. Before releasing the shutter, consider where to place the line. Avoid the center of the frame, since this will cut the picture in two. If the sky is dramatic, or there is a spectacular sand dune or mountain backdrop, give it prominence and position the animals within the lower third of the frame. Large, distinctive animals, such as a giraffe or an elephant, can make a dramatic opener for a feature or a photo essay if they are silhouetted against a vibrant sunrise or sunset.

Wide-open places are ideal for taking these kinds of pictures, because a 360° view makes it possible to check from which direction animals are moving into a scene, and set up a tripod in readiness for them to enter a pre-composed landscape. Avoid placing a single animal in the center of a location shot by either manually focusing it off-center or using the focus lock and recomposing.

A group of alert lechwe in Botswana keep their eyes focused on a leopard as it walks out in the open by day, ready to make a hasty retreat if it decides to change its route.

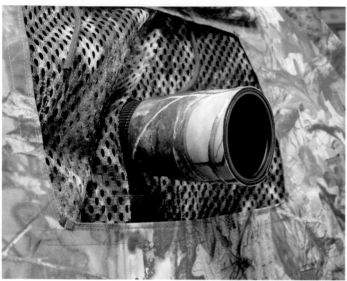

When working in a camouflaged dome blind, it is sensible to camouflage a lens hood with a Neoprene cover when it projects out of a slot. © Wildlife Watching Supplies.

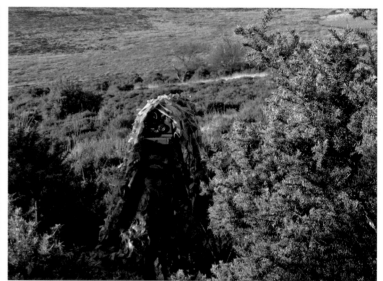

A leafcut scrim draped over the camera and tripod legs makes a temporary blind, so the photographer can approach behind it. © Wildlife Watching Supplies.

Anyone at all serious about photographing wildlife in wilderness situations will avoid wearing brightly colored clothes, or anything that rustles when moving. To have any hope of getting close to the target species, it is essential to blend in with the terrain. This does not mean having to dress in camo fatigues from head to toe; in fact, in Africa where they are standard military dress, it is illegal for civilians to wear them.

On safari in Africa during the dry season, khaki is appropriate; whereas in India, especially in forested areas, dark green is popular with the rangers. On snow and ice, white parkas and over-trousers do such a great job blending in that it can be impossible to locate a person in distress from the air. So in polar regions, an orange waistcoat or life jacket is an essential survival item.

For dusk and dawn forays, make sure all clothing has been washed thoroughly with unscented soaps. When working in one place for a while, camouflage nets (scrim or leaf screen) can be joined together and strung up between trees as a temporary screen. A few snips in the mesh may be needed to make a hole large enough for the lens hood of a long, fast lens. Camo material is also useful for breaking up the body outline when lying prone on the ground. Camouflage camera covers and sleeves for long lenses are available from retailers who specialize in wildlife clothing, blinds, and camouflage nets.

Learn Fieldcraft

Fresh brown bear prints in soft estuarine mud confirmed that a bear had passed by recently at Hallo Bay in Alaska.

Going on safari is an unforgettable experience, but achieving close encounters with wildlife while on foot can be even more rewarding. Setting out on your own is unlikely to reap dividends immediately, but going with someone who knows the area and the habits of the local wildlife will be invaluable. They will be looking for recent tracks or feeding areas so as to increase the chances of spotting wildlife.

Unlike birds, mammals have an acute sense of smell, so subdued clothing is not enough to conceal yourself. When stalking your subject, you need to check the wind direction and approach upwind—with the wind blowing from the mammal(s) to you—so as to reduce the odds of spooking them too early. Also, make sure all shiny parts of camera and supports are masked with either matte-black or camo tape. Elastic camouflage tubing is a speedy and non-permanent way of covering long lenses.

On open ground, move slowly toward the quest, zig-zagging from one tree or boulder to another—preferably when the animal has its head down to feed. Freeze as soon as it begins to raise its

head. It is not difficult to sense whether an animal is relaxed or wary. In the latter case, it is far better to put the animal's welfare first and back off a bit.

A tripod is impractical to carry and set up quickly when stalking, so either hand-hold the camera with the VR or IS switched on and your arms braced against your body, or use a monopod.

Many animals are creatures of habit, so by setting up an elevated blind or simply sitting down to wait at a favorite drinking area or place where animals graze, you can get them to come to you—which is often a more rewarding approach.

On the Arctic tundra there is often little cover for stalking birds or mammals; but by zig-zagging from one rock to another, it was possible to get reasonably close to this bull musk-ox in Greenland.

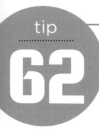

Using Blinds

Digital capture has meant that wildlife photography is no longer restricted to a few dedicated experts. Spurred on by informative television programs, a plethora of photo workshops, and readily accessible blogs, wildlife photography has been made available to anyone who has a camera with a reasonably long zoom lens. With more people visiting wildlife reserves, capacious public blinds ensure overwintering wildfowl or game animals at waterholes are not disturbed by a succession of visitors.

Decades ago, we entered unheated, drafty sheds, where we raised a wooden flap to open a slit through which we could view and photograph the birds. Now blinds are not only getting larger, with intact walls and large glass windows, some are even heated! Picture windows are great for viewing but unless they are clean, they are not always ideal for photography. In the tropics, blinds can be more basic because heating is unnecessary.

In addition, dedicated bird photographers use their own blinds to photograph birds at the nest. The material of the blind needs to be opaque, so the photographer is not visible when the blind is backlit, and it also needs to blend in with the surroundings. In wetland habitats, boats or even an angler's floating ring camouflaged with branches make a mobile blind for getting close to nesting water birds. Any vehicle makes a mobile blind from which to shoot in a drive-through reserve, using a long lens on a ball and socket head fixed to a window mount (see Tip 17).

A panoramic shot of elephants drinking at a waterhole in the dry season in Botswana was taken from an open makeshift blind, made simply from fallen tree trunks on all four sides with an open top.

A pop-up dome blind set up overlooking a river for kingfishers.
© Wildlife Watching Supplies.

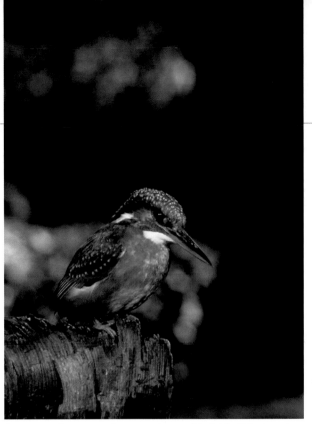

A rotten trunk, positioned just outside a small individual blind, made a convenient perch for kingfishers nesting on Hampshire's River Test. Speedlights were mounted on Benbo tripods in the river to fill in the shadows beneath the trees.

Dos and Don'ts for Working in Blinds:

>•>**Do take a drink with you**

>•>**Do approach quietly**

>•>**Don't talk loudly inside the blind**

>•>**Don't stick out an arm to point to an animal**

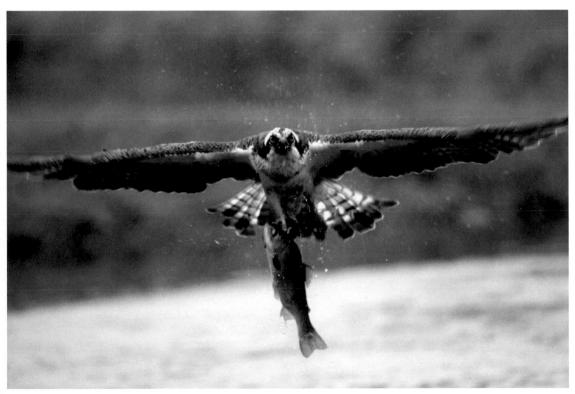

After losing many trout to ospreys, the owner of a Finnish trout farm erected photographic blinds around one pool so photographers could pay for the facility.

63 Working on Water

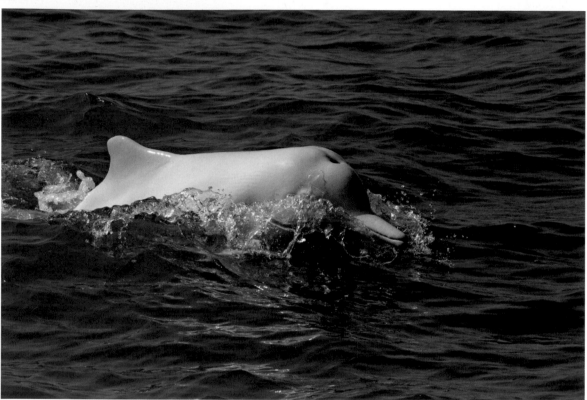

Pink dolphins are a pink form of the Chinese white dolphin, and some 100 – 200 such animals live in Hong Kong waters, where they are protected in a marine park. The pale skin is much brighter than average, so the blue sea was used for metering.

An idyllic way to gain close access to aquatic birds and plants in Botswana is to be paddled in a dugout canoe or mokoro through narrow channels in the Okavango Delta. A low-level camera angle is more interesting than a conventional eye-level one. For larger animals, such as elephants and hippos, it is wiser to work from a more substantial boat, where there's no risk of it being turned over.

Brief the boatman beforehand as to your target species. If there is an engine, ask if it is safe to cut the engine when approaching animals, so they do not take flight or run off. A boatman who has worked with film crews or photographers previously should be able to respond to hand signals and to maneuver a boat to the best photographic position.

Whale-watching trips provide opportunities for taking action shots of whales or dolphins emerging from the sea. A good way to work is to have two bodies with different zoom lenses, one a long telephoto up to 300 or 400mm, and the other spanning from a wide angle to a short telephoto (in case a whale surfaces close to a boat). During a week in the Sea of Cortez, there will be plenty of opportunities for getting whales and dolphins surfacing, blowing, and diving to reveal their tail flukes.

A tripod is rarely practical for working from a boat, unless you are anchored beside birds at a nest, or next to seals hauled out on some rocks. Handholding a large lens on a boat for long periods of time can get tiring, so a monopod with a suction cup fixed to the base helps. A ball and socket inside the rubber cup allows great freedom of lateral movement while maintaining a fixed base.

Endangered gharials are slender-snouted crocodilians that live in the Chambal River in India. Their average-toned bodies are perfect for spot-metering.

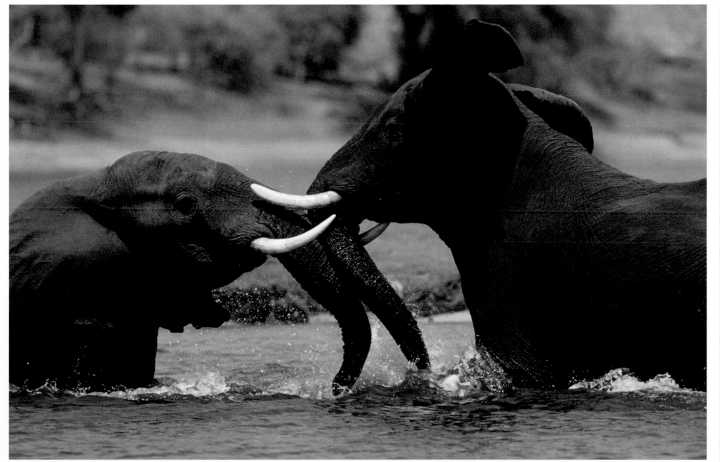

The upper deck of a boat on Botswana's Chobe River provides a clear viewpoint for elephants drinking, wallowing, and swimming across the river. Here, two males are sparring in the shallows.

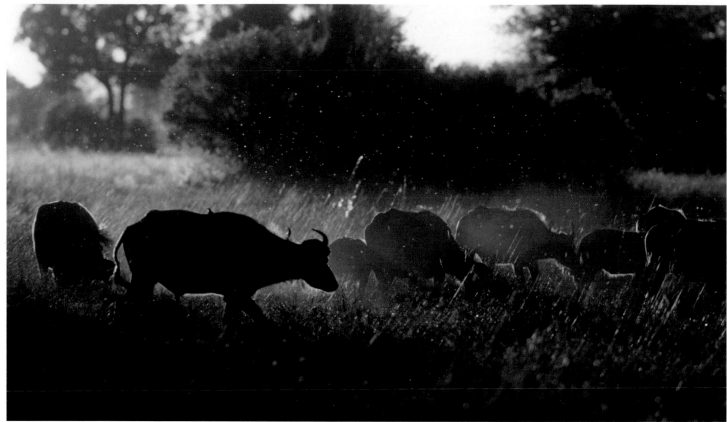

Backlit at dusk, a herd of African buffalo (with attendant flies) passes through the Okavango Delta.

It is essential to plan well ahead for what may be the trip of a lifetime. Before booking a safari, decide whether to stay in lodges or to experience the traditional safari by sleeping outdoors under canvas. Also, find out whether the vehicles are jeeps or minibuses and how many people will be in each one. Even though there are windows on both sides of a minibus, the action is invariably only on one side, to which all the passengers will move to get their shots. For this reason, I prefer working in open-topped jeeps (which are not always permitted).

Safari clothing needs to be made of drip-dry cotton and light-colored (khaki, beige, or gray) as this reflects the sunlight and blends in with the dry grass. The secret is to dress in layers—it can be cold at first light and in the evening. Avoid clothes with Velcro fastenings, as a ripping sound can disturb timid animals, although it can also make an animal look up at the camera.

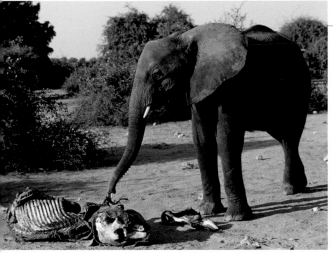
An African elephant uses its trunk to investigate the skeleton of a baby elephant.

In the dry season the biggest problem is dust. Use two camera bodies—one with a long telephoto lens and the other with a shorter zoom lens—to avoid lens changes and the risk of dust getting on the sensor. A Camera Bivvy (see Tip 95) also limits dust contamination. A pillowcase slipped over a camera with a long lens protects it from dust when driving. Avoid making sudden noises or talking loudly, and never urge a driver to get too close to the animals.

Essential Safari Gear:

>•> **Short-sleeved shirts and shorts**

>•> **Long-sleeved shirts and long trousers (protection against sunburn and mosquito bites)**

>•> **Light sweater**

>•> **Windbreaker**

>•> **Sunglasses**

>•> **Bush hat, Panama hat, or pith helmet with built-in fan**

>•> **Bean bag**

>•> **Pillowcase to cover camera with long lens**

>•> **Damp cloth**

>•> **Dust mask**

>•> **Binoculars**

>•> **Insect repellent**

>•> **Anti-malarial tablets**

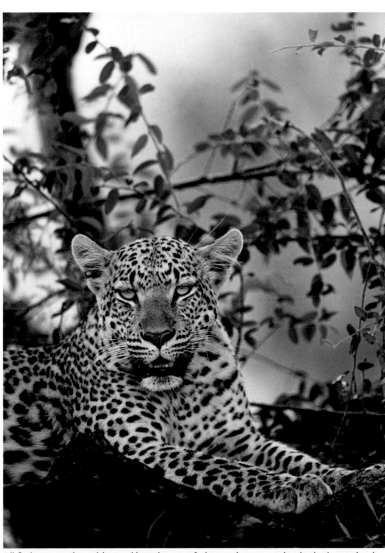
Fill flash was used to add a sparkle in the eye of a leopard resting in the shade during the day.

Animal Transport

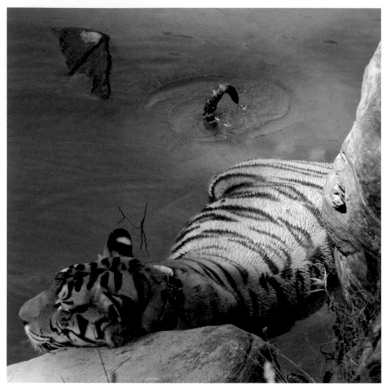

A tiger with a radio collar cools off in the heat of the day, photographed from atop an elephant back in Kanha National Park in India.

While on safari, it is possible to photograph on foot or from a boat, but most often you will be in a jeep or safari van. On the other hand, in India, wildlife—notably tigers—will tolerate a much closer approach by an Asian elephant than a vehicle. A mahout (elephant driver) will take his elephant out early in the morning to locate a tiger, and if one is found close to the road, visitors can—for an extra fee—take an elephant ride to view the tiger at close quarters while it rests in the shade or cools off in water. However, it is all rather stage-managed and lacks the thrill of being the first person to find the most regal of all large cats.

In Kaziranga National Park in Assam, elephant back safaris are an ideal way to see the country's largest population of rhino. Here, much of the land is swamp with tall thickets of elephant grass, so the elephant seat provides a perfect elevated viewpoint.

Before clambering up onto an elephant, it is essential to have everything at the ready. For a start, it is not practical to take a photo pack, unless it is a fanny pack. You need a camera (preferably with a strap around your neck) with a new memory card and fresh batteries because you don't want to waste time changing either of them or, indeed, risk dropping one from high up when retrieval is impossible.

Elephant back safaris take place in Botswana and South Africa. For treks across the desert in central Australia in the austral winter (when the daytime temperatures are a bearable 73°F or 23°C), camels are used to transport all the gear.

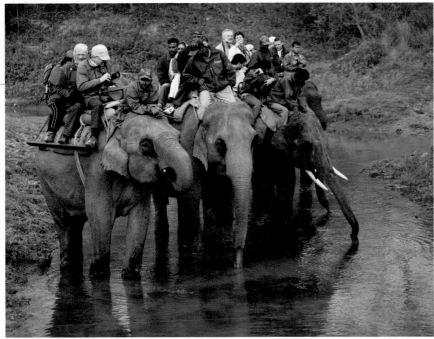

Tourists on an elephant safari pause while elephants drink before going on in search of Asian rhinoceros in Kaziranga National Park, Assam.

Wildlife Wonders

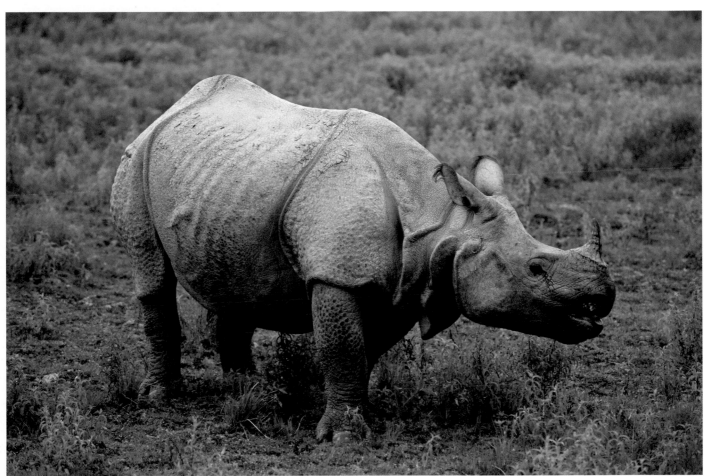

An Asian rhinoceros photographed from an elephant back in Kaziranga National Park.

Facial Expressions

Having photographed complete animals or groups, now try a longer telephoto lens to crop in tight on an animal's face so it fills the frame. You may just be lucky and capture a comical expression. The faces of mammals with soft lips and pliable faces are more interesting to photograph than birds; indeed, many primates communicate different moods to their immediate family or to intruders by means of graphic expressions. Birds, on the other hand, simply open and close their bills; although any pair of birds "billing" (touching beaks) changes the pace of a gallery of otherwise single heads.

Look also for eye-to-eye shots, which will give much greater impact than when an animal is looking even slightly to one side of the lens. Animals with outsized eyes, such as many frogs

A male Siberian tiger curls his upper lip back and extends the tongue, to better detect scent hormones produced by a female in heat.

and nocturnal lemurs, or animals with a colorful tapetum around their pupils, like snowy owls, are all great subjects for eye-to-eye shots. Chameleons are intriguing because of their ability to move each eye independently; so when looking at this reptile head-on, it is possible to get one eye looking forward and one back at the same time.

If shooting in dim light or at night, beware of colored "eye-shine" caused by the on-camera flash reflecting off a layer inside the eye back into the camera lens. Eye-shine varies in color depending on the animal and the angle of the light. The problem is usually solved by using the flash off-camera. Using a flashlight at night is a useful way of locating nocturnal animals by picking out their eye-shine.

A baby snow monkey calls out in a hot pool in Jigokudani Monkey Park, Japan.

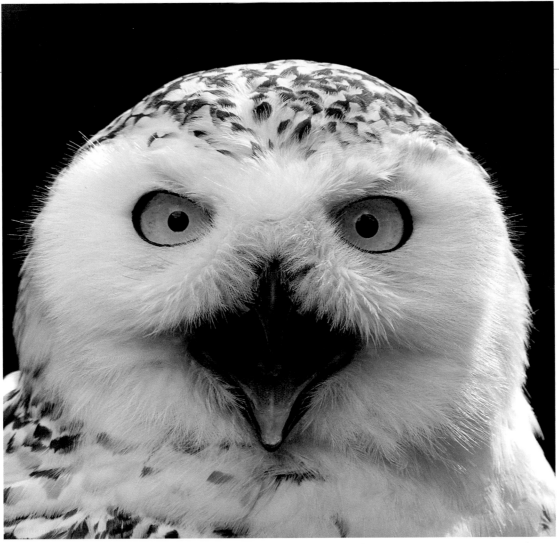

As a captive snowy owl calls out in the shade, fill flash with a Sto-Fen diffuser gives catchlights to the eyes.

The graceful head of an Inca tern, showing the open red bill as the bird calls.

The Need to Feed

A rainbow lorikeet hangs upside down to feed on nectar produced by the drunken parrot tree.

Photographing animals feeding is a bit like a lottery—you may just luck out when a lion makes a kill or a heron snatches a fish. A prime situation is to locate a spot where there is a glut of food so that some time can be spent taking shots of monkeys and birds feasting on a fruit-laden tree, or bears converging at a river when there is a salmon run. Then, if the timing is right, it is not difficult to get varied feeding shots from a choice of individual animals. The secret is to do your homework.

Lion kills are more unpredictable, since both the predator and prey can move in any direction. However, the chase leading up to a carnivore's kill can be among the most dramatic of all animal behavior. It is worth staying put after the lions depart, because jackals and vultures waiting in the wings will move in, only to eventually give way to hyenas. Once a leopard brings down its prey, it is dragged up a tree—a fixed point to which it will return.

Other places for action feeding shots are trout farms, where an open pool is a magnet for herons and ospreys, and a temporary or permanent blind, situated beside such a pool, is perfect for action photography (see page 109).

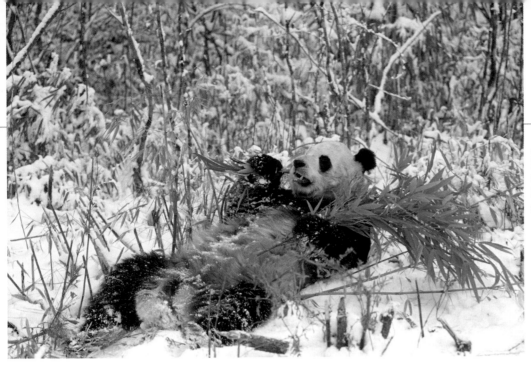

A giant panda feeding on bamboo is a more leisurely affair, since a panda chomps on bamboo day in and day out, regardless of the weather.

Wildlife Wonders

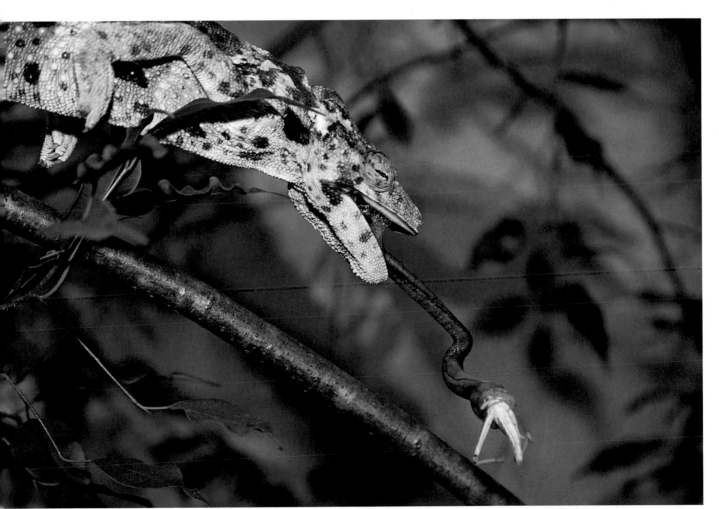

Fast reflexes are essential in order to capture the moment when a chameleon extends its long tongue and wraps the tip around an insect.

Animal Camouflage

A resting buff-tip moth mimics a broken twig.

Many smaller animals, and the young of some larger animals, blend in with their surroundings in order to reduce the odds of a predator spotting them. Animal camouflage is widespread among the chicks of ground-nesting birds, nocturnal insects that rest by day, and bottom-feeding fish. The spotted coats of newborn deer provide the most effective cryptic coloration when bathed in dappled light within a forest.

Since animals go to great lengths to merge in with the background, avoid lighting with a flash that casts an unnatural shadow, thereby negating their camouflage. For this reason, I prefer to take camouflage pictures in natural light, whether on a dull day or in sunlight, because the animal will adopt an attitude that is appropriate for the lighting. For example, if a grayling butterfly lands on the ground when the sun is shining, it will angle the closed wings so they cast the least possible shadow.

Composition is another factor to consider. Filling the frame with an animal misses the whole point of showing how it blends in to its habitat, so I prefer to pull back with a zoom and to off-center the animal. The only problem is that sometimes the camouflage is so effective, an eye needs to be kept focused on the animal; otherwise it becomes impossible to relocate until it moves again!

Predators also use camouflage to help them blend in with vegetation and enable them to approach their prey. Chameleons are the masters of disguise among reptiles, with the light and dark pigment cells in their skin expanding or contracting to match the background. The stripy coat of a tiger and the spotted coat of a leopard both help to disrupt the body outline so that it merges in with light and shadows inside a forest.

A frame-filling black-bellied bustard is quite obvious, but on walking away it soon merges into the long, dry grass in Kenya's Masai Mara.

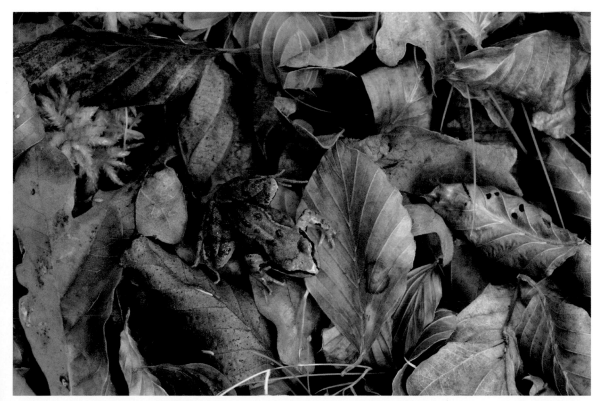

A young frog blends into leaf litter in a beechwood.

Baby Animals

Baby animals, especially fluffy chicks and furry mammals, have huge appeal and are consistent sellers for calendars and cards. Best of all are youngsters photographed while they look directly into the camera. Fluffy baby birds—such as ducklings, goslings, cygnets, and tern and penguin chicks—also have a high cute rating, but their bodies are not so dexterous as baby mammals.

After feeding, baby mammals like to play and explore their surroundings. Young bears and monkeys love playing with one another and interacting with their parents. Set the camera on continuous shooting mode for a rapid sequence of shots of them at play when they are constantly on the move. Natural objects such as sticks, stones, flowers, leaves, or feathers may all become ephemeral play objects.

Using a zoom lens on a tripod is one way of working whereby you can adjust the focal length as the youngsters move nearer or farther away, and also pan if they move sideways. An even more adaptable way—if the youngsters will tolerate it—is to dispense with a tripod and either handhold or use a monopod so you can move around with them, also working with a zoom lens. Try to get a catchlight in at least one dark eye from a skylight reflection; or failing that, use a fill flash.

You have to be prepared to expose a lot of shots, because there will inevitably be quite a high proportion when an animal sneaked just out of the frame, or some essential part of the body appears out of focus.

A darling mallard duckling takes to the water soon after hatching.

When brown bear cubs in Hallo Bay, Alaska stand up to playfully box each other, they are beginning to learn the skills for real fights later on in life.

Wildlife Wonders

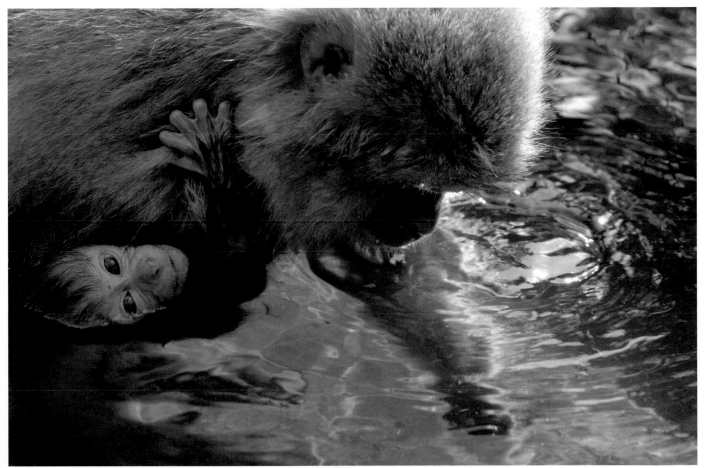

Newborn snow monkeys do not always appear cute and cuddly; as a mother bends over to drink, her baby gets a dunking.

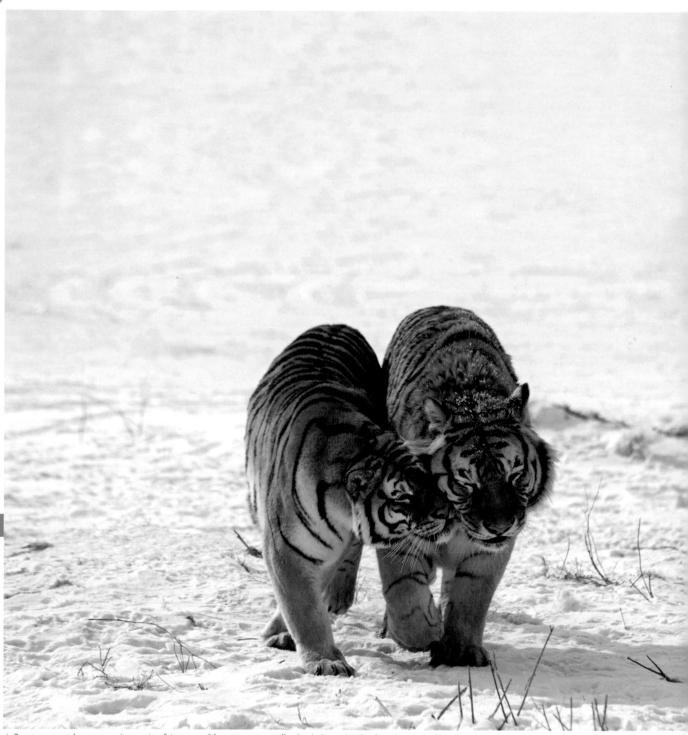

A fleeting special moment: As a pair of Amur or Siberian tigers walked side by side, the female nuzzled her head up to her mate.

One of the most splendid courtship rituals has to be when the peacock raises his tail fan and rotates so the iridescent feathers glisten in the sunlight.

light varies. This is an ideal subject for taking a photo sequence. Avoid using flash because the full beauty of the iridescent fan feathers, at varied angles, will be lost with a unidirectional light.

Courtship is often associated with spring, but some animals court in the coldest part of winter. The Japanese cranes perform their balletic dances on snow-covered ground on the Japanese island of Hokkaido in temperatures well below freezing (see Tip 57). The mute swan also courts and mates in winter (see Tip 76).

Animal courtship displays are some of the most beautiful and bizarre examples of animal behavior. In many cases, courtship and mating can be a brief affair, so the timing is crucial. Stags or bucks may have to fight each other to win their harem, and the deer with the most impressive set of antlers tends to be the victor. In the right season, the noise of clashing antlers can lead you to where the deer are fighting, but you will need to keep your distance and work with long lenses.

For birds, vocalization is often an important factor in the initial stage of attracting a prospective mate. In spring, the raucous calls of the peacocks make it easy to home in on them. The peacock performs his courtship dance by raising the feather train and gracefully rotating on the spot, so the feathers change color as their angle to the

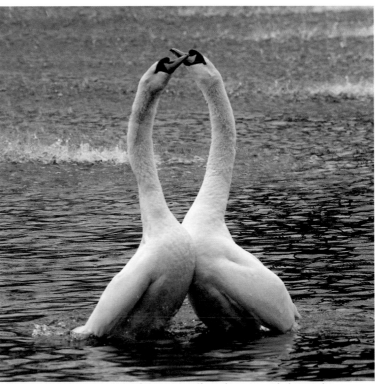

After mute swans mate in winter, the pair erupt from the water with their necks outstretched and bills crossed.

Wildlife and Flowers

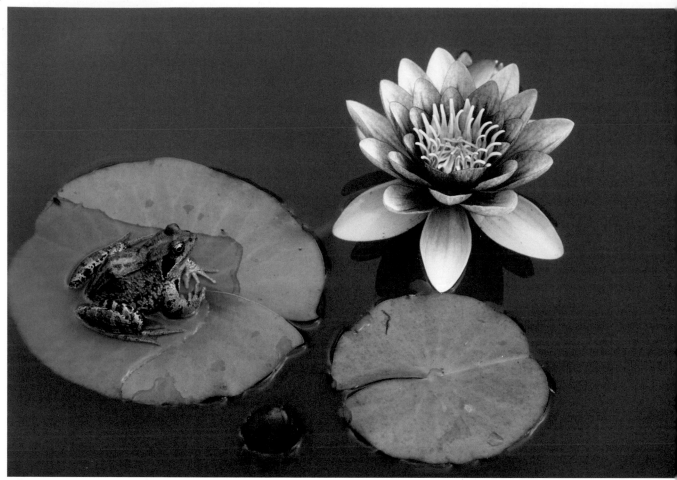

A frog resting on a water lily leaf in a garden pond is a simple yet attractive way of illustrating wildlife in the garden.

Wildlife photographs that depict some behavioral aspect, such as one animal interacting with another or youngsters frolicking with their parents, will tend to arrest the eye. By comparison, a single bird or mammal standing with its flank towards the camera is a mere record shot. Another approach is to photograph birds or mammals among plants or shrubs in flower, to add both interest and color to an otherwise static shot.

Seabird colonies on flat cliff tops provide one of the easiest places to combine fauna and flora shots, because of the sheer number of birds nesting and walking amid flowers. Atlantic puffins, kittiwakes, and gulls often nest alongside clusters of thrift or sea pink flowers; while on Midway Atoll in the Pacific, Laysan albatross mingle with golden crown-beard flowers.

Chinese golden pheasants roam freely at Kew Gardens and the resplendent male birds look stunning as they strut through the bluebells in spring.

As a fox walked into a gorse bush at the British Wildlife Centre, it paused and, for a fraction of a second, one eye was framed by the yellow flowers.

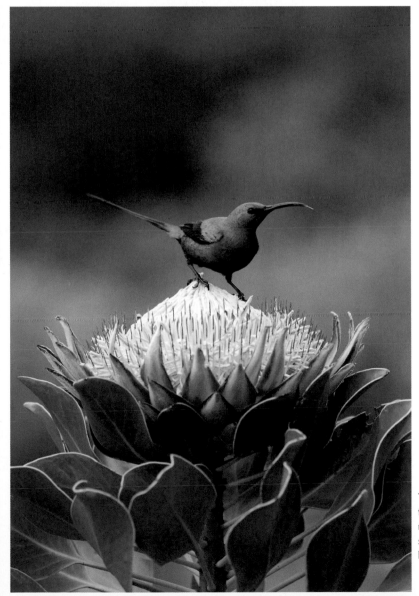

Getting a clear shot of animals feeding on a flower is an extra bonus. Monkeys eat fruits as well as flowers—especially if they contain sweet nectar. If you do your homework and find out which birds pollinate certain flowers and the time they bloom, it is not too difficult to get shots of birds on flowers. Lack of rain in South Africa in 2010 resulted in a dismal year for the massed annuals, but the shrubby proteas put on a good show that attracted both sunbirds and sugarbirds.

Some of the shots will be a matter of luck as to whether an animal pauses beside or atop a flowering plant; but by being vigilant, opportunities will arise that will enable a collection of images combining wildlife with flowers to be built up.

The long, curved bill of a male malachite sunbird is well adapted for extracting nectar from king protea flowers. When there is more than one flower in bloom, it is always a gamble which one to select, but the odds are reduced by using a long lens on a tripod between two bushes, so that both are accessible.

Action Shots

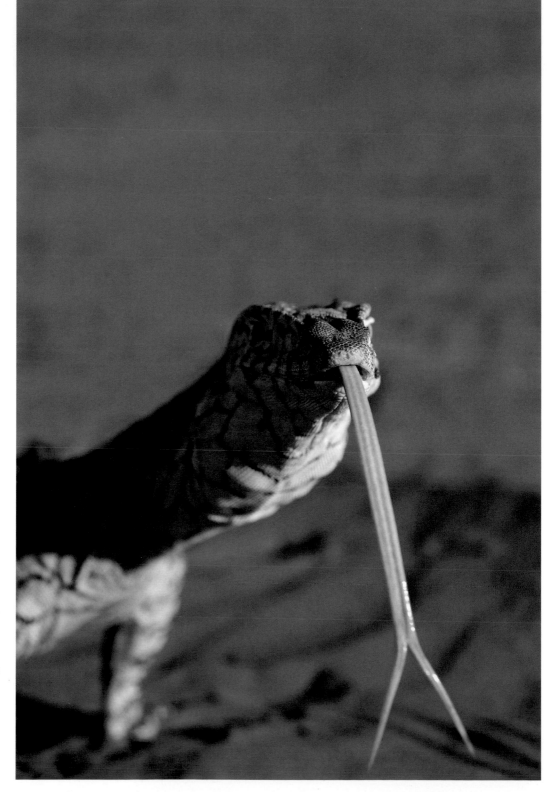

A shutter speed of 1/1000 second was needed to freeze the moment when the long, forked tongue of a perentie was extended to taste the surroundings.

Fortunately I had a camera in my hand when a Chinese ghoral began to make a speedy descent from a cave down a sheer rock face to reach a river in north Sichuan.

Capturing motion within a single still frame is always a challenge, especially when the action is fleeting. Rapid blasts in continuous drive mode interspersed with chimping the LCD is a sure recipe for missing the best sequence ever. Ideally, all the essential camera functions should be instinctive. However, where action is repetitive or prolonged, there will be time to move to the best vantage point, fine-tune the choice of lens, or adjust the ISO.

Each situation needs to be assessed individually and tackled accordingly. A known fixed point, such as a bird's nest, provides opportunities for capturing the interaction between the two mates. Working from a riverbank, a long telephoto lens is useful for taking shots of waterfowl nests—even of large birds such as swans; whereas for an expansive seabird colony, a shorter lens may be more appropriate—provided you approach carefully.

A cliff top, where sea birds are nesting, is a good place to get flight shots because they tend to fly in against the wind to land. Therefore, once the best viewpoint is found, there will be repeated opportunities to capture flight and landing shots.

Getting action shots of large animals such as elephants or polar bears interacting is a matter of luck when shooting from a vehicle. Therefore, when there is a lull, it pays to check the memory card and change it in readiness for the action. A beanbag or a monopod can be used to support the camera from a vehicle, but sometimes it is more flexible to handhold the camera. Most often, these shots will require a long, fast lens; but there are times when a wide-angle lens is the only way to photograph a whale surfacing beside a boat or a flock of large birds lifting off at close range.

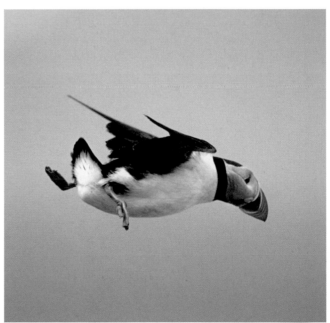

On a windy day in Iceland, all the puffins were hunkered down on the ground until a strong gust plucked a bird off a cliff top. It then hovered in mid-air, hawk-like, making flight shots much easier than in calm weather.

Up the ISO

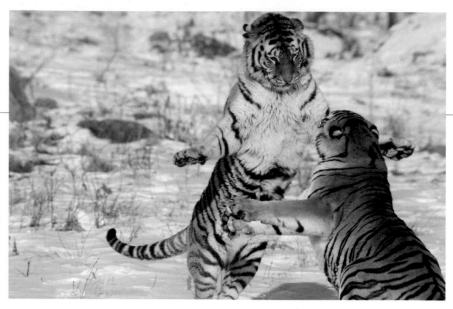

A grabbed shot of Siberian tigers sparring in winter was taken with an ISO of 320 to gain a shutter speed of 1/1000 second. A snow blanket acts like a huge reflector throwing light up from the ground.

The ISO setting on digital cameras measures the light sensitivity of the image sensor. A low ISO number means it will be less sensitive than a high ISO. The ability to increase the ISO—for any frame—in poor light is one of the great advantages of working with digital cameras, although with the first generation of imaging technology it was not practical to push the ISO much above 200 without the risk of intrusive digital noise. Noise becomes apparent when an even-toned area, such as sky or a plain wall, appears with colored, random speckles instead of an even color— most obvious when viewing an image at 100% magnification on a computer screen.

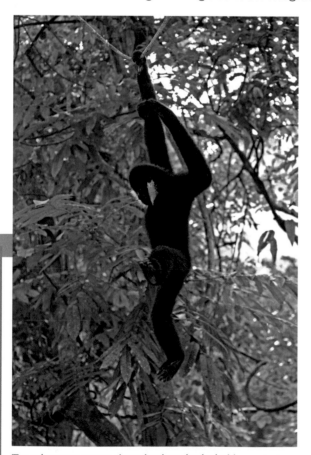

The only way to capture the male white-cheeked gibbon swinging on a liana in a dark rainforest was to increase the ISO to 1000 and to use fill flash to get a sparkle in the dark eyes.

Now, the latest top-end D-SLR cameras have improved image sensors that allow much higher ISO settings before noise becomes discernible. New digital cameras continue to appear with improved specs, so it is difficult to be up-to-date. However, at the time of writing, the flagship cameras for both Nikon and Canon (the Nikon D3S and the Canon EOS-1D Mark IV) both have an ISO range reaching up to 12,800 (and expandable up to 102,400!).

So, in what circumstances would there be a need to increase the ISO? Most often in low light to avoid camera shake, when not using a tripod, or when a faster shutter speed is required. Increasing the ISO to the absolute limit quoted in the specs is not advisable unless you happen to meet a yeti at dusk! The best thing to do is to test a new camera by shooting the same subject against a plain-colored background (preferably using a tripod) at incrementally increasing ISOs (200, 400, 800, 1600, and so on). Then compare two images at a time at 100% magnification on a computer screen. Check the noise and see what is acceptable. To get a sharp shot (rather than one spoiled by camera shake or uncreative blur from a moving animal), selecting a faster shutter speed plus a bit more noise might be the best option, because there are several post-processing software options that reduce noise. Images captured in the RAW format tend to be more malleable in these noise-reduction programs.

tip 74 — Creative Blur

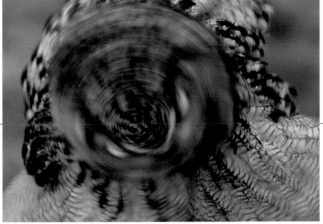

A slow shutter speed was perfect for gaining this swirling impression as a captive-bred young eagle owl shook its head back and forth while ruffling its feathers.

This fox was taken by holding the camera using a shutter speed of 1/60 second and panning it to blur the background as the fox ran. Vertical movements of the animal are blurred, but the head is sharp.

For a completely different approach to freezing movement with a fast shutter speed or flash, try using a slower shutter speed to create blurred motion as an impression of movement. When a mammal emerges from water (or gets soaked by rain), it suddenly and rapidly shakes its head so the surplus water is thrown off. By focusing on an otter swimming at the surface or a snow monkey emerging from a hot pool, it is not too difficult to capture water radiating out from the head.

When a mammal is running or a bird is flying in a line in front of the camera (parallel to the sensor), I follow the animal by moving the camera in the same direction using a shutter speed of 1/30 second—a technique known as panning. For these shots to be successful, you should pan before taking the shot and continue after releasing the shutter. Much of the animal will appear relatively sharp against a streaked background; however, all vertical movement of legs or wings will appear blurred. It takes practice to pan successfully, because the natural instinct is to freeze all movement just before releasing the shutter. Pan the camera either by handholding it, or by using a panning head mounted on a tripod.

In the Pantanal, bats were flying in to grab moths attracted to light. With an exposure of one second, the lower moth trails appear like barbed wire, while a solitary bat with outstretched wings flies through in the center of the frame.

Shoot on the Hoof

Two things have revolutionized the way wildlife is now photographed with a long telephoto lens. First, VR or IS enables slower shutter speeds to be used when handholding before there is risk of camera shake. Second, a new generation of D-SLR cameras appeared with sensors that made it possible to push the ISO without obvious noise (see Tip 73). Being able to change the ISO on the fly makes for a much more fluid way of working, by abandoning a tripod and handholding a long lens for shooting-on-the-hoof occasions.

When driving to a location, it is possible to take a wide selection of lenses plus a solid tripod; but restricted hand baggage allowances on some planes means you have to be selective. I would rather keep my hands on all my gear than have it checked onto some airlines, never to resurface at my destination. This means I take either the 200-400mm f/4 or the 500mm f/4, together with the Nikkor 80-400mm f/4.5-5.6 lens, which weighs 3 lb (1,260 g). Another option for a comparable zoom is the AF-S 70-200mm VR f2.8 with a 2x teleconverter (making it a 140-400mm f/5.6 lens). The focus is faster, but it costs more and weighs in at 4 lb (1,825 g) with the teleconverter.

With a tripod no longer obligatory for working up to 400mm with the 80-400mm lens, I can get action shots that otherwise would have been lost while setting up the tripod. For some scenarios, shedding a tripod is not a sloppy way of working—far from it.

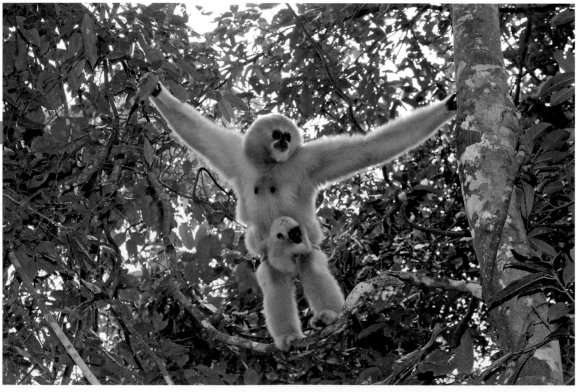

For three days, I followed a gibbon family on foot as they moved through a southern Chinese rainforest. Most of the time they were hidden in the canopy, but sometimes they appeared on an open branch to feed or rest. Even so, working with a tripod was impossible.

Coots frequently fight on water, but this was the first time I witnessed a conflict on ice, where the curious lobed feet are clearly visible.

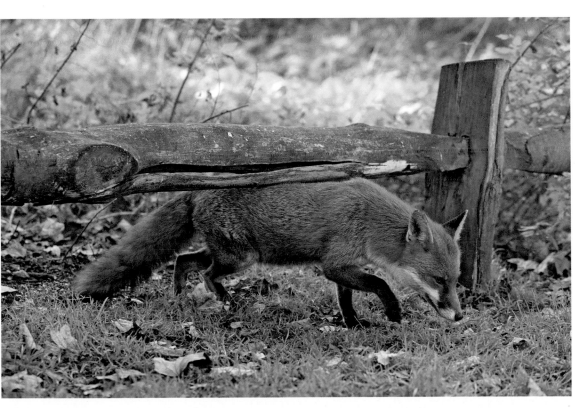

Foxes are creatures of habit, so hanging around a favored location paid off when it squeezed beneath a fence, after picking up food dropped from bird feeders.

Shoot Sequences

Capturing the essence of any action in a single shot can be tricky. There is a better chance of achieving this by switching to continuous shooting mode to capture a sequence of animal behavior. Check beforehand that there is plenty of room left on the memory card and select a fast shutter speed, using either Manual exposure mode or Shutter Priority mode.

Also, do not crop in too tightly when framing the first shot because plenty of room needs to be allowed for the animal to move throughout the frame without risk of cropping out extremities. If using a zoom lens, the focal length should be kept constant and you should try to shoot in constant light, since any variations from the first frame will spoil the look of the sequence. Manual exposure mode can help keep your exposure constant—as metering may inadvertently change between shots when using an autoexposure mode.

There should then be at least one shot that stands out as being better than the other frames. Alternatively, either print a short sequence or load it up onto a website as an animated GIF. Subjects that work well here are animals running or catching its prey, and a whale or dolphin leaping out of the sea. It does not have to be a single animal—it could be a pair interacting or a family of lion cubs crawling back and forth over their parents.

Longer sequences such as plants growing, known as time lapse, are covered in Tip 40.

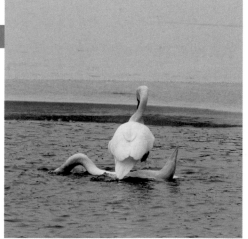
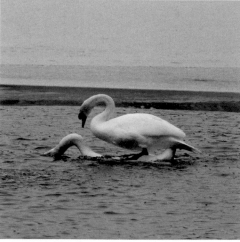
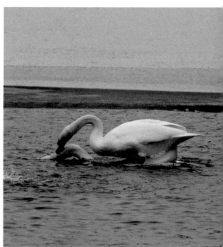

A photo sequence of mute swans mating in mid winter: Once the pen or female swan flattens her body on the surface, the cob or male swan hops onto her back, grabs her neck, and thrusts her bill underwater as he mates with her.

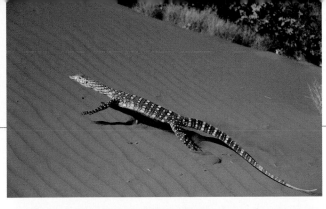

Running up a sand dune to keep up with a perentie in Australia proved hard work, but these two shots show how the legs on one side of the body move away from and toward each other when moving at speed.

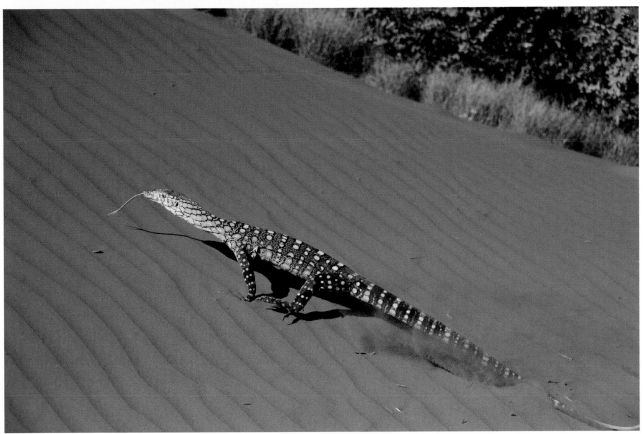

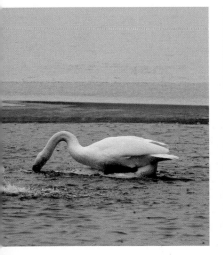

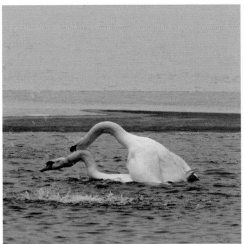

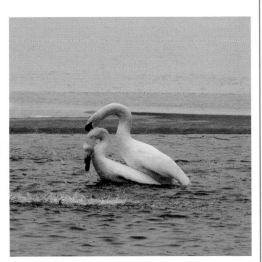

Focus on Plants

If rain falls in winter to trigger the germination of wildflowers, a kaleidoscope of color appears on roadsides in Texas in April, such as these bluebonnets and Indian paintbrush.

After an overnight storm, an ephemeral waterfall plunges through a bamboo forest with ferns carpeting the ground.

Alpine forget-me-not or King of the Alps is a much-prized alpine, taken in the Dolomites with a 20mm lens to show the mountain setting.

Using a macro lens to fill the frame with a flower, a fungus, or an insect is often an easy option. It can often take a lot longer to work out the best way to show any macro subject in its natural habitat to the best advantage. Selecting a wide-angle lens to include as much context as possible is not necessarily the best option. A wide angle works well for a colorful clump of alpines in the foreground with mountain peaks behind, or a fungus surrounded by a forest; but the subject needs to fill a good part of the foreground, otherwise it is overshadowed by mountains or trees. If it is impossible to approach a plant at close range, then a telephoto may be preferable for a plant growing out in a lake or on a branch of a tree high off the ground—although the narrow angle of view will not show so much of the background as a wide angle.

It is an awesome sight when enough rain falls at the right time to trigger the germination of copious annual flowers that paint the landscape in colorful drifts—whether in California for the poppies, Texas for the bluebonnets and paintbrushes, or South Africa for the massed daisies. However, standing on flat ground and shooting across them only shows a sliver of color, which does not do them justice. The solution is to shoot from overhead: Climb a hill or find some other way to look down from a higher viewpoint that overlooks the floriferous slopes.

Plants in flower are perhaps the most obvious subjects to depict within their habitat, but there are plenty of others with scope for graphic images. Try looking at mangroves at low tide when their aerial roots are exposed, backlit cacti in a desert, air plants perched on tree trunks, or early colonizers of lava flows.

Garden Glories

Although a stroll through a garden may not be able to compete with the intrepid experience gained by exploring wilderness areas, expansive landscaped gardens offer stunning vistas at first and last light nonetheless. Look also for a focal point, such as a statue or a water feature within the broader vista. Some of the older, more established botanic gardens may feature tree-lined avenues, but their big attraction for me is the insight they bring to native plants within their particular country. For that reason, whenever I arrive in a country I make a beeline straight for the nearest botanic garden, and often even return at the end of a trip to glean names of plants I photographed in the wild.

A winter garden can still be colorful—here at Kew Gardens the red stems of dogwood add foreground color with autumnal leaves retained on a tree behind.

A backlit willow tree adds foreground interest, and a stormy sky gives background drama, to a massed planting of spring bulbs.

Many private gardens that are open to the public present an opportunity to photograph a wide range of plants in a relatively small area. Some may specialize in particular kinds of plants such as bulbs, spring blossom, or spectacular fall color; elsewhere, herbaceous borders, herb gardens, or knot gardens may be an attractive feature. Sometimes, as an added bonus, gardeners with a sympathetic eye for color harmony create drifts of flowers in soft pastel colors, or maybe a bed of hot yellows, oranges, and reds.

The plethora of flowers grown in gardens attracts a variety of insect pollinators, making ideal macro subjects.

Avoid Typecasting Lenses

We can probably all plead guilty, at some time or other, to buying a lens for a specific purpose or subject and not considering the fact that a lot more mileage could be gained by using it to photograph other subjects as well. Anyone who is at all serious about photographing birds or mammals will invest in a long lens—400 or 500mm—then tend to give it an airing only when birds or mammals are likely to be encountered. Yet, I frequently use both of these lenses to bring larger, otherwise inaccessible blooms closer, whether they are exquisite magnolias, lotus lilies out in a lake, or a large butterfly feeding high off the ground. Long lenses have quite a different perspective from standard and wide-angle lenses, so they provide a welcome change of pace when shooting a photo story of any subject.

A macro zoom is invaluable for taking shots of frogs, reptiles, lizards, and insects—all capable of hopping, crawling, or flying out of frame as you inch your way forward to get a frame-filling shot. A short telephoto zoom can double up to make a useful zoom macro by inserting an extension tube between the lens and the camera—but first be sure to check first that it is safe to use these accessories with your particular lens model.

It was a race against time to set up a tripod with a 500mm lens to get the backlit wild cherry blossom in Japan before the sun set. Once the camera was stable, the light was spot metered through a backlit leaf.

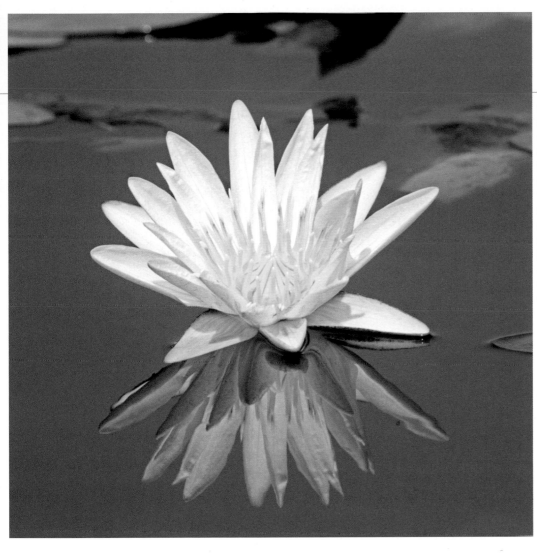

During the dry season in Botswana, game converges on pools to drink, resulting in marginal plants trampled underfoot. This meant wading into a pool with a tripod and pushing the legs firmly into the mud, before returning with a camera and a 500mm f/4 lens to take an intact water lily.

As a colorful swallowtail feeds on a large hibiscus plant some 15 feet (3 m) off the ground, a handheld 80-400mm lens shows how the wings get coated in pollen as the butterfly hovers beside the stamens.

Garden with Care

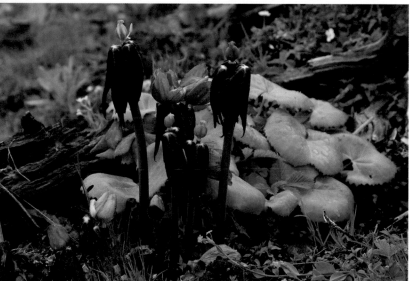

Flowers and new leaves of Himalayan mayapple in Yunnan as found (top) and after the dead dry stems were carefully removed by gardening (bottom).

Before taking a flower close-up, look around and check that it is the best specimen and that insects or birds have not damaged it. Is an important detail hidden by leaf litter or grass? Is the background distracting? Answers to these queries determine the choice of flower and the camera viewpoint. Even then, it may be necessary to remove the odd fallen branch or a leaf or two.

 "Gardening" is recognized by nature photographers as the judicious removal of distracting objects, and it needs to be done in such a subtle way that it is not apparent it has been done at all. Cutting grass at ground level in a complete circle around a plant, for instance, is unnecessary and unnatural.

Purists might argue that the removal of any object within a natural scene is falsifying what was there. Personally, I have no qualms about removing a dead twig or piece of litter that could be blown away by the wind anyway. Using scissors to mow down vegetation is quite another matter. Also, the odd blade of grass that curves in front of a flower can be tucked behind a stem out of shot, while a woody twig can be temporarily tied back with string to a branch.

A coiled fern crozier as found (left) and after fern fronds behind were gently bent out of shot (right). The magnification was increased and and a smaller diameter aperture selected to gain more depth of field.

Because distracting elements can be removed from a digital image in post production, this can make for a sloppy approach to composition. It is far better to get the composition right in the camera than to spend time in front of a computer screen. While it is easy to digitally remove an out-of-focus twig at the corner of the frame against the sky, removing objects from a forest floor takes more skill. In any case, an acorn, pinecone, or leaf of a familiar tree conveys the habitat as well as providing a handy point of reference to indicate scale.

Make Flowers Pop

Photographing a flower so that it stands out from an out-of-focus background makes for an image that is more arresting because it is easy on the eye—unlike a busy shot with criss-crossing stems and grasses, or one cluttered with out-of-focus blobs of color. Certainly, bending down to a flower while holding the camera at a 45° angle makes it virtually impossible to get a whole flower in focus, and also difficult to separate it from the background.

Select an intact flower or flower head growing on its own, slightly separated from leaves or stems behind it. Using a longer macro lens will help here, because the angle of view will be more restricted. Get down on an even level with the flower and select the best camera angle so that the sensor plane is parallel to the main axis of the flower. With the camera on a tripod, focus on the subject and press the depth-of-field preview button to check how much comes into focus. Adjust the aperture to ensure the background is thrown out of focus enough that the flower "pops" out from it. With the aperture set, either manually select the appropriate shutter speed or simply use Aperture Priority mode.

When the sun is beaming on both a plant and the background, a flower can be separated by someone casting a shadow behind it (or, failing that, a coat hung on some branches), as shown by this pair of starry clover images.

Super Tip:

When checking the depth of field, start with the aperture wide open (smallest f/stop) and gradually stop down (increasing the f/stop) while looking through the viewfinder. Then your eye will adapt to the reduced light levels passing through the lens, allowing you to see what comes into focus. Starting with the lens stopped down to a small aperture is akin to walking into a dark cave—nothing will be visible until your eyes have adjusted to the dim light.

A stunning turquoise lake gave a perfect foil for the carmine Rock's aquilegia flower in Sichuan, China.

Steady Wobbly Stems

Who says flower photography is easy? We have all had a time when we gave up after waiting in vain for the wind to abate so a flower would stop wobbling. Fortunately, this problem has all but ceased to exist since I discovered the Plamp—a brilliant accessory for reducing the time for a flower to recover after a gust. Short for **pl**ant cl**amp**, it steadies a plant so its movement is damped right down. Long-stemmed flowers present the greatest problem on windy days, because they pivot back and forth from their base; whereas short-stemmed flowers recover their equilibrium much more quickly.

The larger end of the Plamp is anchored onto a tripod leg or to a pole struck into the ground adjacent to the plant, while the other end—resembling a lobster claw—holds the plant stem. A woody stem presents no problem, but care has to be taken not to damage a sappy one by squashing it in the pincer. Instead, anchor it in one of two holes within the pincer.

By clamping the stem out of shot just below the flower, it soon stops moving when the wind drops, but it won't work miracles in a persistent gale.

145

Focus on Plants

A Plamp was used to steady and hold the fine flowering stem of a climber away from the rest of the plant.

A purple bell vine flower held by the Plamp against a naturalistic backdrop in late evening light.

Super Tip:

Connecting the two ends of the Plamp is a flexible arm, which is moved into position before attaching it to the plant. On no account should you move it after attachment, since it could damage and ruin the specimen.

Use a Windshield

A plant clamp (see Tip 82) is a great asset for steadying a single stem, but impractical for a cluster of flowers. In this case, a windshield is the best solution. A light tent (see Tip 88) can double up as a windshield, especially one with a removable back so the surrounding habitat remains visible.

However, a homemade clear Plexiglas® windshield is even better because there is no loss of light. I get a hardware store to cut pieces to my specifications. The top is a 12 x 12-inch (30 x 30-cm) square, attached to three trapezoidal shapes each measuring 12 inches (top) x 12 inches (side) x 20 inches (bottom)—or 30 x 30 x 50cm. Use either permanent contact cement or see-through cellophane tape to hold the shield together. Remove the tape for transporting the sheets flat. Since Plexiglas® is prone to scratching, the windshield should be wrapped in a soft cloth such as a Domke wrap.

Place the windshield on the ground directly over the plants, with the open side toward the camera. Check that the back wall is clean and the base is covered by leaves or grass. In a light but persistent breeze, it may be possible to remove the back wall to gain the clearest possible view of the background.

For overhead shots of a mass of short-stemmed plants, a different windshield is used—either a topless box or a truncated cone works well. For the latter, I use a rigid cone made from white Plexiglas®, which gives even light all round.

A clear Plexiglas® windshield positioned over a cluster of flowers virtually eliminates movement from wind, and if the side opposite the camera viewpoint is open, the habitat can be seen behind (see Tip 88).

tip 84 — Impressionist Images

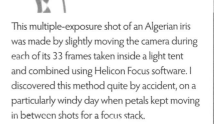

It is possible to create impressionist images either in the camera or afterward using a photo-editing program. Simple blocks of color are ideal for creating a painterly interpretation in the camera by making multiple exposures on a single frame—provided your camera has a multiple-exposure feature. Several Nikon cameras have the option of selecting between two and ten exposures to combine, and automatically setting the gain so that each shot is exposed correctly relative to the others. With a static subject, make very small adjustments to the composition of each exposure, with the camera on a tripod. For large, colorful flowers or trees blown by the wind, the camera needs to be fixed because the moving parts will be slightly out of alignment for each shot.

The light needs to be constant throughout all the exposures; each is underexposed individually but together they build up to the correct exposure on a single frame. If your camera has only a multiple exposure feature without an auto-gain option, meter the scene normally, decide how many shots you want to merge, and then manually dial in the correct negative exposure compensation (see chart).

For cameras without a multiple exposure feature, there is a free Photoshop script (DOP Layer Stack Opacity Blending) which combines separate exposures in CS4 and CS5. Alternatively, use the motion blur filter in Photoshop to create an Impressionist image from a single correctly exposed frame.

This multiple-exposure shot of an Algerian iris was made by slightly moving the camera during each of its 33 frames taken inside a light tent and combined using Helicon Focus software. I discovered this method quite by accident, on a particularly windy day when petals kept moving in between shots for a focus stack.

# of Shots	Exposure compensation
2	-1EV
3	-1.6EV
4	-2EV
5	-2.3EV
6	-2.6EV
7	-2.8EV
8	-3EV

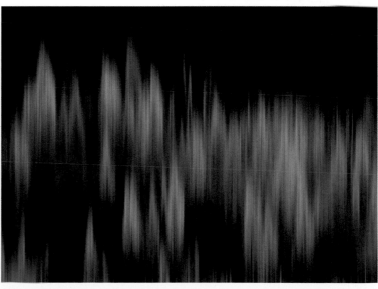

f your digital camera does not have a multiple exposure option, a painterly interpretation of quite simple frames can be made by using the motion blur filter tool in Photoshop. These pink lupines were given a vertical blur using the Filter> Blur>Motion Blur function.

Lighting for Macro

Magic Of Macro

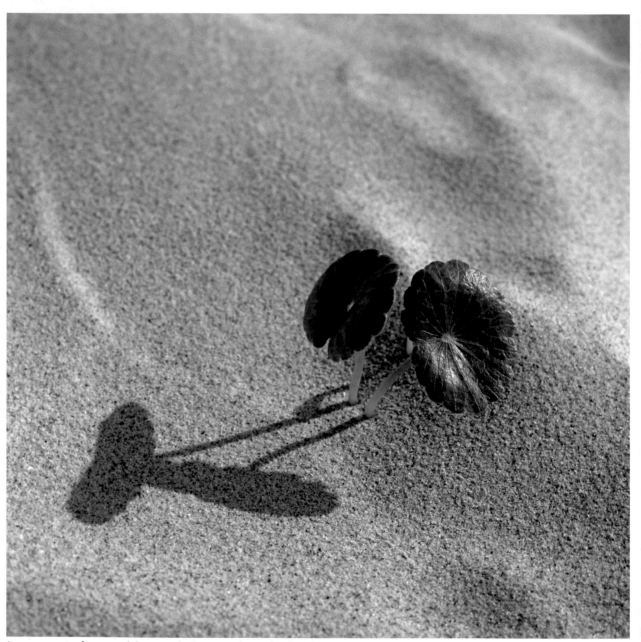

Leaves emerging from a sand dune cast shadows onto the sand early in the morning.

The great thing about macro subjects is that, unlike landscape photography, you have complete control over the light. Unwanted shadows can be filled in using a reflector (see Tip 45) or a fill flash (see Tip 51). If the sun is too harsh, a diffuser can soften it. No macro enthusiast would dream of venturing out without a reflector—whether it be of the small, collapsible circular variety, or simply a card wrapped in aluminum foil.

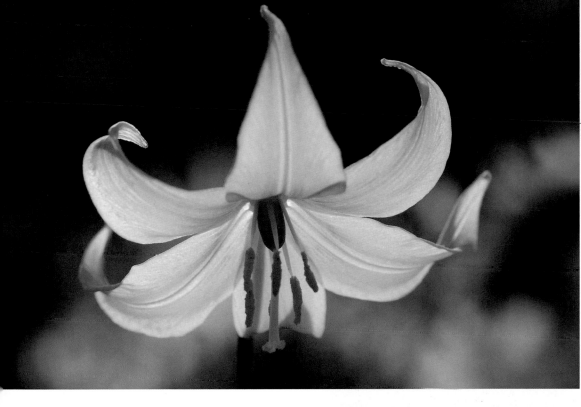

When first seen, this backlit trout lily had a messy background. Using depth-of-field preview, the aperture was opened up to throw the background out of focus, with the petal tips not quite pin sharp.

149

Magic of Macro

For macro shots, reflectors need to be small. Any reflective surface such as a piece of silver card or a handbag mirror can be a makeshift mini reflector, invaluable for filling in shadows. All reflectors have an advantage over flash in that the precise effect is seen before releasing the shutter.

The sun cannot light flowers that hang down, but a reflector can bounce light up into their shadowed center. To find the best angle, place the reflector on the side of the subject opposite to the sun (or skylight) and move it back and forth. A longer focus macro lens, such as 90mm, 105mm, or 200mm, is more convenient when angling a reflector than a 50mm or 60mm macro lens, because they provide a greater working distance between the front of the lens and the subject.

Another easy way to modify the light for macro shots is by using a diffuser. Made of white translucent material, diffusers are held between the sun and the subject to soften harsh shadows on a bright sunny day.

Backlit close-ups are easier to meter than landscapes, especially when the subject fills the frame. I often manually spot meter light beaming through an average-toned leaf.

As a raft spider rests on a pond, the dimpled meniscus formed by the tips of the legs shows up well. Flash was not possible—quite apart from the risk of reflections on the water, it would have spooked the spider. So the tripod was gently maneuvered until the camera was directly overhead.

Depth of Field

Controlling the depth of field is crucial to the success or failure of a macro shot. Focusing the camera with the lens wide open, particularly at close-focusing distances, results in minimal focus along a single, narrow plane. The longer the focal length of a macro lens, the narrower the angle of view, and this can help to isolate the subject from the background.

With macro shots, the depth of field increases equally on each side of the plane of focus. So avoid focusing on the closest edge of a flower, because when the lens is stopped down, it will come into focus both behind and in front of the focal plane (and half of the depth of field will be wasted on empty space). Maximum depth of field is gained by focusing slightly behind the front of the flower.

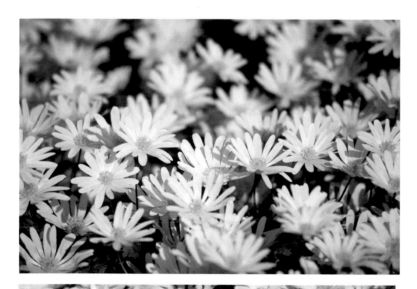

So how do you decide where to focus? This depends on the floral structure— whether it is a flat flower head that lies parallel to the sensor, or a three-dimensional orchid taken at an angle. To bring most of the latter into focus, stop down the lens. This is where learning how to use the depth-of-field preview function is so essential (see Tip 81). To gain optimum depth of field without having to stop down the lens completely, try focus stacking (see Tip 101).

For a more artistic approach to macro photography, shoot wide open so that only a narrow sliver is sharp and everything else appears in soft focus. This is by no means an easy option since the image has to be all the more carefully composed.

Two images of massed white windflowers show that shooting wide open (top) leaves only a narrow strip in focus. By stopping down to f/16 on an f/36 macro lens, virtually all the flowers were brought into focus (bottom).

When taking shots of beached shells, make sure the sensor plane is parallel with the ground, so the whole frame will be in focus without having to stop down too much.

At first sight, these Japanese flag irises and primulas had a cluttered composition (left). By stepping back, using a long lens and a lower camera angle, selectively focusing on the bottom iris, and opening up the aperture, the iris separates well from the diffuse orange/yellow backdrop of primulas (right).

Isolate Shots

One of the secrets of successfully photographing macro subjects that do not fill the frame is to isolate them from their surroundings. This can be achieved in many different ways—by means of color contrast (see Tip 33), selective depth of field (Tip 86), or various lighting techniques (see Tips 85, 88, and 89).

One of the easiest methods is to look for color contrast, such as a red leaf lying on a green moss carpet. Similarly, a red or blue starfish stands out when viewed against rock or coral. Look also for tonal contrast where a sunlit flower appears against a shadow, or even the reverse scenario wherein a silhouetted flower or insect appears against a sunlit backdrop. If you are lucky, you may find a flower or a fungus spotlit by sun on a forest floor.

A blue starfish stands out well when exposed on a flat coral at low tide on a Great Barrier Reef island.

Make a habit of looking at the structure of any macro subject, as this will indicate how best to light it. For example, translucent leaves and petals visibly glow when light shines through them. Backlighting is also brilliant for revealing hairs and spines—especially smaller ones easily overlooked in uniform flat light. Most grass flowers are not particularly showy, so they tend to merge in with other green plants. However, early and late in the day, when the sun is low in the sky and the shadows are long, look out for taller grasses spot lit by side light against a background in shadow.

The longer the focal length of a macro lens, the narrower the angle of view, which can help to eliminate distracting tones or colors on either side of the subject and thereby help to isolate it from the background.

Backlighting enhances flowers and leaves by producing colors that visibly glow, like these dawn redwood leaves in autumn.

tip
88

Light Tents

A light tent is a brilliant way of solving three problems all at once: wind, strong shadows, and reflections from shiny surfaces. Several models are available, and the one that I use in my own garden and when travelling by car is the Cubelite, made by Lastolite. It is made from the same white, translucent material used in their diffusers, and there is a vertical slit in one side for inserting the lens. Ideal for shiny fruits as well as shells such as cowries, the Cubelite is also useful for shooting potted plants and cut flowers—when I want soft, even, all-round light with a complementary, uniform background behind the flowers. Artists' board or foam core makes for a convenient backdrop, and has the advantage over paper because it will not crease.

The highly polished cowry shell shows how easily it reflects light (top). But when a white translucent Plexiglas® cone is placed over it, all the reflections disappear (bottom).

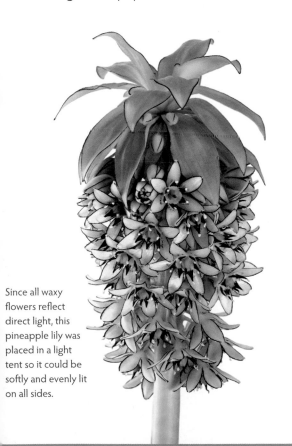

Since all waxy flowers reflect direct light, this pineapple lily was placed in a light tent so it could be softly and evenly lit on all sides.

After I tried out the first generation of Cubelites, I suggested they would be much more versatile if they had an optional removable back (for showing the habitat behind the plant), and also a removable base so the tent could be lowered over a plant in the ground. I now use later versions with a square in the back and the bottom fixed in place with Velcro strips for easy removal.

To produce a homemade light tent, stretch fine white cotton material over the top and sides of a wire cube frame with a slit in one side for the lens. Cylindrical light tents for suspending over a subject are easier and lighter to take on a plane, but you will need to find a branch from which to suspend it.

Macro Flash

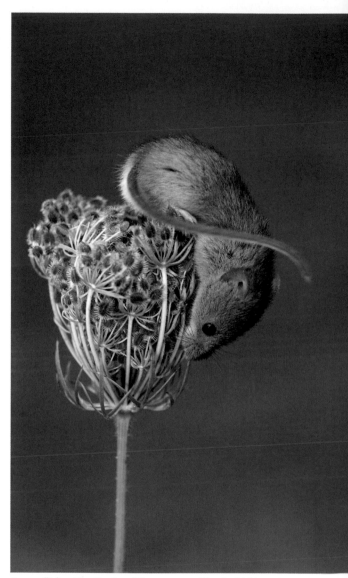

A speedlight with a Sto-Fen diffuser was used for the highly active minute harvest mouse as it climbed down a seeding umbel.

Some people never touch flash, erroneously believing it will always give a black backdrop. This will not occur if the subject fills the frame, or when the flash output is reduced to only fill in shadows. Flash can be a creative means of lighting macro shots, and for active insects in poor light it allows greater depth of field by boosting the light.

Direct flash from a speedlight can cause harsh shadows. Gain a softer light by fitting a Sto-Fen diffuser or one of several small softboxes suitable for macro work. I use the Honl Photo Traveller 8 Software (see Tip 51) for taking plant macros, as it is lightweight and folds away flat. The white circular diffusion screen may, however, cause an insect to take flight.

The cheapest twin-flash setup for handheld macro shots is a simple flash bracket holding two flash units on either side of the camera. But for real macro enthusiasts there is nothing to beat the Nikon R1C1 Commander Kit (part of Nikon's Creative Lighting System) with a wireless Commander unit that connects to the intelligent TTL (i-TTL) control, and communicates with two small wireless speedlights mounted on a ring around the lens. The setup is lightweight, easy to handhold, and eschews dangling cables. Infinitely variable lighting setups are possible, with the option of using further flash units in three groups and up to four radio channels.

In low light, if a flash is used as a fill for photographing a moving insect or a flower blowing in the wind with a slow shutter speed, two images can appear: a sharp one lit by the flash, and a ghostly one as the subject moved during the long exposure. A shutter speed of 1/250 second will cure this problem—even if the ISO has to be increased.

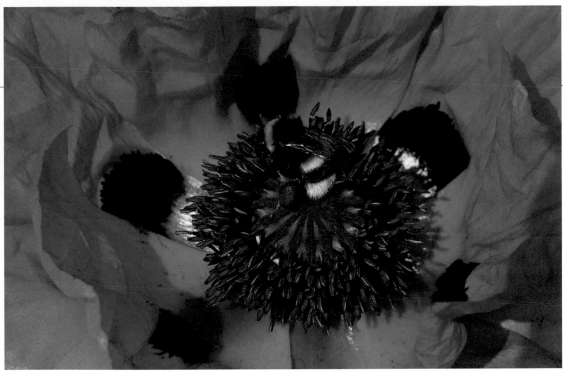

Fill flash was used to bring out the detail of the plum-hued pollen load on a bumblebee foraging in an Oriental poppy.

The circular particle-filled Pod, with a built-in 1/4-inch camera screw on top, is designed to mount a camera, but it also doubles up as a support for an off-camera flash.

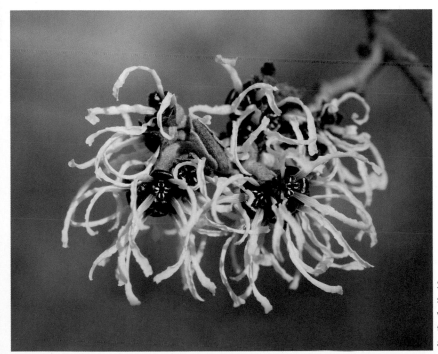

Sometimes the use of a flash softbox is quite subtle; with these witch hazel flowers it has lit up the dark centers to show the arrangement of the tiny stamens.

Enhance Textures

A simple use of natural, grazed lighting in winter shows vertical lines of green moss spotlit by low sun, casting obvious shadows on a slate roof.

Textures abound in the natural world, where they appear as either irregular formations or repeating patterns. They can exist on a large scale as eroded rock canyons, travertine terraces, dried cracked mud, ripples on a sandy beach, or as the cooled and hardened crust of pahoehoe (rope lava) in Hawaii and the Galápagos. On a smaller scale in the plant world, textures occur on the bark of trees, on buds, fruits, newly opened leaves, cactus pads, palm fronds, and encrusting lichens. Animal textures include bird feathers and the scaly skin of reptiles—as well as starfish, brittle stars, and sea urchins in the marine world.

Gardens are a good place to search for inanimate textures such as cobbled paths and courtyards, flintstone walls, or slates used to create a fountain. Remember that shadows convey a sense of depth to any texture. Light (natural or flash) grazing across the surface can help to enhance these shadows. This is akin to a miniature mountain landscape, lit by first or last light with the spotlit peaks distinguished from the valleys in deep shadow.

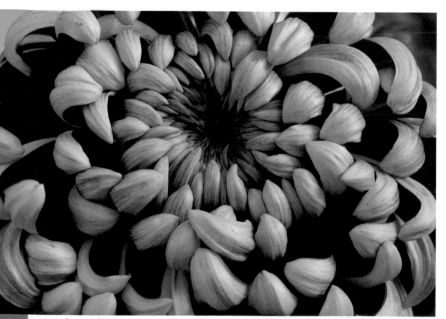

Where a repetitive textured surface lies in a single plane, position the camera so that the sensor is parallel with the surface in order to gain maximum depth of field across the whole frame—preferably using a tripod. This, together with stopping down the lens, should eliminate any distracting out-of-focus areas. For texture shots to have impact, they do need to be tack sharp.

Even when summer has long since faded, with flowers having already bloomed and set seed, there are still plenty of textures around. Look for cones on the ground, large leaves crumpled after a frost, or sunlight dancing on pebbles in a shallow stream.

Many forms of chrysanthemum flowers have been bred in China. Here the enrolled petals, contrasted with the deep red inside, enhance the textured effect.

tip
91

Shoot Through Water

A zoom macro lens (70-180mm) is ideal for working on a rocky shore where access to some parts can be tricky. An off-camera flash avoids unwanted reflections when shooting through water.

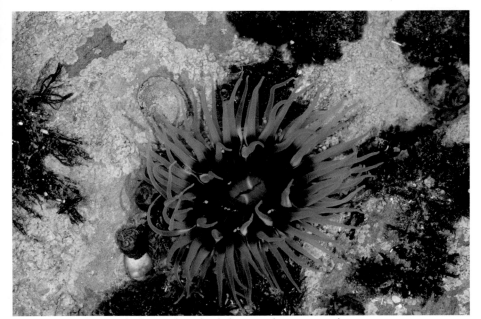

A sea anemone photographed in a rock pool with the setup shown at top right..

When exposed at low tide, rock pool inhabitants such as sea anemones, prawns, and fish become visible for a brief time, often lurking under cover of seaweeds. By walking around the pool, there may be an angle at which it is possible to photograph the pool so that the milky skylight reflection disappears and the natural colors of the underwater life are revealed.

Additionally, as every fly fisher knows, wearing Polaroid sunglasses helps to clear skylight reflections on the surface and spot where fish are resting. A polarizing filter aids photography through water in the same way, and gives the best results at an angle of 37 degrees to the water's surface. The only disadvantage of using a polarizer is that it cuts down the amount of light reaching the sensor; with full polarization, this can be up to 1.7 stops. On a sunlit day this is not too critical, but on an overcast one the ISO may need to be increased.

Using a flash will help to boost the light, but to ensure a flash mounted on the camera does not reflect off the surface and back into the lens, either shoot at an angle to the water surface rather than straight overhead, or mount the camera on a tripod and use the flash off-camera. The same technique can be used to photograph life in touch pools at public aquaria (check that flash is allowed first), or submerged vegetation and fish in garden ponds.

Persistent ripples on the surface can also be a problem, but placing a floating frame on the water surface will keep the interior of the frame still. Wear a headlamp at night to reveal how pools come to life: Newts emerge in garden ponds, and increased activity takes place within rock pools under cover of darkness.

Although not a macro shot, grabbing fleeting natural light as the sun lit up a layer of green blanket weed in a lake, just as a shoal of rudd swam past, is relevant here.

Natural Designs

The leaves of many tropical creepers and ground cover plants exhibit striking patterns with contrasting lines or patches.

A fun aspect of working within the macro realm of the natural world is discovering a myriad of designs, all derived from four basic patterns: circles, spirals, polygons, and bilateral symmetry.

Many flowers such as sunflowers, gerberas, and dahlias have a design based on a circle, as do citrus and other fruits, sea anemones, jellyfish, and starfish. There is always a dilemma of how best to frame a circular subject within a rectangular frame: Should you include more background in the long axis, or crop part of the subject to exclude all traces of the background? A square crop is ideal since it can include the entire subject without too much extraneous background.

The exquisite, hexagonal, waxy cells of a honeybee comb show a repetitive packing pattern, as do the tops of basalt columns and the seeds in a maize cob. Larger-than-life magnification sizes (greater than 1:1) are necessary to reveal how the scales on butterfly and moth wings overlap like tiles on a roof.

As seeds develop inside pits in a lotus lily fruit, they form a distinct packing pattern.

The best time to photograph a tightly coiled tail of a chameleon is when it is resting at night.

The feeding track of a snail appeared after it had rasped a green algal film, formed on the glass inside a tropical glasshouse.

The spiral is an elegant shape found in the coiled shells of land and marine snails, and also in fossil ammonites. Some male sheep carry impressive curled horns, while more ephemeral spirals are spun by orb web spiders. Animals with a long, pliable appendage, such as an elephant's trunk or a chameleon's tail, roll it up into a spiral when not in use. In the plant world, there are twining tendrils, the stems of climbers, and the unfurling fern croziers.

Post-Shooting Tasks

After a Shoot

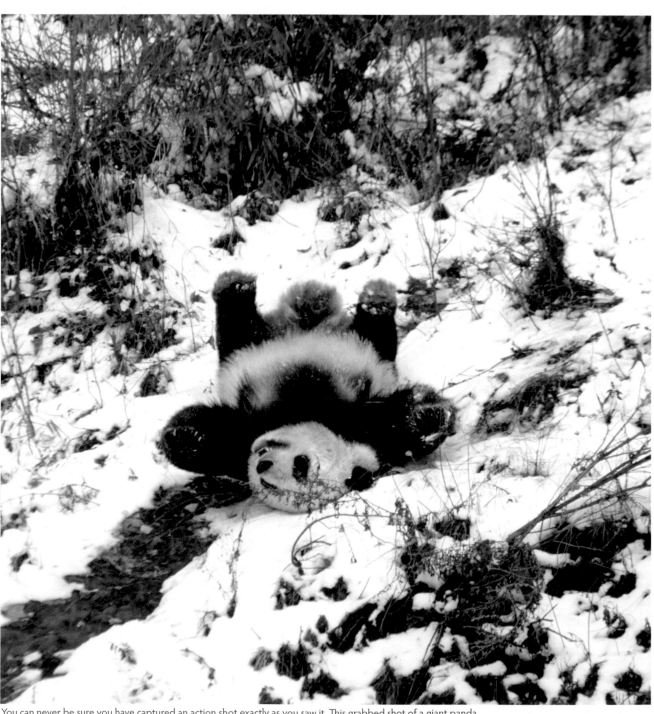

You can never be sure you have captured an action shot exactly as you saw it. This grabbed shot of a giant panda that lost its balance and slid down a snowy slope, is one such surprising shot.

This freak shot of flames forming the shape of a leaping tiger, taken (appropriately) in India, was a complete surprise, seen only after downloading the images.

Shooting new images is the fun part and it is all too easy to feel euphoric after a day's shoot has gone well, with superb lighting and great subjects. However, avoid spending too much time savoring images before essential jobs are done to ensure the following day's shoot goes without any glitches.

While images are being downloaded and backed up, and batteries are being charged for cameras and flash units, write up notes on the day's shoot. Browsing through the images on each memory card, I list the card number with the subjects in the order in which they were taken, so that any shot can be quickly located. Maps are poured over to check with my guide on the spelling of place names and the elevation of mountains. Additional notes may mention extreme weather and distinctive smells or sounds, which help to paint a richer picture of a scene when I write about a place later. If not done on a daily basis, it is difficult to sort it out at the end of the trip.

Then all the lenses need to be cleaned, if necessary. If it has been a wet day, all the gear needs to be removed from the photo backpack and laid out to dry. Zoom lenses are especially prone to moisture creeping inside and they may need drying out with a hair drier. Last, but by no means least, the camera sensor has to be checked for dust and cleaned if necessary (see Tip 95).

If power sockets are limited, the camera and flash batteries are fully charged first, before putting my cell phone and downloader on to charge overnight.

Back Up Files

The most crucial aspect of working with digital cameras is to back up files while on location and then again back at base. If done religiously, irreplaceable images will not be lost. On location each evening, I download the used memory cards onto a small portable hard-drive. Currently I use a 120GB Jobo Giga Vu Sonic, which is big enough for most trips and, if fully charged, usually lasts the whole trip. I prefer this model because it has the facility for viewing images; this way I can show a guide or a ranger a decent sized image of a plant or animal for which I need an ID or further information.

After you've transferred the images to a hard drive, do not proceed to wipe the cards, because you have simply transferred the files without performing any backup! I am amazed how many people I meet do just this. As the capacity of memory cards increases and the price falls, it is not difficult to take enough cards to last a trip.

When you invest time and money in a long-distance trip, it pays to have a foolproof, belt-and-braces system for backing up your images. I have heard horrendous stories of visitors to Far Eastern countries who handed their cards over for copying to a CD, and proceeded to wipe the cards only to find they had blank CDs when they got home! If you run short, either buy more cards or delete second-best frames—with judicious care. If you have been shooting the same subjects over several days, there will always be some frames that aren't as good as others.

The 120GB Jobo Giga Vu Sonic downloader is a convenient way to backup on location. It has a download speed of up to 1GB of data in 30 seconds. Here, a single image fills the monitor.

Thirty square thumbnails are displayed on the monitor of the Jobo Giga Vu Sonic downloader.

95

Keep Sensors Clean

A Camera Bivvy is a lightweight tent that is a cross between a pop-up light tent and a film-changing bag. It minimizes dust contamination when changing lenses in dusty locations. After putting gear inside, the tent is sealed. Access is then granted via two elastic armholes with a clear window on one side for easy viewing.

The Giottos rocket-shaped blower produces a powerful stream of air for blowing dust from lenses, cameras, or sensors. Made of a non-toxic material, it is resistant to both high and low temperatures.

When changing lenses repeatedly on any D-SLR, you increase the risk of dust building up on the sensor. Dust spots are not difficult to remove in post production from plain-toned areas such as sky, but it takes skill and time to remove from more fine-textured areas. To reduce the risk of dust entering the camera, before changing a lens, switch off the camera and hold it upside down. Better still, use two camera bodies, each fitted with different, complimentary lenses.

Many D-SLR cameras now have built-in sensor cleaning technology, which vibrates the low-pass filter placed in front of the sensor and shifts fine dust particles without eliminating them. However, it will not remove marks caused by moisture.

To check if there is dust on the sensor, photograph the sky (by manually focusing to infinity). Either download to view the image on a computer or view it on the camera monitor by using the magnify button (remember the image on the sensor is flipped 180 degrees vertically). If not within easy reach of a dealer or shop with skilled technicians, learn how to remove dust yourself in a dust-free environment. **Caution:** Never use a compressed air can because the nozzle may fly off and damage the sensor. You will need a Rocket blower brush, a magnifying glass to inspect the sensor, and Sensor Swabs™ and Eclipse™ optical cleaning solution. Remove the lens and activate your camera's mirror lock-up function (ensuring that the battery is fully charged so there is no risk the mirror will slap down mid-cleaning).

To remove larger particles, hold the camera upside down and use the Rocket brush—ensuring it does not touch the low-pass filter. View the sensor again. If dust is still present, lay the camera on a clean surface, using the magnifier to view the dust. Put two drops of cleaning liquid on the swab and gently wipe the low pass filter. Take great care not to spill any liquid over the filter edges.

Digital Workflow

CHIN_1498Z_MAM.NEF

The Review Mode in Bridge CS4 and later versions is a quick, visual way to browse and edit multiple similar images. Just select the thumbnails and press Ctrl/Cmd + B on the keyboard to launch an uncluttered carousel viewing platform. Use the left and right arrow keys to scroll through images. Press the down arrow to drop one out of the selection. When finished, either add to a collection or press the Esc key to exit and the remaining thumbnails will be highlighted, ready for tagging or opening in Photoshop.

Capturing images is the easy part. To get the highest quality out of digital images, and to be able to retrieve them speedily, a systematic workflow needs to be developed. I shoot in RAW on Nikon D-SLR cameras. These give me lossless high-quality images to which I can make any necessary adjustments in Adobe Camera Raw. If you need JPEGs in a hurry, you can always shoot RAW + JPEG.

A speedy way to make adjustments to multiple RAW files, all shot in the same light, is to select the thumbnails in Bridge and click Ctrl/Cmd + R to open in Adobe Camera Raw. Select the top image on the left-hand side and make adjustments. Then click on the Select All button on the left, and press Synchronize to apply the same changes to all the images. Alternatively, press Select All first and then apply the same corrections throughout.

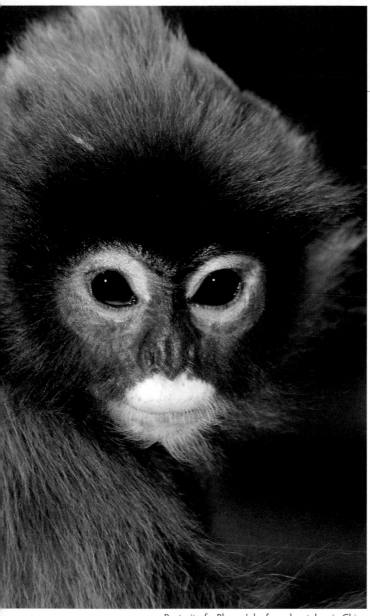

Portrait of a Phayre's leaf monkey taken in China.

A screen grab of a metadata page in CS4 shows the image title, relevant keywords, and copyright notices for the Phayre's leaf monkey.

Typical Workflow:

>•>Download images from memory cards to either a portable hard drive or directly to a computer. All cards are numbered and used in numerical order, so that the locations and names of plants and animals will correspond with notes in my field notebook.

>•>A new folder is created for each card, with the date, location, and subject.

>•>When more than one card is used on the same date, they are sequentially numbered after the date. (e.g., [10_09_19 1 Yunnan Flowers] is the first of several folders of Yunnan flowers taken on September 19, 2010.)

>•>All images are backed up on an external hard drive.

>•>Image folders are opened in Adobe Bridge. "No-hopers" (subpar images) are deleted; the best images are labeled red, while runners-up are labeled green.

>•>Best images are opened in Adobe Camera Raw with the clipping paths switched on for adjustment to exposure, color temperature, and contrast as necessary.

>•>Each image is opened in Photoshop for post production (see Tip 97), and then saved as TIFF file with a unique alpha-numeric prefix. For instance, all mammals start with MAM_, and all wild flowers with FL_.

>•>The original RAW file is given the same ID as the TIFF.

>•>Images are upsized to 54MB using Genuine Fractals as a Photoshop plug-in—the industry standard for upsizing.

>•>Metadata is added: copyright, image title, and relevant keywords.

>•>Processed TIFFs are backed up on an external hard drive.

Post Production

Once the necessary corrections have been made to a RAW file, there may be some additional retouching work to do in Photoshop. If the horizontals appear unintentionally angled, use the Crop Tool to straighten them. If necessary, use the Filter>Lens Correction tool to correct converging verticals. Branches, power lines, or jet trails are easy to remove from the sky, but other objects on the ground can take a lot longer and sometimes it will be quicker to just crop them out. If any further corrections are required, work in 16-bit mode so that you're dealing with the maximum information possible. This will double the file size, but after all the retouching is complete, save another copy at 8-bit for printing.

Sometimes it is useful to increase the sky or ground area to provide a larger area of negative space for overprinting. First increase the canvas size, then copy sections of the existing sky and ground and save as two separate files. With textured areas, invert these strips (to avoid repetition of obvious marks) before copying and dropping into the blank areas. Check the whole image at 100% for dust. The Healing Brush Tool will remove obvious dust spots (although at the interface of two tones or colors, use the Clone Stamp Tool). If there are many small spots, it is quicker to use the Spot Healing Brush Tool. Once a uniform area is cleaned, the Patch Tool will speedily clear up the rest of a same-toned area.

Using a Photoshop Action I have already set up, European page-sized JPEGs are automatically created from the TIFF file, archived for later emails (especially for book reviews), and then uploaded to my commercial website: www.naturalvisions.co.uk

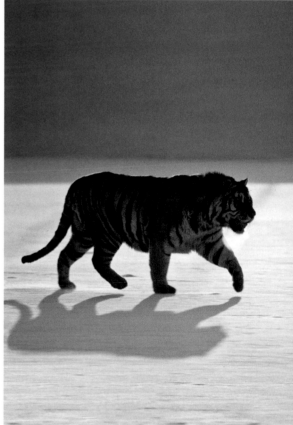

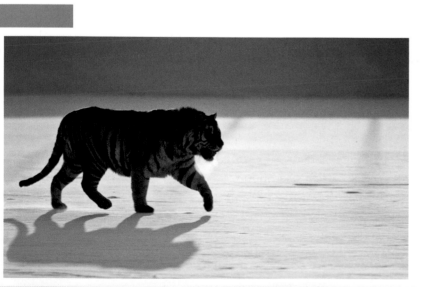

When a Siberian tiger walked over a frozen lake with its shadow cast in front of the body, the best shot was tightly cropped (left). Extending the top and bottom of the frame gave more negative space for overprinting before the image was cropped to a vertical format (above).

tip
98

Recover Highlights

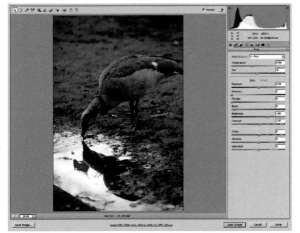

This screen grab of Adobe Camera Raw shows highlights clipped on the water (red area) where a goose is drinking from a puddle. These were removed by moving the Recovery slider to the right.

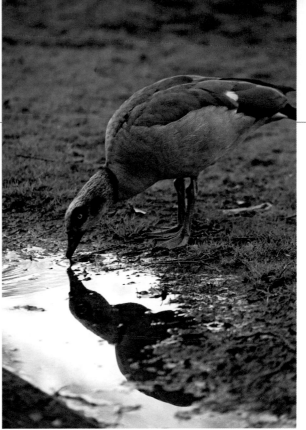

Final image after selective lightening of shadow areas on the goose and grass in Shadows/Highlights, and with the white stone in the background removed.

167

There is more than one way to fix problematic highlights. Expansive areas in landscapes can be pulled back using a graduated filter (see Tip 18), or a series of bracketed exposures can be taken for combining in HDR (see Tip 99). Both of these options need to be decided at the time of shooting, but there are other ways for toning down highlighted areas during post production.

By shooting RAW files, some detail in blown highlights can be recovered by moving the Exposure slider in the RAW converter with the highlight-clipping warning switched on. After saving the file as a TIFF, check for any improvements in each of the RGB channels. A speedy way to make slight adjustments to the dynamic range is to use the Shadow/Highlight tool to lighten shadows or darken highlights (or both) via Image>Adjustments>Shadow/Highlight. Tone down bright skies or light on wet rocks or a beach using the Gradient Tool. First, go to Select>Edit in Quick Mask Mode, select the Gradient tool, then select the half gray/white square in the Gradient Editor toolbar. Now draw in the gradient from any corner or side of the image, and press Q to define the Quick Mask area. If this is outside the required area, select Inverse, and then use levels or curves to selectively adjust highlights and shadows, color, or saturation.

When taking a shot in a forest looking up toward the canopy, bright patches of sky highlights often spoil the background of an otherwise perfectly exposed plant or animal. No graduated filter can cure this, and the only way round it is in post production. I use the Clone Stamp (at around 50%) to clone from colored parts of the canopy (vary this so it does not produce a uniform colored wash). Finally, I use the Patch tool to soften the edges where the color changes. This also helps to add the same degree of noise to the cloned area as the rest of the image. It is a very speedy and effective way of toning down smaller highlights with which any filter, whether on the camera or in post production, cannot cope.

High Dynamic Range Blending

When it is not possible to reduce the dynamic range of a scene by using a neutral density filter (see Tip 48), it is well worth shooting a series of exposures for High Dynamic Range (HDR) blending. The human eye can see a much wider range of details in shadows and highlights than an imaging sensor, but this technique (another benefit of shooting digital) allows for a greater range of tonal detail than is possible to capture in a single image. Using either Photomatix Pro HDR software or the Merge to HDR feature in CS4 extended or higher versions of Photoshop, a series of bracketed exposures can be blended into a single image embracing all the tonal detail captured throughout the series of multiple images.

This technique is particularly appropriate for capturing the dynamic range in a wide scenic shot early or late in the day. The example here is from the New Forest in Hampshire—now an ancient forest, but created in 1079 by King William 1 as a royal deer hunting preserve. During stormy weather, ancient trees often shed branches. Indeed, a large, moss-covered branch caught my eye and, as I looked up the bank, there was the beech tree from where it had fallen, with bright patches of the sky shining through the canopy. Using a tripod, I exposed a first image for the mid-tones and then, by manually adjusting the shutter speed, took subsequent shots on either side of that first exposure to capture the highlights and shadows.

After converting the RAW files to TIFFs, 8-bit images were blended using Photomatix Pro with exposure fusion, which tonemaps a 32-bit TIFF down to 16-bit or 8-bit to allow for further editing in Photoshop, or output to print. Slight adjustments were then made to the Shadows and Highlights to create the final image.

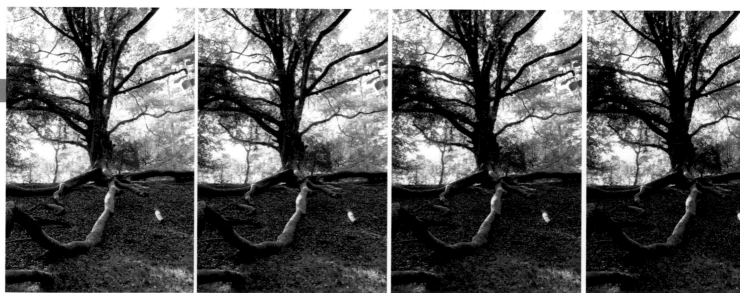

Six original shots of an ancient beech trees with a fallen branch cover the dynamic range from the foreground area, largely in shade, to the backlit trees behind.

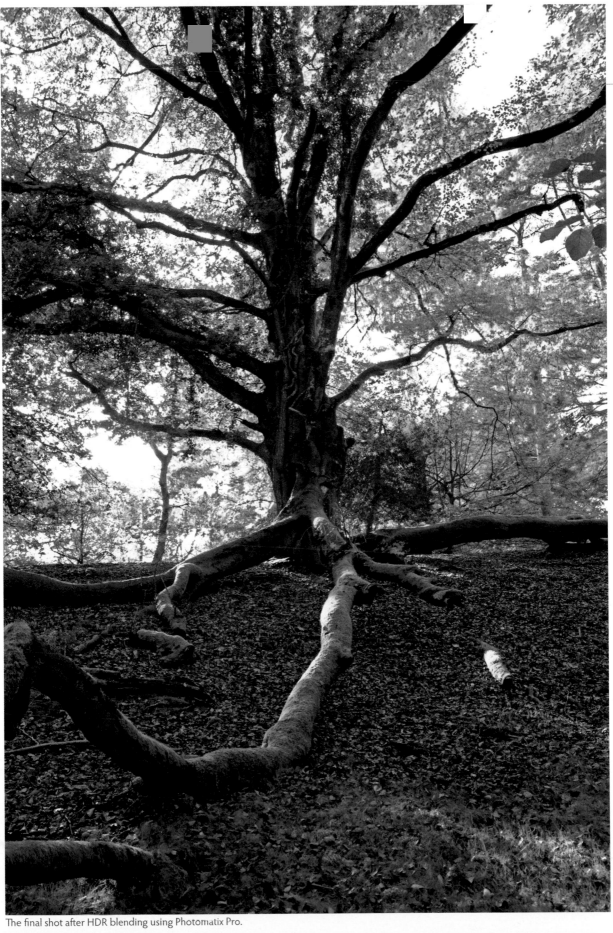

The final shot after HDR blending using Photomatix Pro.

Stitched Panoramas

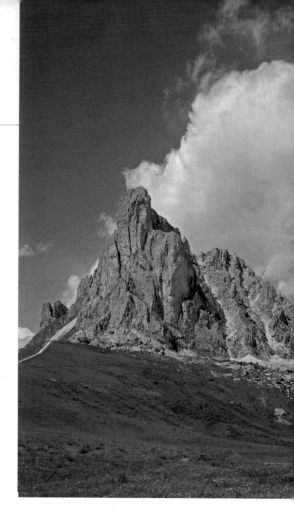

Not many years ago, photographic panoramas were possible only if you had access to a panoramic camera. Now, anyone with a digital camera—and preferably a tripod—can shoot multiple images and join them together to make a stitched panorama. Like any landscape, they will be more striking if the sky is dramatically lit, although the lighting needs to be consistent throughout the exposure sequence. The most important points to remember are that each image must overlap the previous one (25 – 30% for a telephoto lens and 30 – 50% for a wide-angle lens), and that the axis of the camera needs to be kept as straight as possible.

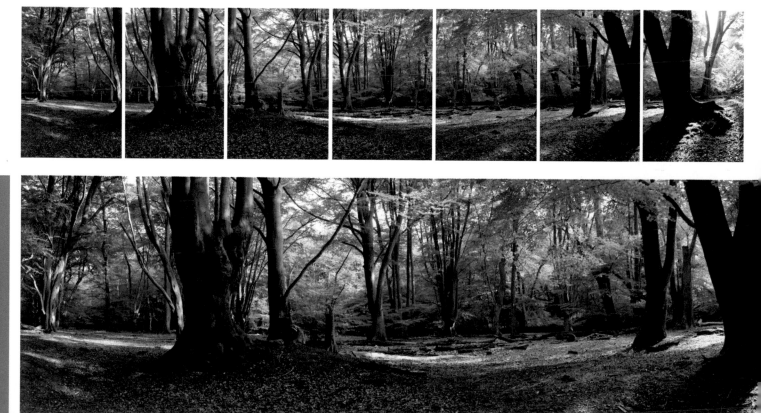

The seven original vertical images (above), taken within Epping Forest in summer, were stitched together to make this final panorama (below).

Summer panorama of Italian Dolomites made by stitching together twelve original vertical images using Photomerge in Photoshop CS4.

A stitched panorama can be achieved by handholding the camera, but more consistent results will be gained by using a tripod and, if possible, a panoramic head—or at least a ball-and-socket head that can be panned. It is best to pan the camera back and forth while looking through the viewfinder beforehand, to ensure that the position of the horizon remains fairly constant. Otherwise, if the horizon drifts up or down, the top and bottom of the final image will need to be cropped, resulting in a panorama with little depth.

For best results, use a panoramic head such as the Nodal Ninja. This allows the center point of rotation to be set at the nodal point, which is usually at the rear lens element. It prevents alignment errors on foreground elements.

Selected images are merged together using File>Automate>Photomerge>Auto Blend in Photoshop. The result is a much bigger file than a single frame and a much wider angle of view than is possible from a single wide-angle lens.

The angle of view and the number of exposures can be as varied as you wish, although half a dozen is a good starting point when shooting in a horizontal format. More are needed when using a vertical format, which adds height to the panorama.

Focus Stacking

This is a great technique for increasing the depth of field for three-dimensional macro shots when it is otherwise impossible to get the whole subject completely in focus. Essentially, the software blends a sequence of several digital images, each focused on different planes, to create a single image with significantly increased depth of field. The most popular software programs used for stacking images are Helicon Focus and CombineZM.

Not all subjects are suitable for focus stacking. The essential criteria are a static subject, constant lighting, a fixed aperture, and a fixed magnification. To gain the optimum aperture for the sharpest possible image with any lens, open up several stops from the smallest aperture.

Even though it is possible to get results by handholding the camera, the quality is improved by using a tripod and keeping the camera angle constant. It is possible to take a series by refocusing slightly farther back for each image, but I prefer to keep the focus constant and to move the camera itself forward, mounted on a macro-focusing slide rail. It is possible to achieve a focus stack with just three images, but more will give better quality; it really depends on the magnification and the depth of field. I prefer to use a minimum of 12, and often double that.

Focus stacking also makes it possible to work in low light levels when only a limited depth of field is possible for single shots.

A final stacked shot of a hellebore flower showing the floral parts made from 21 images taken inside a light tent with a black backdrop.

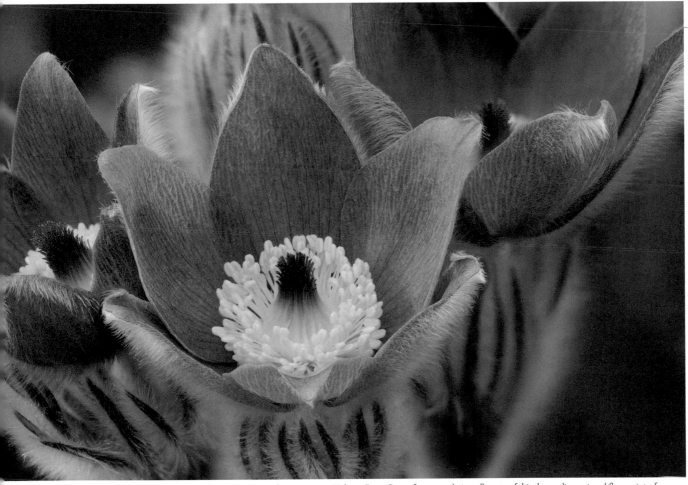

The final image of the pasque flower, made after combining 25 original images using Helicon Focus Pro software, to bring all parts of this three-dimensional flower into focus.

The first and last image of a pasque flower in a sequence of 25 frames taken using a macro focusing rail to advance the camera from the front to the back of the flower.

Resources ————————●

All these links worked at the time of going to press; but if any fail to link, use a search engine.

Adobe Photoshop
http://www.adobe.com

Benbo tripods
http://www.patersonphotographic.com/benbo-tripods.htm http://www.bhphotovideo.com, search "Benbo tripods"

BreezeSystems
Breeze software to download, browse, select, organize and post process images, create web galleries.
http://www.breezesys.com

Cascade Designs
Packtowl® absorbent towels, KodiakTM window dry bags, Platypus® hands-free hydration
http://cascadedesigns.com

Cotton®Carrier System
http://buy.cottoncarrier.com

Dietmar Nill Tripod Head
http://www.dietmar-nill.de (in German) http://www.dietmar-nill.de/english (in English)

Ewa®-marine
Rain capes for cameras
http://www.ewa-marine.com http://www.rtsphoto.com/html/ewamar.html (US dealers)

Giottos
Cleaning kits, filters and protectors
http://www.giottos.com http://www.giottosusa.com/

Gitzo
Tripods, monopods and heads
http://www.gitzo.com http://www.gitzo.us/

HelioconSoft
Helicon Focus - image stacking software
http://www.heliconsoft.com

Honl
Produce softbox, grid and snoots for flashes
http://www.honlphoto.com

Jobo
Portable digital storage
http://www.jobo.com
http://www.omegabrandess.com (official US dealer)

Kirk Enterprises
Camera mounts (Window Mount and Low Pod Mount or the Skimmer Pod 11), flash brackets and Flash X-Tender
http://www.kirkphoto.com

Lastolite Limited
Manufacture lighting control systems – reflectors, diffusers, soft boxes
http://www.lastolite.com http://www.lastolite.us/

Lee Filters
High quality filters and filter holders
http://www.leefilters.com

Leonard Rue Enterprises
Blinds, tele-flash systems and gear for outdoor photography
http://www.rue.com

Litepanels
Scaled down versions of film lighting systems use eco-friendly LED lights.
http://www.litepanels.com/home.html

Manfrotto
Tripods and super clamps
http://www.manfrotto.com http://www.manfrotto.us/

Morco Ltd
Camera Bivvy
http://www.morcophoto.co.uk

Nikon
Cameras, lenses, speedlights and macro flash units
http://www.nikon.com

Packtowl®
Absorbent towels
http://cascadedesigns.com/msr/camp-towels/packtowl-original/product

PocketWizard
Wireless Triggering Systems
http://www.pocketwizard.com

Power Traveller
Manufacture portable power chargers and solar chargers for mobile and cell phones, iPods, PDAs, laptops, netbooks and more devices.
https://powertraveller.com

Really Right Stuff
Camera support experts in quick release equipment and tripod heads.
http://reallyrightstuff.com

Scottevest
Travel Vest
http://www.scottevest.com

Seculine Action Level
http://secu-line.com http://www.interfitphotographic.com/SeculineUSA/Seculine%20index.htm

Sto-Fen
Bounce flash specialists
http://www.stofen.com

Stroboframe
Flash Brackets
http://www.tiffen.com

Sunrise and sunset world map
http://www.sunrisesunsetmap.com

ThinkTank
Inventive Camera Bags
http://www.thinktankphoto.com

Weather
http://www.weather.com http://www.bbc.co.uk/weather http://www.worldweather.org

Wildlife Watching Supplies®
Bean bags, blinds, clothing, camouflage materials, camouflage mats and chairs, blinds everything for wildlife photography.
http://www.wildlifewatchingsupplies.co.uk

Wimberley
Wimberley head for large telephoto lenses and the Plamp
http://www.tripodhead.com

ACKNOWLEDGEMENTS

Many people helped with the production of this book and my grateful thanks to you all. I should especially like to thank my son Giles Angel, who advised and assisted on the post production of some images. Kate Carter and Valerie West assisted with inputting my copy and proof-reading.

INDEX

A abstract 71, 74, 75
accessories **13**, 31, 140, 145
angle of view **66**, 137, 144, 150, 152, 171
autoexposure lock 36, 41, 43
autofocus 84

B background 36, 66, 68, 72, 73, 82, 120, 121, 130, 131, 137, 139, 142, **144**, 146, 149, 150, 152, 153, 158, 167
backpack **18**, 19, 99, 161
blur 85, 130, **131**, 147
bracketing
 auto 40
 exposure 65, 78, 85, 96, 167
brightness 35, **40-41**, 43, 44, 57, 59, 65, 74, 76, 78, 84, 85, 167

C camera support **24-33**, 93, 129
clipping 12, 35, 39, 165, 167
color balance 78
color cast 37
color saturation 27, 84, 167
compact camera 85
composition 27, 28, 29, 30, **46-62**, 67, 74, 76, 78, 85, 105, 121, 143, 147, 151
contrast 54, **60-61**, 78, 80, 82, 84, 85, 152, 156, 158

D depth of field 36, 49, **68**, 143, 144, **150**, 152, 154, 156, 172
depth-of-field preview 30, 36, 144, 149, 150
diffuser 13, 19, 23, 33, 73, **82**, 88, 91, 148, 149, 153, 154
D-SLR 35, 47, 48, 87, 130, 132, 163, 164
dynamic range 12, 85, 167, 168

E exposure compensation 38, 41, 43, 147
extension tube 140

F file formats
 JPEG **12**, 164, 166
 RAW **12**, 37, 130
 TIFF **12**, 165, 167, 168
 filters
 graduated neutral density 43, 65, 78, 82, 84, **85**, 167
 polarizer 27, 53, 82 **84**, 85, 157
 flare 42, 49, 96
 focal length 25, 47, 49, 50, 66, 68, 72, 87, 122, 134, 150, 152
 focal plane 150
 foreground 42, 50, 65, 68, 73, 137, 138, 139, 168, 171
 f/stop 35, 68, 144

H hard drive 17, **162**, 165
histogram 12, 35, 36, **38**, 40, 41
high dynamic range (HDR) 43, 65, 78, **168**
highlights 8, 35, 39, 65, 83, **167**, 168
highlight warning 35, 167

I image stabilization 25
ISO 12, 28, 35, 36, 42, 68, 78, 84, 86, 93, 98, 129, **130**, 132, 154, 157

L landscapes 6, 30, 43, 47, 49, 53, 54, 65, 66, 68, 70, 73, 74, 78, 82, 84, 85, 93, 102, 105, 137, 148, 149, 156, 167, 170
lenses
 macro 137, 144, 149, 150, 152, 157
 prime 42, **49**
 telephoto 32, 42, 49, 50, 53, 105, 110, 113, 116, 129, 132, 137, 140, 170
 wide-angle 18, 19, 27, 42, 49, **50**, 51, 52, 53, 66, 69, 73, 87, 129, 137, 140, 171

zoom 18, 32, 42, **49**, 50, 72, 75, 108, 110, 113, 121, 122, 132, 134, 140, 157, 161
lighting
 backlight **42**, 88, 92, 152
 catchlight 117, 122
 diffuse or soft 59, 73, 82, 83, 85, 88, 148, 149, 153, 154
 direct or hard 37, 42, 54, 83, 91, 96, 97, 153
 fill flash 98, 113, 117, 122, 130, 148, 155
 flash 16, 19, 20, 22, 36, 37, 65, 81, 86, **87, 88**, 90, 91, 99, 116, 120, 125, 131, 149, **154**, 155, 156, 157, 161
 flashlights 13, 17, 27, 65, 86, 91, 116
 magic light 65
 night light 86, **90-91**, 116
 reflected light 35, 40, 43
 side light 152
 spotlights 76, 86, 97

M macro 6, 19, 30, 68, 82, 88, 93, 137, 139, **148-158**, 172
metering
 center-weighted **35**, 36
 multi-segment or evaluative **35**, 40
 spot 34, **35**, 36, 40, 41, 42, 43, 44, 111, 140, 149
monopod **30**, 31, 107, 111, 122, 129
movement
 camera **30**, 111
 subject 26, 36, 131, 145, 146

N noise 35, **130**, 132, 167

P panoramic 47, 66, 108, **170-171**
perspective 26, 27, 50, **66**, 140
post production 60, 93, 143, 163, 165, **166**, 167
printing 47, 166

R reflections 25, 47, 50, 53, **70-71**, 75, 84, 91, 122, 149, 153, 157
reflectors 13, 19, 23, **80-81**, 130, 148, 149
resolution (pixels) 12, 48

S sharpness 25, 31, 68, 69, 130, 131, 149, 150, 154, 156, 172
shooting modes
 aperture priority **36**, 40, 68, 144
 continuous 122, 129, 134
 manual **36**, 40
 program **36**, 40
 shutter priority **36**, 40, 68, 134
shutter speed 25, 35, 36, 49, 68, 85, 86, 93, 94, 128, 130, 131, 132, 134, 144, 154, 168
silhouettes 42, **44**, 56, 59, 78, 98, 105, 152
softbox **88**, 89, 154, 155
stalking 31, **107**
stitching photos 47, 66, **170-171**

T temperatures, extreme 14
textures 44, 54, 76, **156**, 163, 166
time lapse **72**, 134
tripod 18, 19, 22, 26, 28, **30-31**, 32, 35, **48**, 72, 82, 93, 98, 100, 101, 105, 106, 107, 109, 111, 122, 127, 130, 131, 132, 140, 141, 144, 145, 147, 149, 156, 157, 168, 170, 171, 172

W white balance 12, 37
windshield 146
workflow 164
workshops 108